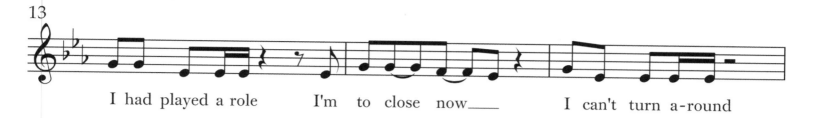

I had played a role I'm to close now___ I can't turn a-round

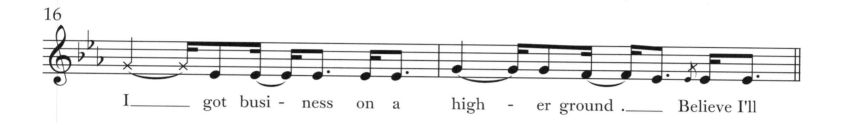

I_____ got busi - ness on a high - er ground ._____ Believe I'll

Chorus

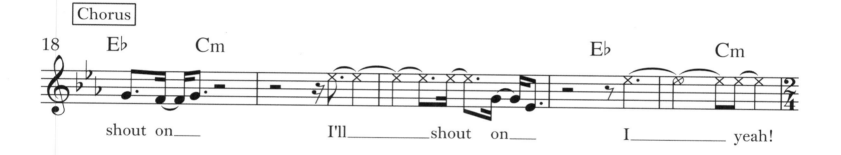

shout on___ I'll_____shout on___ I_____ yeah!

(de)clare__ long white robe,

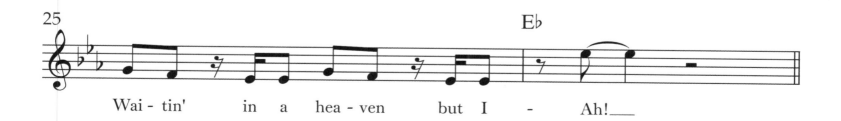

Wai - tin' in a hea - ven but I - Ah!___

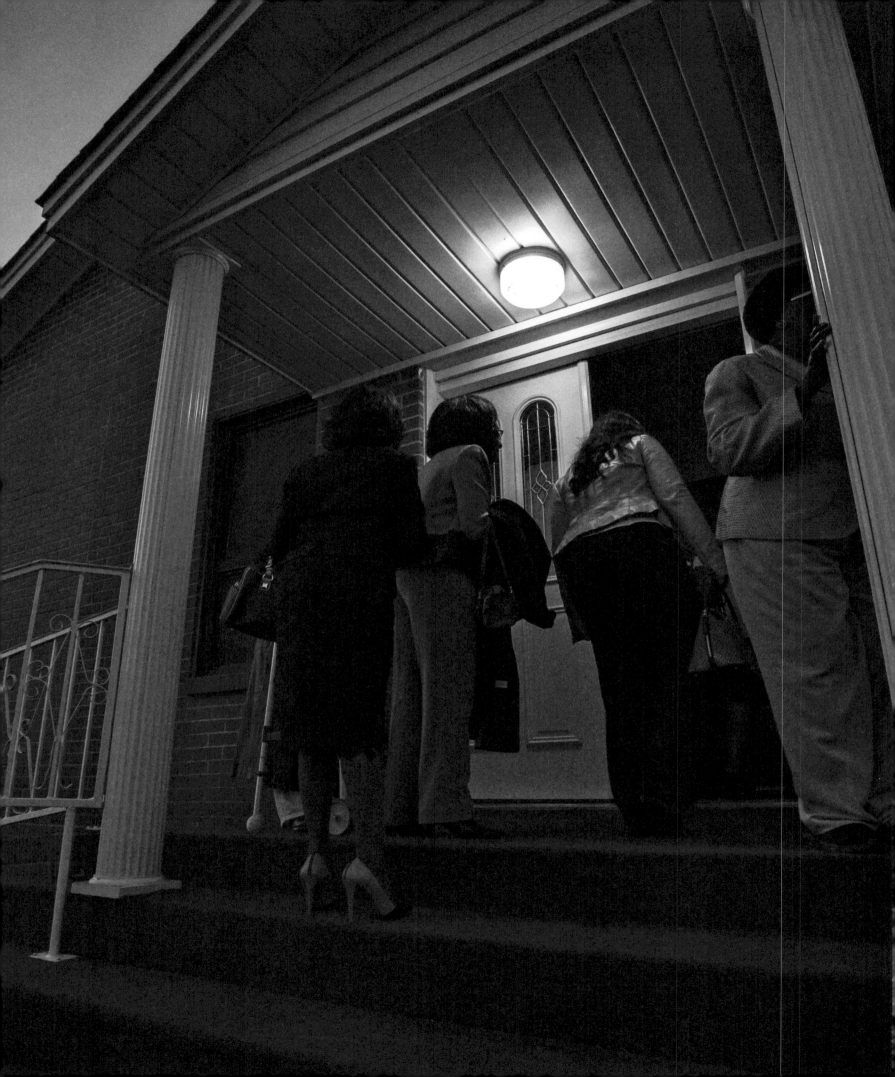

Joshua Rashaad McFadden

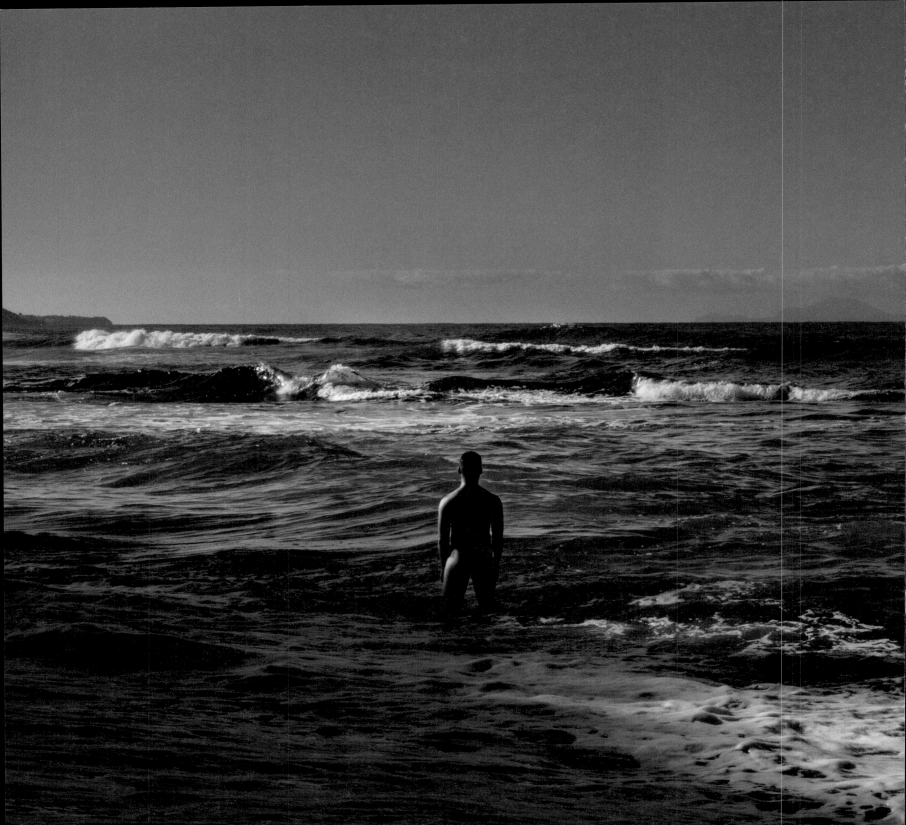

Joshua Rashaad McFadden

I Believe I'll Run On

Essay by LaCharles Ward, PhD

Conversation between Lyle Ashton Harris and
Joshua Rashaad McFadden

Rochester

New Haven and London

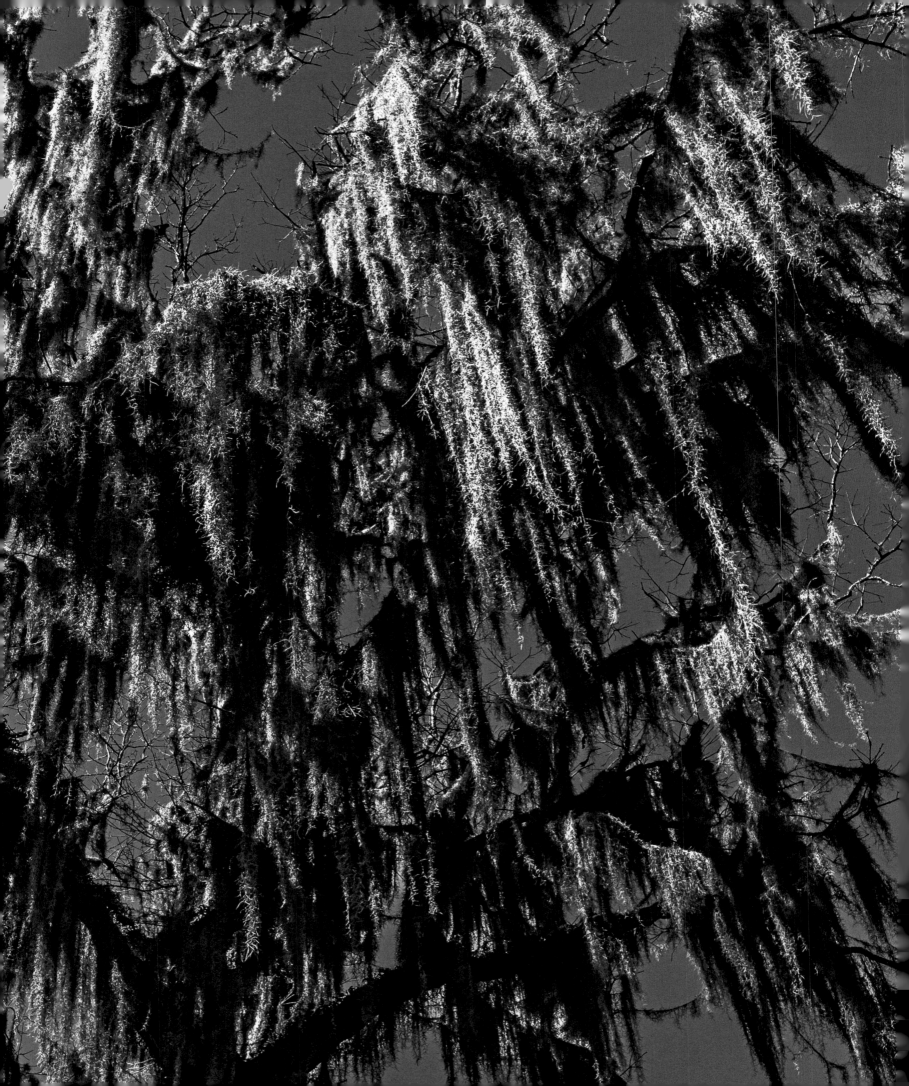

Co-published by:

George Eastman Museum
900 East Avenue, Rochester, NY 14607, eastman.org

Yale University Press
302 Temple Street, P.O. Box 209040, New Haven, CT 06520, yalebooks.com/art

Publication of this book has been made possible by the George Eastman Museum Publishing Trust Endowment, which was established by Thomas Gosnell and Richard Menschel with funds donated by Thomas and Georgia Gosnell and the Horace W. Goldsmith Foundation.

This catalog is published in conjunction with the exhibition *Joshua Rashaad McFadden: I Believe I'll Run On*, presented by the George Eastman Museum, November 5, 2021–June 19, 2022.

All works are by Joshua Rashaad McFadden (American, b. 1990) except as noted. All images courtesy of the artist. © Joshua Rashaad McFadden

Ron and Donna Fielding Director: Bruce Barnes
Director of Publishing: Amy Schelemanow
Project Originator: Heather A. Shannon
Curatorial Assistant: Meghan Jordan
Copyeditor: Gretchen Oberfranc
Proofreader: Anne Canright
Rights Clearance and Digital Asset Coordinator: Lauren Lean
Sheet Music Transcriber: Richard Desinord
Production Assistant: Victoria Falco
Photographic Support: Elizabeth Chiang and Trevor Clement
Designer: Patrick Seymour, Tsang Seymour LLC

Typeset in Azo Sans and Source Serif
Printed on Arctic Volume by Cantz, Riederich, Germany

ISBN: 978-0-300-26426-5

Library of Congress Cataloging-in-Publication Data

Names: McFadden, Joshua Rashaad, artist, interviewee. | Ward, LaCharles, 1988- writer of added commentary. | Harris, Lyle Ashton, 1965- interviewer. | George Eastman Museum, publisher, host institution.
Title: Joshua Rashaad McFadden : I believe I'll run on / essay by LaCharles Ward ; conversation between Lyle Ashton Harris and Joshua Rashaad McFadden.
Description: Rochester, NY : George Eastman Museum ; [New Haven, Connecticut] : Yale University Press, [2022] | "This catalog is published in conjunction with the exhibition Joshua Rashaad McFadden: I Believe I'll Run On, presented by the George Eastman Museum, November 5, 2021-June 19, 2022." | Includes bibliographical references.
Identifiers: LCCN 2021039220 | ISBN 9780300264265 (hardcover)
Subjects: LCSH: McFadden, Joshua Rashaad--Exhibitions. | George Eastman Museum--Catalogs. | African American photographers--Exhibitions. | Photography, Artistic--Exhibitions. | Documentary photography--United States--Exhibitions. | African Americans in art--Exhibitions. | United States--Race relations--In art.
Classification: LCC TR647 .M39249 2022 | DDC 770.74/74788--dc23
LC record available at https://lccn.loc.gov/2021039220

Cover: *A. W., 2016.* Inkjet print with charcoal, 90 × 44 in. George Eastman Museum, purchase with funds from the Horace W. Goldsmith Foundation.

Back cover: Flower painted on Joshua Rashaad McFadden's forehead at his 6th birthday party, Rochester, New York, 1996. © Joshua Rashaad McFadden

Half-title: Detail, *Gathering #1*, 2015. From *After Selma*. Gelatin silver print, 14 × 21 in.

Title: Detail, *Water No Get Enemy*, 2020. From *Love Without Justice*. Inkjet print, 59 3/4 × 79 11/16 in.

Copyright: Detail, *Southern Tree*, 2015. From *After Selma*. Gelatin silver print, 14 × 21 in.

Table of Contents: Detail, *George Floyd Memorial Site #5, Derek Chauvin Found Guilty (Minneapolis, Minnesota)*, 2021. From *Unrest in America: George Floyd*. Inkjet print, 21 x 28 in.

Yale

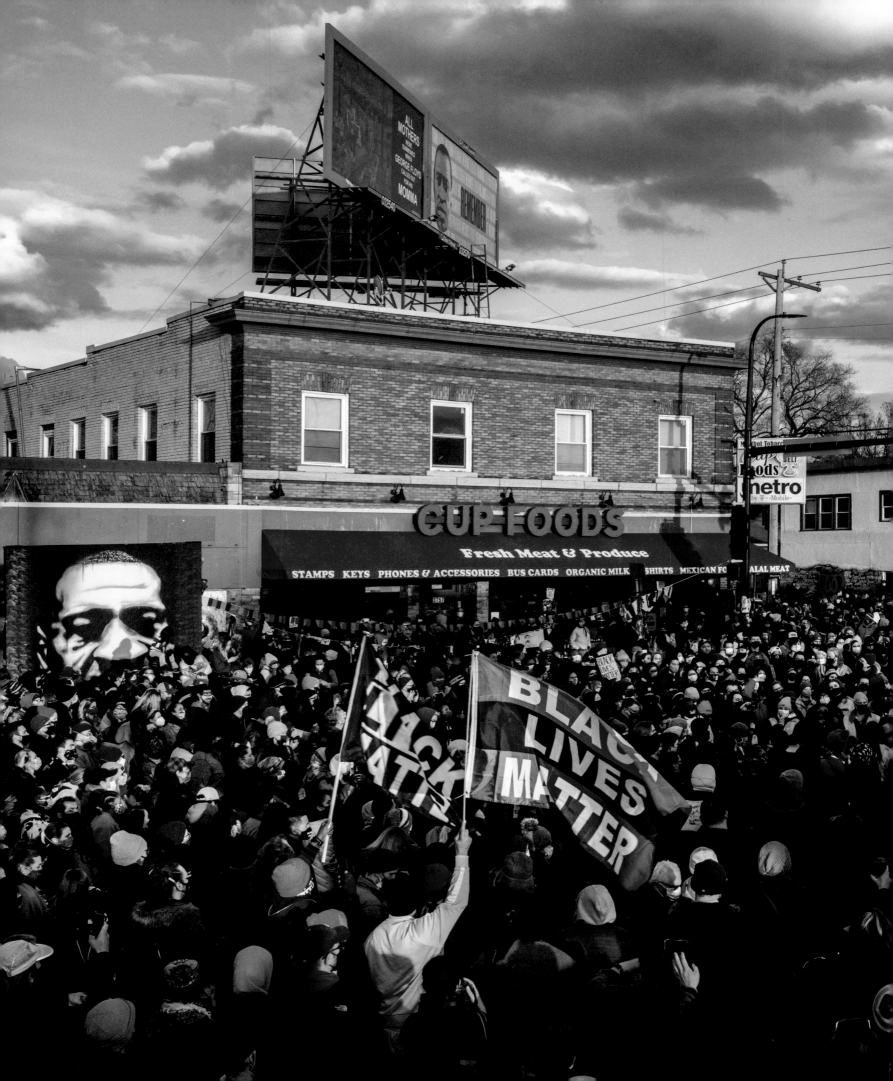

Contents

Acknowledgments

First and foremost, the George Eastman Museum thanks Joshua Rashaad McFadden for collaborating with our institution on this exhibition and book project. He has worked with many members of the project team to realize our shared vision for exhibiting and publishing an early-career survey of his work.

As is manifest in his autobiographical series, *Love Without Justice*, McFadden's life and work are significantly influenced by his family and culture. He credits two song recordings as being inspirations for the exhibition's subtitle. The records are very different arrangements of a traditional gospel song. The earlier is "Believe I'll Run On (Gospel Jam)," performed by Wilson Pickett and released by Atlantic Records in 1965. The more recent is "I Believe I'll Run On," performed by Mighty Clouds of Joy and released on their *Live in Charleston* album (1996), which is currently available on Intersound Records. Sheet music representing a portion of the vocals for each recording has been recreated in this book's endpapers.

Dr. Heather Shannon, former associate curator of photography, initiated the project and dedicated many hours of work in partnership with the artist to plan the book and exhibition. Their work together was foundational. Drs. Lisa Hostetler, Leigh Raiford, and Tanya Sheehan offered crucial advice during early research and planning for the project.

When the COVID-19 pandemic made another exhibition impracticable, Dr. Bruce Barnes, the museum's Ron and Donna Fielding Director, encouraged and advocated an accelerated timetable for this book and exhibition. The book project was expertly helmed by Amy Schelemanow, director of publishing

Detail, *E. W. Higginbottom and Elwood Higginbotham*, 2018.

and exhibitions, who developed and implemented its ambitious schedule with equanimity. Nick Marshall, head of exhibitions and programs, deftly managed the expedited preparations, layout, and production of the exhibition with keen problem solving. He also worked closely with the artist and organized programs to accompany the exhibition. Jamie M. Allen, the Stephen B. and Janice G. Ashley Curator and Interim Head of the Department of Photography, provided selfless contributions and steady leadership to the department through evolving circumstances.

Dr. LaCharles Ward's essay insightfully interprets McFadden's photographs and astutely contextualizes his contributions as a Black artist. We are grateful to Leigh Raiford for recommending him as a contributor to the catalog.

In addition to lending artworks from his collection to the exhibition, Lyle Ashton Harris graciously agreed to interview the artist. In their deeply personal conversation, Harris's incisive, poignant questions provide readers with critical background for themes that resonate throughout McFadden's life and work. McFadden studio administrator Melanie C. Gordon facilitated many essential discussions and transcribed the conversation with the assistance of Josh Rabineau, Ashton's studio assistant.

K. Anthony Jones collaborated with the artist on the organization and editing of the monograph. McFadden's former studio assistant Louis Chavez coordinated the artist's family photographs and organized their digital files for both the publication and the exhibition. Their assistance was invaluable.

Patrick Seymour of Tsang Seymour LLC was a talented and collaborative designer of the book. Gretchen Oberfranc and Molly Tarbell did outstanding work editing the book texts, which Anne Canright carefully proofread. Lauren Lean, the museum's digital asset coordinator, navigated the extensive process of clearing rights with media outlets and McFadden's fellow artists. Elizabeth Chiang photographed the *Selfhood* works for the catalog. The other images of the artist's work were sourced for the book from his digital files.

Our colleagues at Yale University Press provided expert advice on key aspects of the book. The collegial guidance from their team, especially our primary contacts Stephen Cibek and Nicholas Gellar, was most welcome as the book was being completed.

This book was made possible by the George Eastman Museum Publishing Trust Endowment. In 1990, Thomas Gosnell and Richard Menschel established

the endowment with funds donated by Thomas and Georgia Gosnell and the Horace W. Goldsmith Foundation. We are grateful that these two prescient donors recognized the paramount importance of scholarly publications to our institution's mission.

Dr. Jared Richardson took over as curator of the exhibition after Shannon stepped away to pursue another profession. He embraced the project with energetic enthusiasm, expanding the interpretation of the themes in the artist's work.

Many staff provided their unwavering support to the book and exhibition projects. Meghan Jordan, curatorial associate in the Department of Photography, and members of the Registrar's Office—Sarah Evans, Olivia Arnone, and David Howe—provided crucial support and guidance.

Conservator-in-charge Taina Meller and assistant conservator Sarah Casto performed nuanced treatments to McFadden's *Selfhood* works, which, because of their scale and unique properties, benefited greatly from the conservators' expertise. Tate Shaw, director of the Visual Studies Workshop, opened their facilities for McFadden to print the *Come to Selfhood* photographs. Trevor Clement worked tirelessly on many of the exhibition prints of the artist's works and produced the reference prints used for this book's production.

The preparation and installation of the exhibition was executed by dedicated museum staff. Production designer Victoria Falco helped develop the graphic elements of the exhibition and shepherded them through production and printing. Emily Phoenix, head preparator, expertly led the team that prepared the works and installed the exhibition.

The museum's engagement and marketing department worked tirelessly to bring the exhibition and related programs to the public through expanded interpretive materials, social media content, and print and media publicity. Those collaborative efforts were led by Eliza Kozlowski and Dr. Kate Meyers Emery.

Since it was established by Drs. Dawn and Jacques Lipson in 2010, the Lipson Visiting Artist Fund has provided unwavering support of our public programs, which have enabled countless audience members to enjoy in-person opportunities to hear artists' stories. We appreciate the fund's essential support of the speaker programs that accompanied the exhibition.

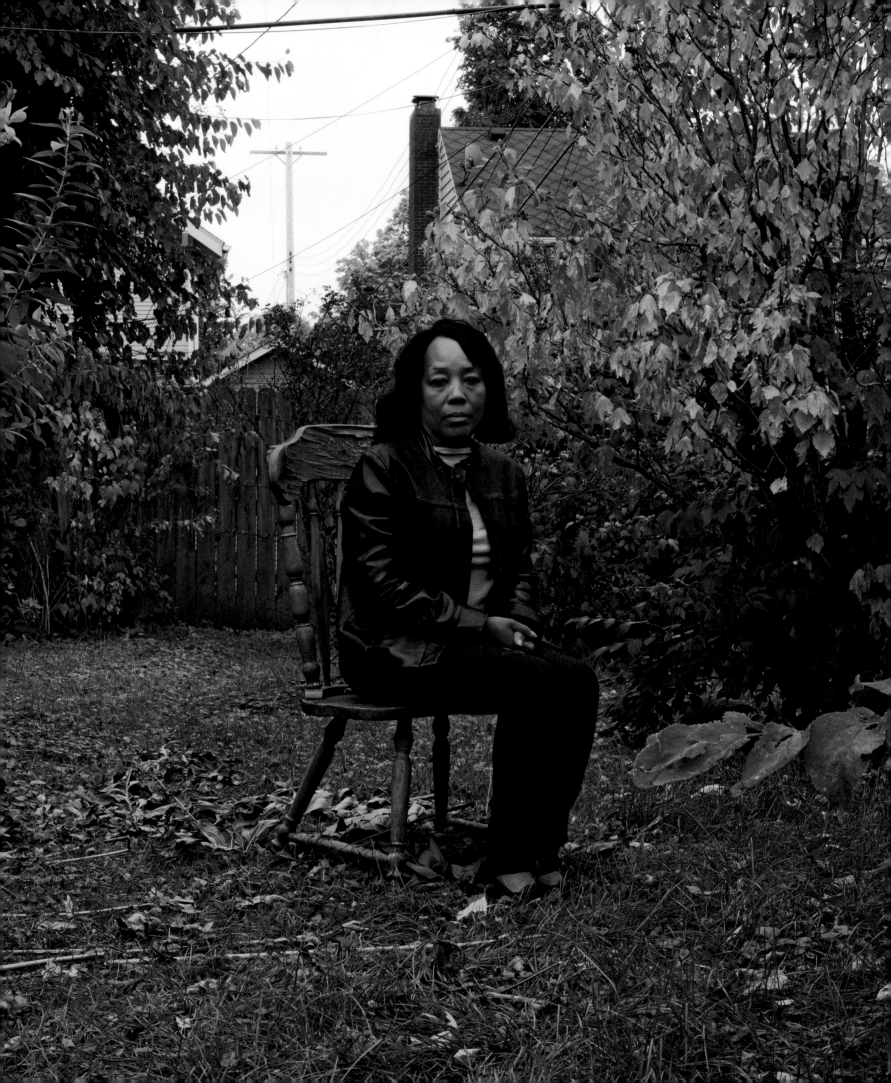

Introduction

Bruce Barnes, PhD

Many times in the history of the George Eastman Museum, we have been the first institution to present the works of a photographer or to organize a monographic compendium early in an artist's career. We have been proud to present an early-career survey of the work of Joshua Rashaad McFadden in our main galleries from November 5, 2021, through June 19, 2022.

My first encounter with McFadden's work was through his towering pinup portrait *A. W.*, a stunning artwork included in our 2020 exhibition *Gathering Clouds: Photographs from the Nineteenth Century and Today*—and now part of the museum's collection (cover image). My immediate inquiry to the curator was, "Is all of his work this good?" As I learned, McFadden has consistently created strong work, rich with meaning and interpretative opportunities.

At that time, there was already a preliminary plan for an exhibition of his recent work in our Project Gallery. I mused aloud that we should consider instead a broad survey of his work in our main exhibition galleries. A consensus quickly formed that, with heroic effort, we could organize such an exhibition to open in fall 2021. Consisting of works from seven series, which span the past decade, the exhibition and book *Joshua Rashaad McFadden: I Believe I'll Run On* demonstrate his mastery of a wide range of photographic genres—fine art, social documentary, and reportage.

After Selma (2015) meditatively presents the commemoration of the fiftieth anniversary of the Selma to Montgomery marches, led by the Reverend Dr. Martin Luther King Jr. The black-and-white photographs quietly invite contemplation of the courage, sacrifices, and hopes of the original nonviolent

Detail, *Come Ye Disconsolate Wherever Ye Languish*, 2019.

13

marchers—who were met with police brutality—and of how far our society still has to go. The commemorative event was by no means a victory march of a people who had reached the promised land.

Come to Selfhood (2015–2016) combines narrative texts with photographs to explore the connection between young Black men and their father figures. McFadden couples his portraits of the young men with either snapshots or professional images of their self-selected paternal figures. Handwritten notes by the young subjects serve as the link between the two images in each collage. In each case, there is—or one imagines—a shared aspect discernible in the images of the paired men.

In *Selfhood* (2016), McFadden portrays confident and empowered young Black men with a distinctive technique—applying charcoal and coffee to inkjet prints of photographs—in works that recall paintings by Barkley Hendricks and Kehinde Wiley. All three artists have built on centuries of Western art tradition, but their subjects are proudly Black. The clothes help make and define the men, as they did in, for example, Pontormo's *Portrait of a Halberdier*, Thomas Gainsborough's *The Blue Boy*, and John Singer Sargent's *Dr. Pozzi at Home*.

Evidence (2017–2020) juxtaposes portraits of Black men whose appearances and thoughts do not conform to traditional standards of cis-maleness with their handwritten reflections on issues of Black identity, masculinity, sexuality, fatherhood, and fraternity. Their statements are candid, introspective, insightful, moving, profound. McFadden's portraits celebrate in them both the strength and vulnerability that they reveal in their writings. Their still waters run deep.

A Lynching's Long Shadow (2018), commissioned by the *New York Times*, offers a lyrical approach to an unfathomable legacy. McFadden observes the descendants of Elwood Higginbotham—a twenty-nine-year-old tenant farmer who was killed by a lynch mob over a dispute with a white landholder— and the site of his murder in Oxford, Mississippi. The photographs do not avoid the beauty of these Southern woods, but their effect is elegiac and haunting.

Love Without Justice (2018–2021) is a set of autobiographical works of contemporary art, which in the exhibition were installed surrounding a digital projection of more than a hundred of the artist's family photographs. This series is the first body of work in which the artist reveals himself directly and through his family, rather than through images of others. The somber *Come Ye Disconsolate Where Ye Languish* captures McFadden's mother seated alone

in an autumnal backyard on the day of her mother's funeral. A few of the images show the artist nude, evincing neither modesty nor immodesty. Yet, the most revealing of the photographs is perhaps *Tenderly Speaks the Comforter*, a shadowy image of the heads and shoulders of two shirtless men in a loving embrace.

Finally, *Unrest in America* (2020–2021) is a body of photographic reportage of protests in the wake of the police killings of George Floyd in Minneapolis, Rayshard Brooks in Atlanta, Breonna Taylor in Louisville, and Daniel Prude in Rochester. In these locations, McFadden was frequently acting as a photographic correspondent for national newspapers or magazines.

I conclude this introduction by summarizing some compelling insights about the exhibition and McFadden's oeuvre that are offered by Jared C. B. Richardson, PhD, the consulting curator who authored the interpretative text for the exhibition. Illustrative of his upbringing in the Black Pentecostal church, McFadden took the exhibition's title from a traditional gospel song recorded by the famed gospel group Mighty Clouds of Joy (1996) and rhythm-and-blues singer Wilson Pickett (1965). "I Believe I'll Run On"—as both a song and a phrase—exemplifies the sacred and secular endurance found in Black life within the United States. The song joyously details a believer's perseverance to behold God and enter paradise. In the context of the worldly obstacles of oppression, discrimination, and anti-Blackness, the lyrical title also evokes the arduous marathon toward justice.

Richardson's central thesis is that *I Believe I'll Run On* observes the interiority and quietude of Black people despite this marathon and the various evils that simultaneously impede and inspire it. He cites scholars Kevin Quashie and Lokeilani Kaimana, who explain that Black culture has all too often been framed as a public spectacle, thus obscuring meditative moments of inner life. The truth of Black people's possessing an interiority and quietude ruptures commonly held expectations of journalistic photography. Instances of interiority and quietude serve as the leitmotif in McFadden's work, appearing in unique ways in each of the exhibition's series, except the *Selfhood* portraits.

I join Richardson in concluding that, fundamentally, *I Believe I'll Run On* chronicles the intimacies of Black life in the United States. The show is a testament to the healing and protective possibilities of turning inward.

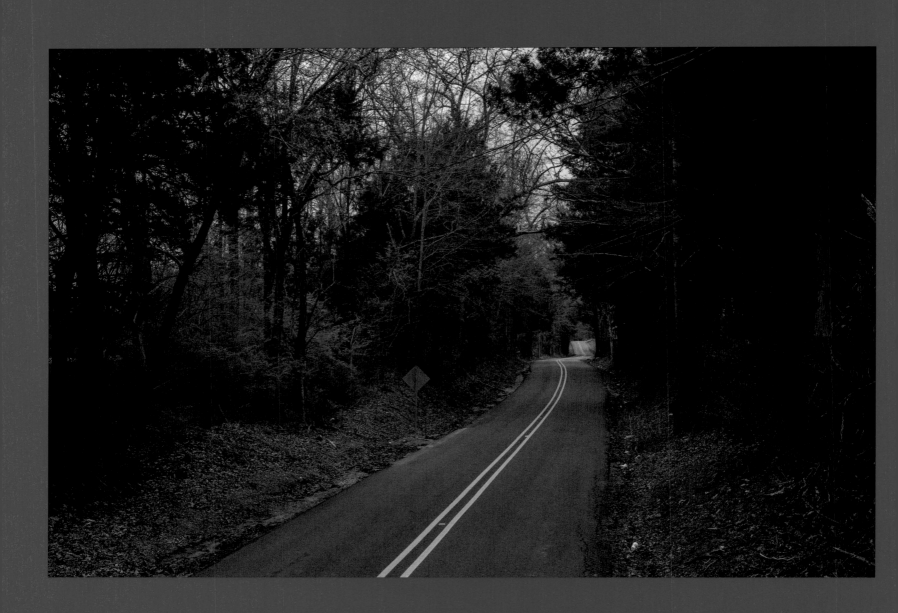

In the Long Shadow

Black Photography, Anti-Black Violence, and the Great Beauty of Black Life

LaCharles Ward, PhD

To look at photographs by Joshua Rashaad McFadden is to surrender wholly to photography's affective capacities, violently ugly histories, and ability, when mobilized with care, to illustrate the great beauty of Black life. In *Joshua Rashaad McFadden: I Believe I'll Run On*, an early-career survey, McFadden embarks on an artistic, historical, and cultural journey through the medium of photography to describe Black living in the continuing wake of anti-Black violence and death. In the long shadow of photography's documentary function, which simply sought to record the plight of Black life and the violence against Black people, to serve as evidence to promote social reform, and to universalize blackness and the Black experience, McFadden refuses the constraints of that project. Instead, like many Black photographers before him—Roy DeCarava, Gordon Parks, Carrie Mae Weems, Dawoud Bey, and LaToya Ruby Frazier—he not only zooms in on the specificity of Black living in our *historical present* with granular precision, but also centers the Black aesthetic and Black people as worthy subjects of art. Indeed, McFadden's photographs gesture to the "beautiful experiments of living free" or, we might say, to the conception of "how to live as Black" that theorist Saidiya Hartman understands is to always exist within the confines of violence.[1] Moving across genres, McFadden addresses blackness, anti-Black violence, social protest, grief and mourning, notions of intimacy, gender, sexuality, and a range of lived experiences that we might understand, following Fred Moten, as *Black social life*.[2] In this essay I engage, thematically, with only some of the works that appear in *I Believe I'll Run On* in order to contextualize McFadden's work with some depth. The sections that follow pay specific attention to how McFadden addresses the violence of lynching photography, anti-blackness, and images of Black life.

Unless noted all photographs are by Joshua Rashaad McFadden, © Joshua Rashaad McFadden and appear courtesy of the artist.

1.1 *The Road to Oxford Mississippi*, 2018. From *A Lynching's Long Shadow*.

I.

Photography has been central to the narration of lynching across the twentieth century, and lynching photography is nearly omnipresent in the narration of black life in this long century as well. The lynching archive functions as a site of struggle over how to memorialize the dead, how to organize for the future, that also reveals the vagaries of an ossified memory.

—Leigh Raiford, *Imprisoned in a Luminous Glare*

Lynching is an extralegal act of brutal violence. The "camera work"—to redeploy a term coined by Alfred Stieglitz—of the winding road in one of McFadden's photographs in the series *A Lynching's Long Shadow* both transports us back to a site of a lynching, literally, and visually tracks the long history of lynching that shaped Black life from the final quarter of the nineteenth century through the twentieth century (fig. 1.1). It is not possible to determine the exact number of lynchings that occurred; however, scholars concur that its regularity and intensity formed a *patterned regime of racial terror* after the Civil War and Reconstruction. According to historian Amy Louise Wood, "between 1880 and 1940, white mobs in the South killed at least 3,200 black men."[3] It is important to note, still, that while the majority of lynchings happened in former slaveholding states, they also took place across the American North and West.[4] Lynching in and of itself is a heinous act, but its mobilization by white mobs as a tool to proclaim the supremacy of whiteness produced a large visual record of unfathomable racial terror and spectacular scenes of Black subjection.

Thus, even if one accepts the argument that lynching, as an act of racial terror, was uniquely specific to the South and occurred between a set of dates in American history, one still has to reckon with how regional acts of racialized violence would continue to shape an entire country's disregard for Black people and their lives. Indeed, as Ida B. Wells-Barnett noted in *The Red Record* (1895), lynching was not simply a response to crimes (real or not), but far deadlier in its persistence. It represented the conscious effort to solidify white supremacy as America's national culture and empower white people and their institutions as its protectors. This effort by white mobs to trumpet the supremacy of whiteness and the expendability of blackness found its initial ally in photography.

The social practice of lynching was a "theatrical production," and newspapers "often announced the time and location so that crowds could gather."[5] It was a spectacle, or more aptly put, one of the many scenes where Black people were subjected to grotesque violence and death for the morbid entertainment of white people, both present and afar.[6] These scenes traveled across the United States as postcards despite a 1908 amendment to the Comstock Act that prohibited the United States Post Office from dispatching them.[7]

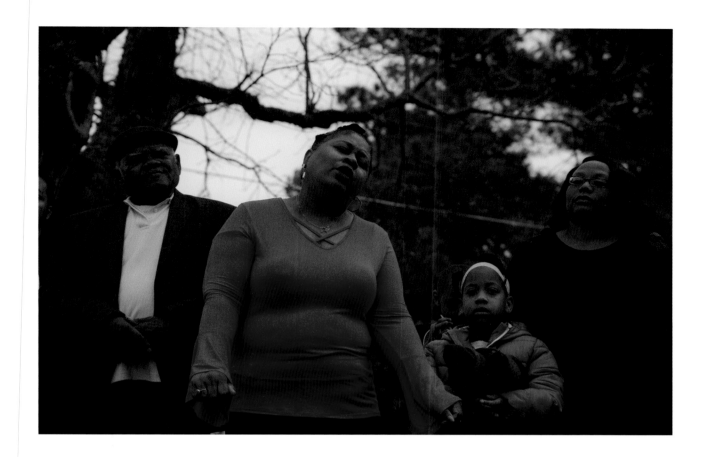

As historian of photography Shawn Michelle Smith argues, lynching photographs, like lynching itself, "proved central to the consolidation of a white supremacist vision of whiteness at the turn of the century."[8] Exhibitions such as *Without Sanctuary* (1999) demonstrate the fundamental role photography played in the ritual of lynching.[9] The photographs show a cheerful, anticipatory crowd of white spectators as they await the impending death of another Black person; they look directly at the camera without shame or guilt. If we understand that lynching, as an act of racial terror, is the unlawful killing of Black people by a white mob, often with the complicity of state and local officials, and that the intended outcome is to demand subservience to white supremacy, then we must also understand the modern policing institution as an extension of the lynch mobs that proliferated in the late nineteenth and early twentieth centuries.[10]

Within this long shadow of lynching is where we must locate McFadden's series. The winding road, nestled in a forest sparse with greenery, takes us back to Oxford, Mississippi, where Elwood Higginbotham was murdered by a white mob in 1935. Except, McFadden's intention is not to re-center whiteness or white looking practices. Nor does he seek to document with his camera the specific act of lynching or the attendant white spectatorial experiences. Instead, the photographs in *A Lynching's Long Shadow* record a Black family's confrontation with the past, but also more. For example, in *Descendants*

1.2 *Descendants of Elwood Higginbotham*, 2018. From *A Lynching's Long Shadow*.

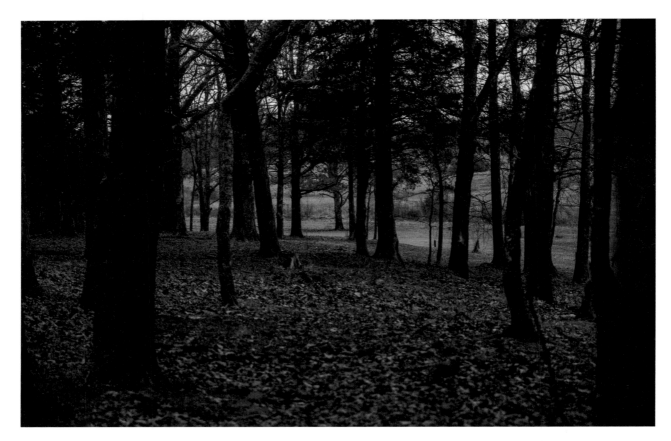

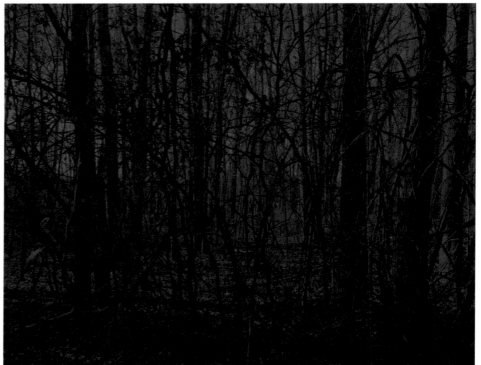

of Elwood Higginbotham, McFadden captures the family on the possible grounds where their father, grandfather, and great-grandfather might have been murdered (fig. 1.2). In the *terrible beauty* of this photograph, McFadden visually gestures to how that past has marked the present everyday lives of

the Higginbottom family and how it will continue to shape their futures (here, I am thinking of the young girl in the image).[11] The photographs register, too, the mourning (*To Bear Witness*) and burial practices (*E. W. Higginbottom and Elwood Higginbotham*) that were often denied Black families (pgs. 152, 144, and 149). Strikingly, McFadden's haunting photographs of the landscapes marked by Black death wrought by white violence disrupt the romanticism associated with *pastoral scenes of the gallant South* and its sprawling terrain.[12] It is hard not to locate photographs such as *And Blood at the Root* and *The Burial Site* alongside renowned Black photographer Dawoud Bey's recent series *Night Coming Tenderly, Black* (pg. 146 and figs. 1.3 and 1.4). Like Bey, McFadden demands another way of seeing the American landscape, a place that is marked by racial violence, yes, but also one where Black people made life and sought to imagine another future. It has also been (and continues to be) a place to imagine *something akin to freedom*, to move waywardly in the ongoing wake of anti-Black violence.[13]

II.

If the photograph is emblematic of the way a past persists in the present, it also foreshadows how fragments of the present will punctuate a future moment.
—Shawn Michelle Smith, *Photographic Returns*

The past is never quite past. It reappears, and for Black people, the past is always the present. The series *After Selma* and *Unrest in America* both affirm this notion. In *After Selma*, a set of beautifully composed black-and-white gelatin silver prints, McFadden returns to the past with a contemporary eye to capture how the Black community remembered the march from Selma to Montgomery fifty years afterward and mourned the victims who were wantonly beaten by police on Bloody Sunday, March 7, 1965. In his revisitation, viewers encounter a contemporary photographic composition of the Edmund Pettus Bridge (fig. 1.5), which was made infamous by the televised images of the brutal attacks. Two middled-aged Black men occupy the frame's center. Their hands are interlocked, and their gazes look past the photographer and the viewer. In the background are groups of Black people marching and talking among themselves. Absent from this photograph are the dogs, police, batons, blood, and Bull Connor—the iconic scenes of the Pettus Bridge images—though they linger at the edges of this frame (in our memories). Instead, the photograph depicts a jubilee, as the shirt of one of the subjects in this image reads. McFadden does not sidestep this violent iconography through his photographs. He is fully aware of photography's capacity to draw on memory, its ability to "apprehend a past in felt fragments."[14] Photography is always in a delicate and complicated waltz with history, violence, and memory. Yet I also propose that McFadden is likewise committed to portraying how the celebration of Black life and, most importantly, how the

1.3 *The Burial Site*, 2018. From *A Lynching's Long Shadow.*

1.4 Dawoud Bey (American, b. 1953), *Untitled #17 (Forest)*, 2017. Gelatin silver print, 48 × 59 in.

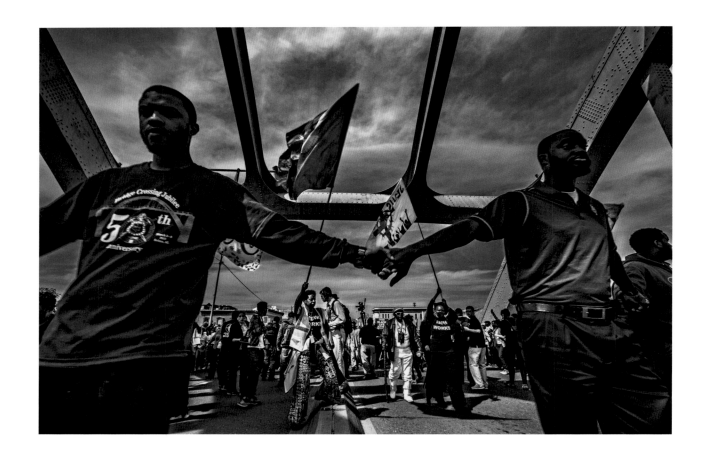

1.5 *50 Years*, 2015. From *After Selma*.

struggle for freedom, though elusive, does not collapse under the weight of violence, including the histories and memories of acts of anti-Black violence.

Here, then, we might understand McFadden as both embracing and mobilizing what photography scholar Leigh Raiford terms "critical black memory."[15] As a mode of both historical interpretation and social and political critique, "critical black memory recognizes the salience of memory to African American life, history, and culture."[16] In a 2015 interview with *LensCulture*, for example, McFadden drew direct parallels among photography, Bloody Sunday in 1965, the images of *After Selma* (fifty years later), and the present-day struggles for justice. "[P]hotography exposed the brutality of Bloody Sunday in 1965," he stated, "and also the death of Eric Garner sparking national protest in 2014. It is interesting to see the huge role photography, both still and moving images, are playing in the contemporary struggle for civil rights."[17] In making these links, McFadden addresses another aspect of critical black memory: how contemporary artists, cultural producers, and Black activists are engaged in an ongoing practice to "speak back to history and assess the ongoing crises faced by black subjects."[18] In his *photographic returns*, McFadden not only works through history and, indeed, lingers in it, but he also calls forth the present, as visually signaled by the "Black Lives Matter" banner in one photograph (fig. 1.6). Black Lives Matter (BLM), as a contemporary slogan and movement, confronts the ongoing crisis of anti-Black police violence perpetuated on Black bodies in

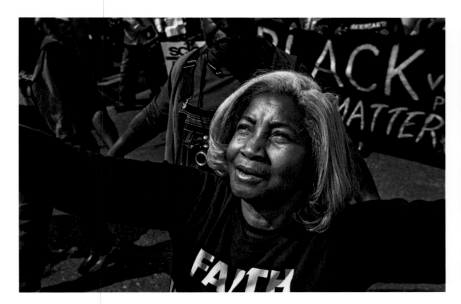

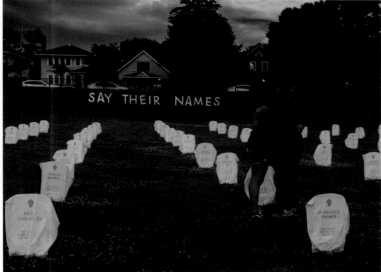

the twenty-first century. The presence of BLM signs in photographs meant to memorialize events in 1965 functions, whether intentionally by the artist or not, as a reminder that how we look at images of BLM protests today must be contextualized historically. Critical black memory enables an understanding that the present(ness) of Black life, the now of Black living, then, is always interdicted by the monstrous intimacies of anti-Black violence and its histories.

The ongoing crises faced by Black people are precisely what McFadden attempts to capture in *Unrest in America*. Whereas *After Selma* sought to memorialize a particular moment in history, a past that is not so past, *Unrest in America* is devastatingly not about memorialization. It is about the now and the future of Black life, with the past always in view. The series focuses on the radical uprisings in response to the deaths of George Floyd, Rayshard Brooks, Daniel Prude, and Breonna Taylor. The photographs also site the geographies of Black death: Minneapolis, Atlanta, Washington, D.C., Rochester, and Louisville. We could add to this list Atatiana Jefferson (Miami), Aura Rosser (Ann Arbor), Stephon Clark (Sacramento), Botham Jean (Dallas), Philando Castile (Falcon Heights), and so many more names and places. This *rollcall for the absence* barely scratches the surface of the sheer disposability of Black life in the contemporary moment.[19] McFadden's photographs capture the pain and anger of a community that continues to recognize how elusive justice is, but more, a community denied the right to mourn. Indeed, their attempts to heal are violently rebuffed by yet another Black death at the hands of the State (fig. 1.7). This fact is emphasized visually by a repetition of photographs that capture makeshift memorials (fig. 1.8 and pgs. 110, 115, 118, 130 among others). What I find most striking about McFadden's photographs in this series, and throughout the entire exhibit, is how the camera remains on Black people and their everyday lives, even when some of subjects are police officers (fig. 1.9 and

1.6 *Faith (Heaven Help Us All)*, 2015. From *After Selma*.

1.7 *Say Their Names (Minneapolis, Minnesota)*, 2020. From *Unrest in America: George Floyd*.

23

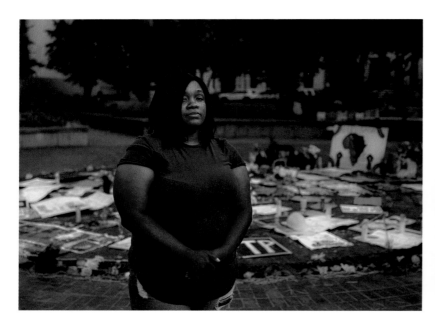

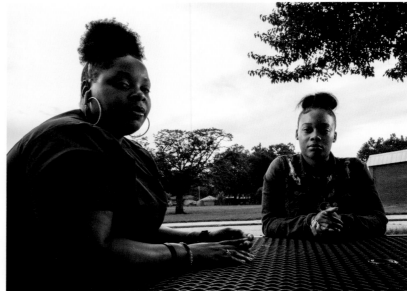

pgs. 119, 125, and 127). Across the entire show, he attempts to capture what it means, drawing on Black critical theorist Christina Sharpe, to *live in the wake of slavery, or in the midst of so much death.*[20] McFadden's photographs, then, catalog the largeness of Black life, even as they ask us to linger on the gratuitous repetition of anti-Black violence and death in the United States at the hand of law enforcement.

III.

Our job is also to really look at and describe and apprehend the multiple ways that Black people make life. How to describe that living in the face of the state's malevolence.

—Christina Sharpe, *In the Wake*

In *Listening to Images*, Tina Campt, a theorist of Black visual culture, wonders what would constitute futurity in the shadow of the persistent enactment of premature Black death? Specifically, she ponders what Black futurity would comprise in the face of the rampant disposability of Black life in the contemporary moment. She asks, "How do we create an alternative future by living both the future we want to see, while inhabiting its potential foreclosure at the same time?"[21] As a working response to Campt's vital question and to bring this essay to a close, I want to suggest that the photographs in McFadden's *Love Without Justice* series provide us with a visual grammar for imagining Black life in the future. This series remains, for me, one of McFadden's most aesthetically compelling and visually affective pieces of work. On the one hand, the photographs are snapshots of everyday Black life: conversations among family and friends; the burial of a loved one; the search for food in the fridge; objects that might linger on one's coffee table; intimate moments with friends, lovers, and former lovers; a wall empty of photographs, gesturing to loss,

1.8 *Tamika Palmer (Louisville, Kentucky)*, 2020. From *Unrest in America: Breonna Taylor*.

1.9 *Katrina Curry and Preonia Flakes (Louisville, Kentucky)*, 2020. From *Unrest in America: Breonna Taylor*.

24

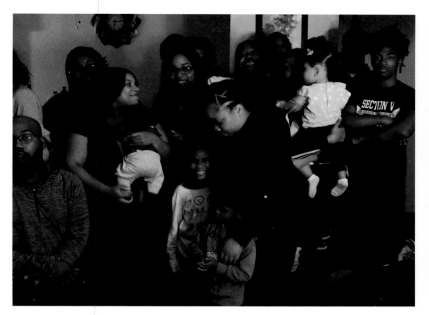

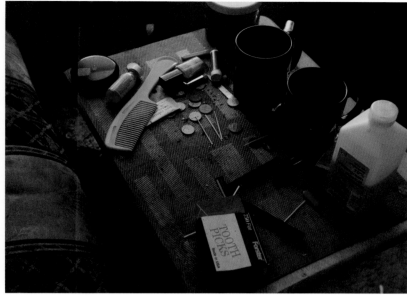

absence, or change; social gatherings where Black joy leaps from the smile of a young girl as she is embraced by a loved one; and the stunning beauty of the nude Black male body.

In *For the Stone Will Cry Out from the Wall*, viewers encounter several generations of family members (fig. 1.10). It appears to be a partly planned, partly unplanned candid shot. We might imagine multiple conversations happening at once when the photographer either asked to take a photo or simply raised his camera to indicate, "Look, I'm about to take some photographs!" Some individuals are looking at the camera with excitement, such as the little girl in the middle wearing the white shirt or the person far back (at right) whose white teeth glimmer with the invitation, get me! Others look hesitantly or pretend to look, like the teenager to the right of the frame wearing the black shirt with white writing or the man in the center left of the frame. Based on the other photographs in the series, we know that this gathering of Black family is a celebration of the life of a matriarch who moved on to dance on that *astral plane* that Valerie June sang so beautifully about.[22] McFadden manages to capture Black living and love without disrupting its ongoingness.

Speaking of love, he finds it again, though without a human subject in the frame, in *For All We Know* (fig. 1.11). In this still life, the body of his grandmother is not there, but some of the things that shaped her daily life remain, well, *still*. Their presence signals a life not gone, because, *for all we know*, these objects are her life. They remain the ghostly remnants of a life that was tended to, even if in ways unremarkable to the viewer. In this photograph, McFadden gets at the specificity of how Black people make life, build a whole way of life, which is now embodied by objects of great intimate

1.10 *For the Stone Will Cry Out from the Wall*, 2019. From *Love Without Justice*.

1.11 *For All We Know*, 2019. From *Love Without Justice*.

1.12 *Hot Stuff and a Bit of Blow*, 2018.
From *Love Without Justice.*

meaning. Objects are part of the social world and, depending on the meanings and memories we and others invest in them, can and do affect us. So, whereas a toothpick might seem mundane to most viewers, it might be something profound to those who recall how, for example, their grandmother placed the toothpick in her mouth or used it as an object when talking. As viewers, we know nothing about these specific objects, but that unknowing is what makes this still life remarkable: it prompts questions and imaginative speculations about a life lived.

Love and, we might say, Black intimacy in all its permutations continue to be subjects for McFadden. For example, in *Hot Stuff and a Bit of Blow,* viewers are privy to three people enjoying moments of laughter and conversation while hanging out during World Pride in New York City (fig. 1.12). The proximity of their bodies suggests a level of closeness; they are friends. Even though we cannot see the face of the third person, we can assume that one is talking and the other two are listening. In *Tenderly Speaks the Comforter* and *Upon Our Beds to Rest*, we get a glimpse of another form of intimacy, one marked by profound tenderness (the embrace of another) and raw vulnerability (a person sleeping) (fig. 1.13). In the former, bodies touch, and their "relation of proximity," expressed visually by the extended embrace, disrupts heteronormative looking practices that shape how viewers typically see intimacy. This same-sex desire (or the possibility of it), these Black bodies rubbing against one another, and this possibly more than friendly embrace capture the beauty of Black queer and intimate life. In another set of photographs, *Let Me Not to Him Do as He Has unto Me* and *I Stand Before You Naked*, McFadden offers beautifully rendered

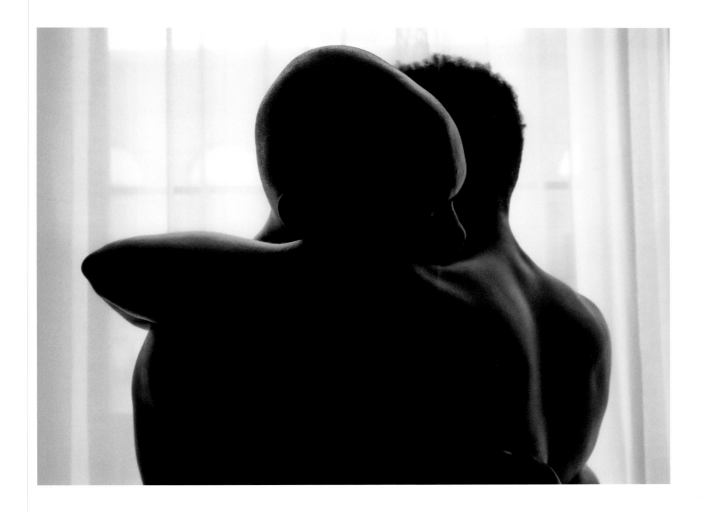

nude self-portraits but also, importantly, invites viewers on an introspective journey (pgs. 232 and 222). Based on the titles of the photographs, it will be an exploration of hurt and pain and openness and sheer vulnerability. The photographs highlight the range of human emotions that often accompany love and intimacy.

Indeed, across all these photographs, viewers encounter forms of Black intimacy both loud and quiet, or what Kenyan theorist Keguro Macharia calls "frottage."[23] The term "tries to grasp the quotidian experiences of intra-racial experience, the frictions and irritations and the translations and mistranslations, the moments where blackness coalesces through pleasure and play and also by resistance to antiblackness."[24] Frottage is not just about proximity, Macharia continues, "it is the active and dynamic ways blackness is produced and contested and celebrated and lamented as a shared object. It is bodies rubbing against and along bodies. Histories rubbing along and against histories. It is the shared moments of black joy and black mourning."[25] This last sentence seems to encapsulate the series *Love Without Justice* in profound ways. McFadden does not, at least from my perspective, seem to be interested in directing his camera at Black people to imagine or visualize a response to a larger white society or to a white queer culture, which, as

1.13 *Tenderly Speaks the Comforter*, 2020. From *Love Without Justice*.

Macharia notes, is debilitating. Instead, these images are produced by, for, and about Black people and their social lives. Full stop. The point is this: the entirety of the Black experience is imaged in these photographs, not through a gaze of voyeurism, whiteness, or violence, but through a *Black gaze*. Campt states that the "black gaze" refers to "a framing that positions viewers in relation to the precarity of black sociality" and a gaze that "uses precarity as a creative form to affirm" blackness and the lives of Black people.[26] McFadden shifts viewers from passive looking to active looking with and alongside Black pain and joy—key hallmarks of the black gaze.

On the other hand, viewers encounter colorfully exquisite photographs of landscapes: mountains rendered in a blue hue reflecting off a body of water; a self-portrait brought to life by ethereal yellow fabric against a backdrop of sky and trees; the great expanse of a body of water; and a sunset that dances with a blue sky and a warm pink as it envelops the Black body in the lower part of the frame. Aesthetically, these photographs beckon us to succumb to our own emotions, to get lost in the fog of our own intimate encounters. In *Still Water Runs Deep Yes It Do*, I find myself lost in the hues of blue as if I've entered some type of dreamlike state (fig. 1.14). I am left wondering about the political, intimate, and affective power of blue, especially in relationship

1.14 *Still Water Runs Deep Yes It Do*, 2018. From *Love Without Justice.*

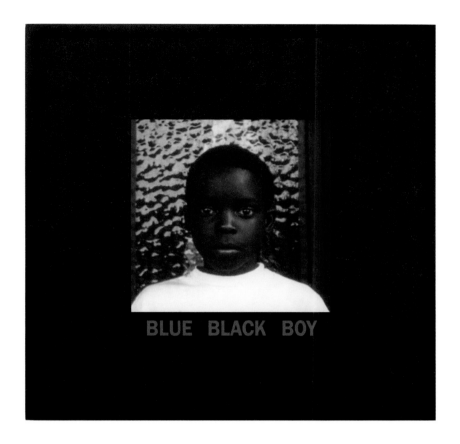

BLUE BLACK BOY

to Black people and life. From Langston Hughes's poem "The Weary Blues" (1926) to Carrie Mae Weems's photograph *Blue Black Boy* (1997; fig. 1.15) to Tarell Alvin McCraney's play *In Moonlight Black Boys Look Blue* (2003) and Barry Jenkins's film adaptation, *Moonlight* (2016), and to the *Blue Black* exhibition curated by Glenn Ligon at the Pulitzer Art Foundation in 2017, blue/s have been invoked by Black artists and intimately entwined with Black life. In her stunning book-length *ars poetica*, *The Blue Clerk*, Trinidadian Canadian poet and novelist Dionne Brand offers a capacious meditation on history, race, and gender, and also on blue and its aesthetic power. Brand writes, "Blue tremors, blue positions, blue suppuration. The clerk is considering blue havoc, blue thousands, blue shoulder, where these arrive from, blue expenses. . . . The clerk hears humming in her ears; blue handling, she answers; any blue, she asks the author, any blue nails today? . . . Blue arrivals. Oh yes."[27] What does this retreat to blue open up for thought? I encourage viewers to read these latter images as profound sights and sites for imagination, places we run to for solace, to imagine an alternative to the precarity of the now, and where we long for a Black future more humane than this one.

Ultimately, in *Joshua Rashaad McFadden: I Believe I'll Run On* we are compelled to hold on to the quotidian aspects of Black life even as the spectacular acts of anti-Black violence and death threaten to erase this living in their wake. This, right here, is *the great beauty of Black life*, its ability and desire to stick around, to persist.

1.15 Carrie Mae Weems (American, b. 1953), *Blue Black Boy*, 1997. Monochrome color photograph with silkscreened text on mat, 30 x 30 in.

A Conversation
Lyle Ashton Harris and Joshua Rashaad McFadden

LYLE ASHTON HARRIS: So, it's February 9, 2021, and we have been sheltering down since early March of last year. Where have you been over the last several months? When the country began to shut down, where were you?

JOSHUA RASHAAD MCFADDEN: Well, in February 2020, I was here in Rochester, New York. We had just opened the *Evidence* exhibit at Visual Studies Workshop (fig. 2.1). About a day after the opening, I left the country to go to Martinique to continue the work I've been doing there.

LAH: And what project was that in Martinique?

JRM: I've been documenting Carnival for a few years, but also just existing there, meeting people, trying to learn more (figs. 2.2 and 2.3). I've also been making work there and even gave a lecture at the Campus de Schoelcher of Université des Antilles about documenting protest, my interest in archives, and building the archive that would become *Evidence*.

LAH: Backing up a bit: You now live in Rochester, but when did you move back?

JRM: I moved back to Rochester [to assume] an assistant professorship at the Rochester Institute of Technology. We began the academic year in August of 2019, so that fall.

LAH: So, this is like a homecoming for you. Coming back to where you were raised, and at this time?

2.1 *Evidence*. Visual Studies Workshop, August 29–November 21, 2020, Rochester, New York. Photograph by Sari Oister.

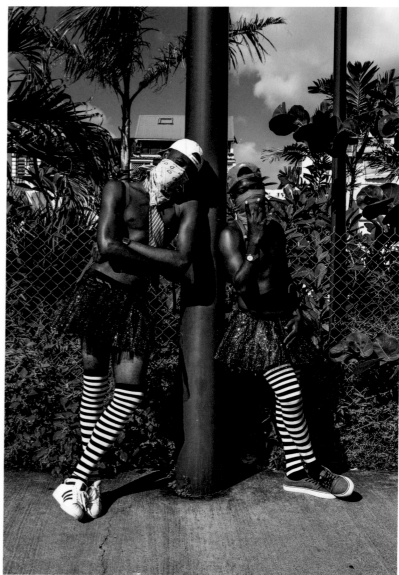

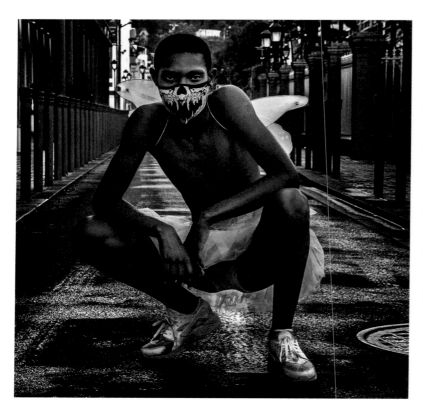

2.2 *Masked young person, Carnival, Martinique,* 2018.

2.3 *Two friends, Carnival, Martinique,* 2018.

JRM: Yes, I was born and raised here in Rochester . . . elementary school, junior high school, high school, right here. After my schooling, I left to go to the South. I went to Elizabeth City State University in North Carolina for undergrad. After that, I went further south to Atlanta, Georgia, to attend Savannah College of Art and Design. So, it's been almost eleven years since I've been here.

LAH: What was it like making that return, back to Rochester, considering it was a very different landscape, both in terms of your family, as well as, let's say, returning after teaching at Spelman and a couple of other schools in Georgia? You had left thinking of the issues of gender, sexuality, and racism. I'm thinking of what it may have been like then versus now.

JRM: All of my projects are about journeys across those varying contexts. Particularly towards an idea of freedom—personally and politically (fig. 2.4).

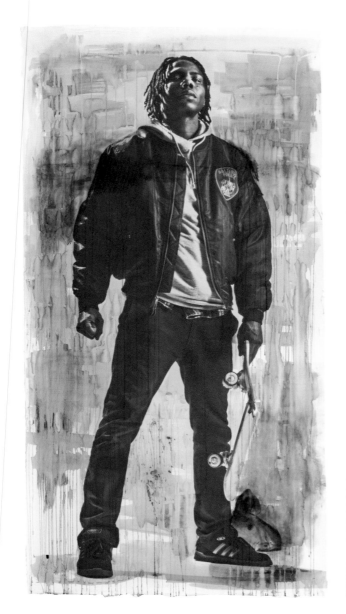

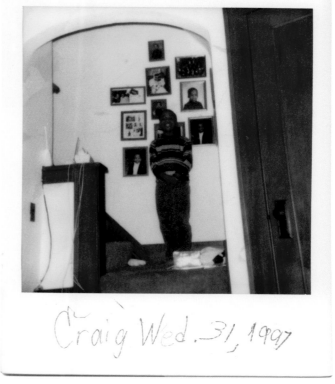

Craig Wed. 31, 1997

What does freedom mean for me? I believe that's what I was looking to discover when I left Rochester. I didn't know then, but I know that now. It's fascinating to see how my urge to discover freedom led me back to a place I said I'd never come back to.

LAH: But why was that? I think it'd be helpful to be around family. Are you the eldest, and if so, of how many kids?

JRM: Well, I'm not the eldest. I have an older brother and two younger brothers (figs. 2.5 and 2.6). We lived in the city for about half my childhood, in the 19th Ward. My father worked at a juvenile delinquent center, and my mother was an insurance agent for a very long time. For a while, it was just my older brother and me. We went to school, played outside, things like that—childhood experiences.

2.4 *K. B.*, 2016. From *Selfhood*. Lent by Lyle Ashton Harris.

2.5 Family photograph. Joshua Rashaad McFadden's older brother Craig B. McFadden II, 1997. Joshua Rashaad McFadden made this portrait at age 7 with a Polaroid camera he received from his mother.

2.6 Family photograph. Younger brothers, Marcus J. McFadden and Myles J. McFadden, 2007.

LAH: Did you attend church?

JRM: Yes. The church was a central part of our lives for a very long time. My father was a minister, and our grandparents were pastors, too.

LAH: What denomination?

JRM: Pentecostal. We still have a church here in Rochester, and when I think far back to childhood, even as far as my great-grandmother, she was heavily involved in the church. My grandmother on my father's side is still the pastor of the church today. So, again, the church was central to our lives. Every Sunday we'd go; really, my older brother and I would go to Sunday school. It felt like an all-day event on Sunday (figs. 2.7–9).

LAH: I'm glad you're speaking about this because I had a similar experience within the church. I grew up AME—African Methodist Episcopal—which is a historically Black church. In fact, Henry Louis Gates Jr. is premiering his documentary in a couple of weeks on the Black church and its historical importance.[1] He has significant figures in the film talking about whether we would have survived without a church. And I understand how the church helped form a better walk, let's say, for Black activism, for the custodians of history (fig. 2.10). But it was always a space that I was ambivalent about as well. I grew up as the grandchild of two prominent members of the church and at the same time was always aware of contradictions in terms of issues of sexuality. However, I also realize it was within the Black church that I was able to be sequestered away and to be exposed to Black culture. I would have been radically different had I not had that exposure.

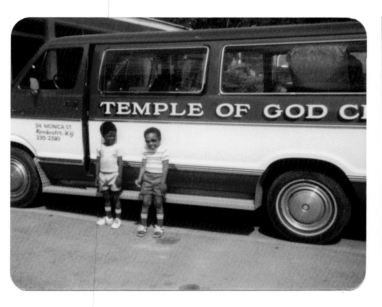

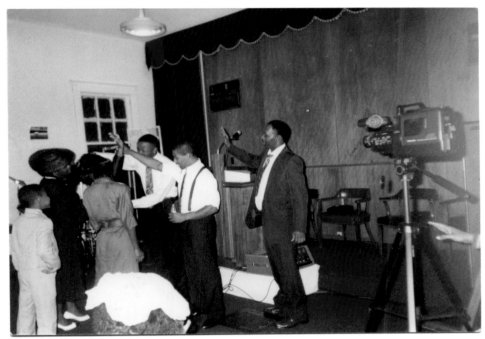

So, was yours similar? Was it a space that you found safe? Or was it a space of contradiction?

JRM: I suppose as a child, I didn't pay attention [*laughs*], particularly in Sunday school. It was a thing that I just knew I had to go to because my parents said so. My mother taught children's church, and my brother and I sang in the children's choir (fig. 2.11). I was not heavily involved in scripture or what people were actually saying in sermons, but there was always this kind of fear that was instilled, like fear of this idea of God and Hell. And so that stuck with me. But regarding your question, I didn't, as a child, really have the knowledge of the role of the Black church in the community. It wasn't until I attended college

2.7 Family photograph. Robert Clayton McFadden, left, and Emmanuel Langford, right, in front of the Temple of God Church van while on a road trip to a tent revival at Lookout Mountain, Tennessee, 1982.

2.8 Family photograph. Temple of God Church van, early 1990s.

2.9 Family photograph. Grandfather Robert McFadden, New Hope Deliverance Church, Rochester, New York, late 1980s.

that I started to learn those types of concepts and also learned of and fully experienced religion's contradictions and what not to engage in—ultimately deciding not to attend church any longer.

Nonetheless, the church was a large part of my upbringing. It was social. That's where so many of my childhood friends were, or where we met. And of course, it was also because they were family friends.

LAH: I understand. One of the things I'm drawn to is that you're insistent on creating, somehow, a community in the arc of your work. The fact that through *Come to Selfhood, Evidence,* and the most recent work there is a concerted effort to create language around this, or to create a community that brings that into evidence, to use your term (figs. 2.12–14). What I really appreciate, and am strongly drawn to, is that through the process of documenting as well as engaging the archival image, you foreground a multiplicity of diverse experiences of young Black men and their fathers. You let us, the viewer, see how your subjects see themselves through not only the image but text and language.

I'm wondering if that impulse to create community was because there wasn't one, that there was a sense of absence of that in your own particular experience. You made a leap to somehow create a community, to offer a home that can both conceptually and historically exist, if that makes any sense.

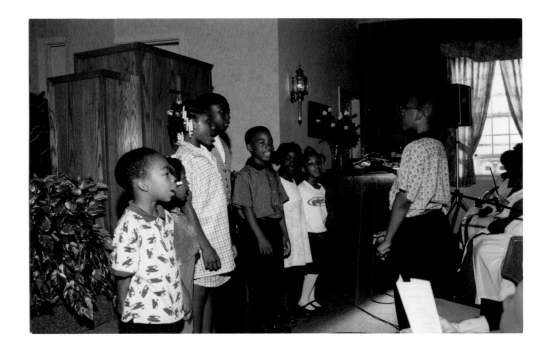

JRM: Oh, for sure. It does. Much of my work begins to piece together the concept of community for me, almost like a longing-for or searching-for. I realized that I made *Come to Selfhood* because I was searching for community as I looked within the answers I received from the participants (fig. 2.15). I was essentially on this quest for self, hence the name *Come to Selfhood*. It was an epiphany, an idea that this is who I am and who I want to be. I once read about the idea of selfhood in an essay by bell hooks, then pieced that together with a conversation I engaged in with my aunt one night. I expressed that I was reading and completing this project, and my aunt, who was heavily into church and scripture, said, "Oh yeah, um, you need to read something." But she's usually referring to the Bible and Jesus [*laughs*].

That's when the phrase *come-to-Jesus moment* came to mind. People use that phrase and it refers to arriving at a deep realization within yourself. Whether a person believes in Jesus or not, they are still apt to use that phrase. I said, "Okay, well what if it's *Come to Selfhood*?" That moment where you know deep within yourself that this is who you are and now deciding to live within that truth or not.

Love Without Justice, I think, begins to reveal the inner parts of me, whether it be my relationship with the church, my relationship with my family, childhood traumas, or other concepts centered around that (fig. 2.16).

LAH: Part of the discursiveness of your way of working and thinking, as I perceive it, is that it is operating on the level of the unconscious—challenging perceptions of not belonging in certain communities. I see the parallel, the fact that you are embodying community. Because I don't think you would come to those subjects, seek them out, seek out their narratives, and gain their trust

2.11 Family photograph. Joshua Rashaad McFadden singing in the children's choir as his older brother, Craig B. McFadden II, directs. Temple of God Church, Rochester, New York, 2001.

I have been afraid to express my true identity in the past because as gay black man I could potentially be threatened about it or killed. I've had friends who've been jumped & harassed because of their true identity. Not to say I'm ashamed of who I am but I have to protect myself. Being black is one thing, but being black & Queer poses a different topic of discussion. This has shaped me into not hiding who I am, & understanding that representation is important b/c you never know who you're helping by being you. No one should live timid & afraid because things they have no control over, such as skin color & sexual orientation. It's also shaped me to be fearless & fight for true unity amongst the black community. Not talking about something doesn't erase its existence.

without a certain yearning on your part and a level of openness in which to engender that trust with your subjects.

But I think I am drawn to the unconscious part that was trying to create a space that maybe you feel you did not have. Similarly—this could be an assumption—the fact that it seems that there was a birth of a community that was happening through the image-making process, through the collecting of images, and the creation of community through which these men existed.

I felt that was a very subversive way to create this narrative art that you actually fit into. And the fact that often a range of masculinities exists within our culture—anywhere from Martin Luther King Jr. to Malcolm X to Muhammad Ali to, let's say, Bayard Rustin to Little Richard to Prince. There's a normalizing of notions of masculinity. What I'm drawn to in your work is the degree to which you formally language that.

JRM: Yes, that takes me back again to Rochester and my childhood. A tremendous mental shift was just knowing, as a child, that I didn't fit the traditional masculine persona. I knew I was different; I knew I was a queer child, without having the specific language for what I was experiencing at that time (fig. 2.17).

2.12 *Jeremiah Thompson, left, and his father, Joseph Thompson, Sr., 2016. From* Come to Selfhood.

The statement "I am a man" brings up several different feelings for me.

My initial thought when uttering those words is, "what exactly does that mean?" I don't rightly know. I suppose it denotes my maleness. Perhaps it signifies that I have "come of age" and have stepped into a certain societal role as an adult male.

It brings up feelings of inadequacy — of having to prove that I am strong, masculine, courageous enough. Having to prove that I can be a provider & protector. That I can fuck shit up through sheer will, with no explanation necessary except being a man.

It brings up feelings of pride, privilege & honor. Manhood, the idea of it, MY idea of it connects me to tradition. It links me to the generations of men that have come before me.

"I am a man". I say the phrase and get lost in a sea of varying & competing thoughts that ultimately leave me feeling unsettled & perhaps a bit confused. I wrestle with it every day. I probably always will.

Freedom in this country means being able to live, love & thrive without fear of persecution.

It means not having to apologize for my existence. To be bold, confident & proud of everything that makes me who I am & the life I pursue.

It means equal access to resources, opportunities & representation.

2.13 *Dyllón Burnside*, 2017. From *Evidence.*

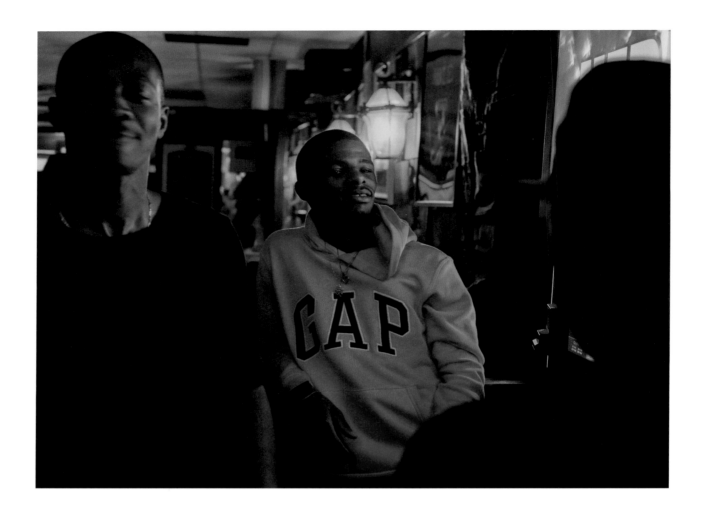

2.14 *Hot Stuff and a Bit of Blow*, 2018. From *Love Without Justice.*

LAH: But what would you say about yourself now?

JRM: I'm a gay Black man who's moving further and further away from the prison of traditional ideas of gender conformity.

LAH: It's interesting you claim that identity, because I was recently in conversation with scholar Darius Bost, author of *Evidence of Being: The Black Gay Cultural Renaissance and the Politics of Violence,* and he shared with me that when selecting a title for his book there was some pushback from his colleagues. They said that the term "Black gay" is sort of an antiquated term since it's all about queerness. We both disagreed, and to quote Yale professor Tavia Nyong'o, there is almost a "colonialism of the present" in regards to identities. LaToya Ruby Frazier's *Notion of a Family* project comes to mind as well, in thinking about your return to Rochester (fig. 2.18). Please talk about your parents' decision to move from the inner city.

JRM: Sure, sure. First, I know that my family moved from the inner city to the suburbs so that my brothers and I could get a better education and have more access to developmental resources. I was ten at the time. Well, nine, turning

Positive rolemodels played a major role in my development as a black man. They provided inspiration, guidance, and Knowledge. I learned so many things about my history from them. Things that I ~~wouldn't~~ wouldn't have learned in the school systems.

Growing up with three brothers made it difficult to find my own identity. My father and Grandfather always encouraged me to be unique. My Mother did too! They also pushed me to get an education, they constantly told me and my brothers how important it was. Black people will continue to face oppression in this country, but we must not let it ~~stop~~ us. We are powerful beyond measure. Please make an effort to be a positive rolemodel in someone's life.

ten. My father actually brought it up to me a few months ago. In December 2020, he said, "Do you know that it was twenty years ago that we moved out to the suburbs and you started fifth grade?" I bring that up because it was in fifth grade that I was first called the N-word by a white boy in gym class. I was a nine-year-old—I was outside the city.

I already knew I didn't fit in. I was this artistic kid who didn't care for sports [*laughs*]. So, there were also these systemic encounters that were happening: white teachers and administrators wanting to place this child from the inner city in classes to put them behind, keep them behind, later saying they are not up to speed—referring to myself here. My parents had to advocate for my education constantly, and I'm just learning of this now; I didn't know it was occurring back then. The educational system wanted to place me in remedial courses for a year to catch up. But of course, that would have had an impact on my education in general.

LAH: You're saying your parents were advocates for you.

JRM: My parents always advocated for our education. I attended college because of them. But, of course, as a child, I didn't know the inner workings

2.15 *Joshua Rashaad McFadden, his father Craig B. McFadden, and his grandfather Robert McFadden, 2016. From* Come to Selfhood.

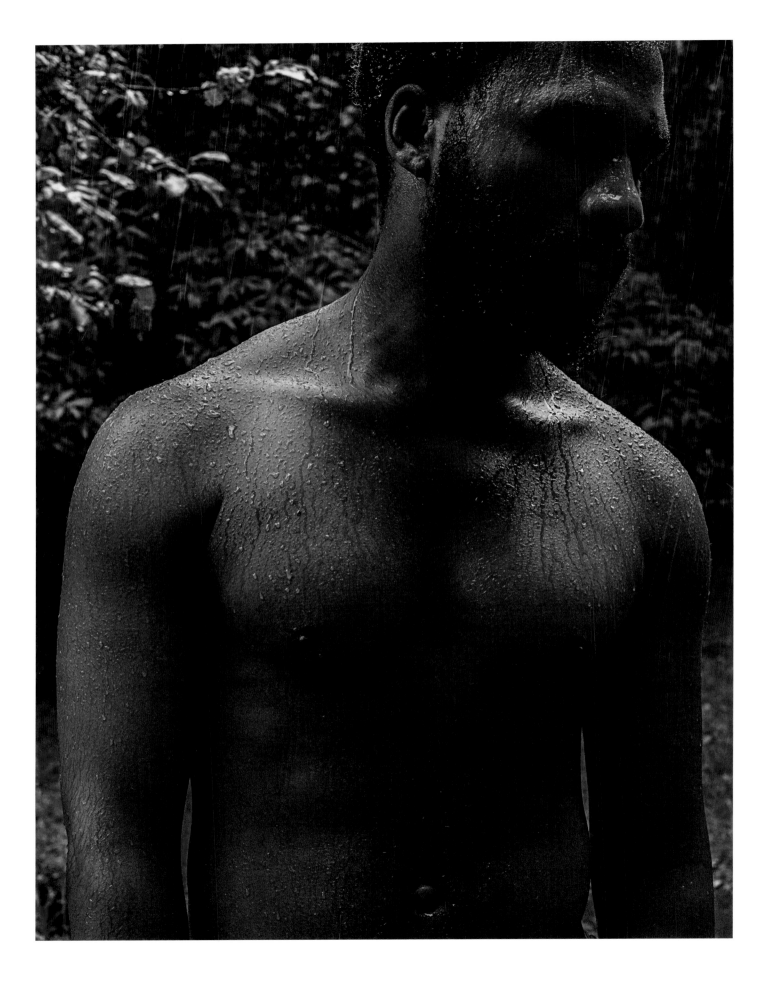

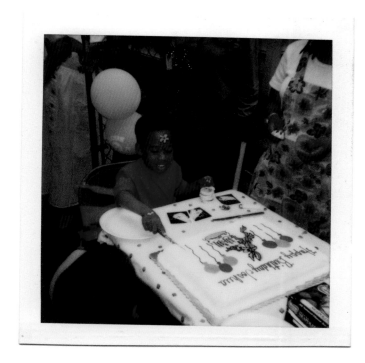

of racism and institutionalized racism. I didn't consciously experience any outward, direct racism in the form of a racial slur until that day in gym class. I think we were playing basketball and our team won. In the locker room, a white boy called me the N-word. It was the first time I ever got called that by a white person. What was strange was I knew that it was bad and I was upset—I knew that he felt like he had some form of power in saying that. I knew. Though I didn't know how to respond.

LAH: What were the demographics of the school?

JRM: Predominantly white. I believe there were three Black people in my class, including me.

LAH: In what town?

JRM: This is in [the] Gates Chili [district] of Rochester. The thing that stuck with me is, I got in trouble; I was reprimanded by the teacher.

LAH: Okay, wow. Why? You were reprimanded why?

JRM: They said that I provoked the occurrence.

LAH: Wow. And how did your parents respond to that?

JRM: Well, not only for this, but they had to visit the school constantly. There was another incident. There were many. The next one involved a project, and

2.16 *It's the Journey,* 2018.

2.17 Family photograph. Joshua Rashaad McFadden cuts the cake at his 6th birthday party, Rochester, New York, 1996.

I believe this is what upset my parents the most. We had to complete a project about our heritage, a project all the fifth-grade students had to do. We had to incorporate a famous person, a public figure, so my choice was Martin Luther King Jr. We also had to include a holiday. I chose Kwanzaa. I simply had to share about myself in the form of a collage.

So, my mom and my dad assisted, because we were encouraged to ask our parents about these details. There were specific questions about where we come from, and of course, my Black heritage had many backgrounds, whether it be African American, Native American, Haitian, French Creole, Gullah-Geechee, and other bloodlines we were still discovering.

LAH: From your mother's side of the family? Just give me a little lineage.

JRM: Unfortunately, again, we were unsure of some details and, for example, didn't know where my great-great-grandmother was from. However, we did know that she came on the boat, as my grandmother would say. We thought we could be from Haiti, possibly. We knew it was one island or another, we just weren't sure.

Back to my grade school project. So, we're looking in magazines. We're looking in encyclopedias. We had a computer at the time. Just think about the year 2000 and a computer. Our family computer ran very slow, so imagine using AOL to look for images on the internet. Think about where we are now and where we were then, searching for information.

Nonetheless, my project got done and was turned in. It was amazing, if I do say so myself. I was an artist [even] back then, so I know it looked great. We also had to present this project to the class. So I presented it, and my classmates received it well. However, it seemed like my teacher questioned every part of the project, questioned it in a way that said, "That can't be true." As a child, there's no way to put your finger on that. It was a feeling I couldn't prove; it was a tone. My suspicions weren't proven until I got the grade back, and I believe I got a D or C on the project.

LAH: Wow.

JRM: Imagine this fifth-grader getting a poor grade on a project that his parents helped him with throughout the entire process. And the project is about my life.

My parents were livid and knew at that point the teacher was issuing me poor grades on purpose because it would affect my ability to move on to middle school. They had to have meetings with the principal, administrators, the teacher, and on and on and on. My parents still talk about that moment today

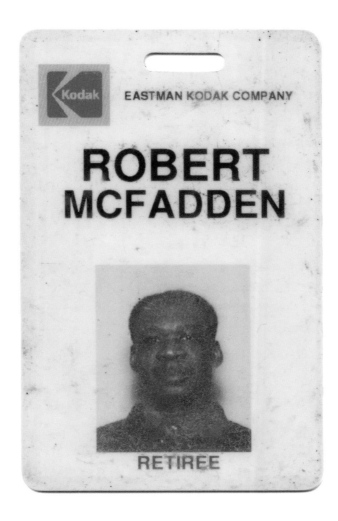

because I believe it was a traumatic experience for them to constantly fight for their child's education, especially after he was just called a nigger by a white student. That white boy learned that word from his parents—I'm convinced. That behavior, we know, comes from the parental structure. Where else would they get that from?

It makes me upset to this day, and yet it directly relates to my work. My father and mother watched me create all of the projects in *I Believe I'll Run On*. But when they specifically heard about the show and it being back here in Rochester, my father brought up that moment in fifth grade. And he said, "Do you know that was twenty years ago? And that was really what started your journey on making this work."

LAH: So your father was able to see a direct link between your fifth-grade school project in 2000, where you created a pantheon of African American icons in the form of collage, to the show at the George Eastman Museum. Wow, this is quite potent, quite powerful.

JRM: Yes. But not only that. Knowing that my grandparents on my father's side worked at Kodak in the '70s and '80s, through the '90s, it is an incredible full-circle moment for me (fig. 2.18).[2]

2.18 Family photograph. Kodak retiree badge of Robert McFadden, Joshua Rashaad McFadden's grandfather, 1997.

LAH: And what did they do there?

JRM: My grandmother was a quality assurance investigator, which was actually pretty rare for, of course, Black women at the time. She talked about it all the time. My grandfather worked in building services, and retired from Kodak.

LAH: And is Kodak the biggest employer in Rochester?

JRM: I believe it was at that time. You know, I've been digging deep into Rochester history.

There were also race riots in Rochester in 1964, July 1964. That's a year before the occurrence in Selma.

LAH: What ignited those riots? Do we know?

JRM: I believe it was July 24, 1964, when there was a Black dance held in Rochester, and police officers with dogs arrested young Black people, and it just escalated from there.

Even Kodak had their issues with race and Black workers, the same kind of issues we see today with work equality, equal pay, working conditions, things of that nature. So their issues, of course, added to the racially tense atmosphere in Rochester. My grandparents endured a great deal, and I compare that era to what I experienced as a young person in the year 2000. Throughout grade school, it was my goal to leave Rochester. I was looking, looking for something else. You explained that as looking for community.

LAH: And as a millennial, it's amazing you could somehow still make a connection between that early experience of your mother and father trying to make a better life for you and your family, and to invest in the family, only to encounter that level of violence within what should be a space of transmission of knowledge and possibly affirmation.

• • •

LAH: Could you recount for us when you first heard about the murder of George Floyd? We're talking about a few months after the country and the world had come to a halt due to COVID-19. I'm interested in knowing your impulse to move back home from Atlanta, after getting your master's degree there, teaching at Spelman, and traveling internationally for your work. What did it mean to begin this uncharted path for yourself having just arrived back in Rochester? What was it about this particular police murder of another Black man that you felt that you had to drop everything and travel to Minneapolis?

Clearly, at that time you could not have imagined that this impulse would open up a whole other arc in terms of your life's work over the next couple of months: meeting Breonna Taylor's mother, making photographs that appeared on the front page of the *New York Times*, being awarded grants from *National Geographic*, receiving commissions from *The Atlantic*, and being invited to multiple speaking events, all focusing on the unprecedented, biggest social movement of our time (figs. 2.19–21). It's also important to mention that you put your body on the line in terms of possibly getting arrested, definitely suffering from being perceived as the enemy, and getting tear-gassed and shot with rubber bullets. What was the impulse that led you on that journey?

JRM: Sure, I'll take you back. But first I want to remind you of when we were in New York City at your studio doing the conversation for *Come to Selfhood*, in 2016. Philando Castile had just been killed by police and the live footage was on Facebook. I showed you. Protests broke out in the streets, and we literally heard it from your window.

LAH: Oh, you're right, and we went outside, right? That's extraordinary just to think about, just the eruption of the state violence, the police violence against Black bodies. But also just in terms of the intense amount of response of young people getting out there and protesting.

JRM: Well, right. I distinctly remember being there, and I went out to document the protesting. You reminded me, "Well, make sure you're taking care of yourself. Remember self-care."

LAH: Tell us about the young gentleman who was killed.

JRM: It was two men killed back-to-back, actually, one day [apart]. On July 5, 2016, Alton Sterling was killed by two Baton Rouge police officers, and a day later a St. Anthony, Minnesota, police officer murdered Philando Castile during a traffic stop. The protest I documented was in New York City and became too much for me, and I said to myself, "I'm not documenting any more protests." It became emotionally taxing at that point. I felt depressed and hopeless. After that, we finished the *Come to Selfhood* book, and I was done with documenting protests as well, or so I thought. Fast-forwarding: it's 2020, we're on lockdown because of coronavirus. I was teaching at RIT and we were shut down through April.

LAH: But teaching remotely?

JRM: Teaching remotely, and dealing with the difficulties of that, too. We finished the semester in May, and it was around Memorial Day that I received word of what happened to George Floyd. You and I talked about it, and a good friend of mine sent the video. I hadn't yet seen it.

LAH: That, I remember. What was it about seeing the video that you not only processed the information but kept alert enough to actually get in the car and drive fifteen hours?

JRM: So the first day we talked about it was when we heard about it. The next day, I think on the morning of the 26th, I woke up to a text message with the video attached. I watched it, and that's when I saw how George Floyd was murdered by the police, with passersby witnessing a police officer on Floyd with his knee, suffocating him to death. It was . . . so difficult to watch.

For me, what came to mind was inhumanity. It conjured up all of the other videos that I saw, like Philando Castile, how he was murdered in front of his loved one and his child in the car, live on Facebook. It brought up all of the countless other times, and the fact that he called out for his mother. It just struck me, not even struck me, but triggered me. I believe it was a different kind of trigger. I was triggered in a way that I could not ignore.

Then we spoke again. I was going out for walks at this time, and I remember going to the park with my mask on. It was a bit strange going outside because we were on lockdown. But I would go to the park to walk and could hear people there talking about this video.

LAH: Hmm. And what were they saying?

JRM: You could hear little snippets of people's conversations as you walked past them: "Oh, but I think such and such," or "Oh, but I think what he should have . . . ," and "Oh, but they said he had a fake $20 bill." And I could hear these conversations everywhere I went. It was a different atmosphere; it was just different. It sat with me, and I believe it was the next day that I woke up again and meditated.

Right after meditation, it almost immediately came to me. I explained it to my grandmother that it was like a whisper that just said, "Go. You need to go."

LAH: Beautiful.

JRM: And it was loud. It was like a loud whisper, if that makes sense. It shook me a little bit because I remembered I said I wouldn't photograph protests anymore because of how emotionally taxing it was. But I was also thinking that nobody

2.19 Joshua Rashaad McFadden for the *New York Times*. "At Floyd Service, A Cry of Pain: 'Get Your Knee Off Our Necks,'" *New York Times*, June 5, 2020. "George Floyd's story has been the story of black folks," the Reverend Al Sharpton told mourners in Minneapolis.

48

"All the News
That's Fit to Print"

The New York Times

Late Edition

Today, sunny, humid, afternoon showers or thunderstorms, high 83. Tonight, evening thunderstorms, low 69. Tomorrow, warm, showers, high 86. Weather map, Page B12.

VOL. CLXIX No. 58,715 © 2020 The New York Times Company NEW YORK, FRIDAY, JUNE 5, 2020 $3.00

UNEASY WORKERS RISK LOSING JOBS BY STAYING HOME

FEARS OF THE REOPENING

Those Who Refuse Can Lose Unemployment Benefits, Too

By JACK HEALY

DENVER — After scraping by for weeks on unemployment checks and peanut butter sandwiches, Jake Lyon recently received the call that many who temporarily lost their jobs because of the coronavirus pandemic have anticipated: The college-town tea shop where he worked was reopening, and it was time to go back.

But Mr. Lyon, 23, and his co-workers in Fort Collins, Colo., who were temporarily laid off, worried about contracting the virus, so they asked the shop's owners to delay reopening and meet with them to discuss safety measures. The reluctance cost them. Six of them permanently lost their jobs in May, and their former employer reported them to the state's unemployment office to have their benefits potentially revoked.

"You have all refused to go back to work," their former boss wrote in an email.

As people across the United States are told to return to work, employees who balk at the health risks say they are being confronted with painful reprisals: Some are losing their jobs if they try to stay home, and thousands more are being reported to the state to have their unemployment benefits cut off.

The coronavirus pandemic continues to strain the economy. On Thursday, the Labor Department reported that 1.9 million Americans filed new claims for state unemployment insurance last week. Businesses want to bring back customers and profits. But workers now worry about contracting the coronavirus once they return to cramped restaurant kitchens, dental offices or conference rooms where few colleagues are wearing

Continued on Page A7

NEWS ANALYSIS

Military Vets Break Silence On President

Ex-Officers Denounce Partisan Use of Troops

By DAVID E. SANGER and HELENE COOPER

WASHINGTON — For the first three years of President Trump's time in office, his blunt-force view of the military was confined to threatening American adversaries: "fire and fury" if North Korea challenged American troops. A warning that he would "shoot down and destroy" Iranian forces in the Persian Gulf. Billions spent to rejuvenate a nuclear arsenal he viewed as the ultimate source of American power.

His generals and admirals accepted a commander in chief with what they diplomatically dismissed as a "unique style" — and they welcomed the increase in military spending. His chief diplomats, while embarrassed, saw some utility in trying to force adversaries to the table.

Now, that tolerance has frayed. Mr. Trump's threat to use the 1807 Insurrection Act to send active-duty troops on American soil against protesters has laid bare the chasm in the national security community that was forming even when he ran for office in 2016.

Back then it was only a limited group of "Never Trumpers" — establishment Republican national security professionals repelled by Mr. Trump's description of how American power should be wielded around the world — who wrote and spoke of the dangers. He "lacks the character, values and experience" to be president, they wrote, and "would put at risk our country's national security."

This week, it was his former defense secretary, a former chairman of the Joint Chiefs of Staff and a range of other retired senior officers who were saying in public what they previously said only in private: that the risk lies in the fact that the president

Continued on Page A19

AT FLOYD SERVICE, A CRY OF PAIN: 'GET YOUR KNEE OFF OUR NECKS'

JOSHUA McFADDEN FOR THE NEW YORK TIMES

"George Floyd's story has been the story of black folks," the Rev. Al Sharpton told mourners in Minneapolis on Thursday.

From Behind Closed Doors to Out in the Streets

By MICHAEL WILSON and SANDRA E. GARCIA

A teenager outside the Port Authority Bus Terminal, taking a knee on a block crowded with protesters, relished the feeling lost these last months — of being part of something.

A 23-year-old art teacher, Evan Woodard, was thrilled to see his city at the fore of a nationwide event. "I'm proud to call myself a New Yorker," he said. "This is everyone's city."

People who just last month were dutifully keeping behind doors and masks have turned out by the tens of thousands in the past week to gather in the streets

United Over Injustice, New Yorkers March Back Into the Sun

and shout to be heard.

The lurch between twin crises with opposing aims — isolation and assembly — has been jolting, and to many, positively liberating. People feeling penned for months, then pushed past a tipping point by images of a man's life ending under an officer's knee, have surged to the streets — for some, mask be damned — to be part of something.

For those coming out day after day to protest, marching with friends and strangers under cheers from the open windows above feels something like normal. If sheltering at home was a reaction to a threat, this is the opposite — action.

Simonez Dega, 23, a waiter at Olive Garden at a protest near the Barclays Center in Brooklyn, welcomed the change from making music alone in his apartment to marching. "It feels truly warm," he said. "It felt like we were all bees in the hive. Now it's like, that's another bee, that's another person that is here for the same reason. It's a different energy.

"As a black male, I had to go out

Continued on Page A12

Senseless Killing Prompts a Call for Justice

By DIONNE SEARCEY

MINNEAPOLIS — Hundreds of people filed into a Minneapolis chapel on Thursday to remember George Floyd, the man whose death at the hands of the police opened a nationwide flood of anguish, protest and demands for change in American policing.

By turns somber and defiant, the mourners celebrated Mr. Floyd as a friend and father and uncle to those closest to him, but also as a victim of racial injustice whose killing had drawn a legion of people to the streets.

"George Floyd's story has been the story of black folks," the Rev. Al Sharpton said in a eulogy of Mr. Floyd, who died after a white police officer held him down on a Minneapolis street with a knee to Mr. Floyd's neck for nearly nine minutes. "Because ever since 401 years ago, the reason we could never be who we wanted and dreamed of being is you kept your knee on our neck."

The gathering, the first of several memorials for Mr. Floyd in different cities in the coming days, drew Mr. Floyd's family members, political leaders, civil rights leaders and celebrities — many in masks out of concern for the coronavirus.

"We were smarter than the underfunded schools you put us in," Mr. Sharpton said. "But you had your knee on our neck. We could run corporations and not hustle in the streets, but you had your knee on our neck. We had creative skills, we could do whatever anybody else could do. But we couldn't get your knee off our neck."

"It's time to stand up and say 'Get your knee off our necks,'" Mr. Sharpton went on, as raucous applause broke out in the university sanctuary where Mr. Floyd's body rested inside a closed, shiny copper coffin.

All the while, marches were taking place around the country on Thursday, as thousands of people poured into parks and streets calling for an end to systemic racism in the justice system on a 10th day of protests. Demonstrators marched in cities including New York, Nashville, Seattle and Santa Monica, Calif. And around the

Continued on Page A14

Defiance in Hong Kong
Despite a ban, a vigil was held for victims of China's 1989 Tiananmen Square crackdown. Page A8.

LAM YIK FEI FOR THE NEW YORK TIMES

This Case Is Already Different: The Police Are Breaking Ranks

This article is by Kim Barker, John Eligon, Richard A. Oppel Jr. and Matt Furber.

MINNEAPOLIS — Two of the former police officers charged with aiding and abetting in the killing of George Floyd turned on the senior officer accused in the case, making for an extraordinary court appearance on Thursday afternoon. A third officer was cooperating with the authorities, a sign that the four fired officers would not be presenting a united front.

Facing 40 years in prison and a bail of at least $750,000, the former officers Thomas Lane and J. Alexander Kueng, both rookies, blamed Derek Chauvin, the senior officer at the scene and a training officer, their lawyers said in court. The lawyer for Tou Thao, another former officer charged in the case, said his client had cooperated with investigators before they arrested Mr. Chauvin.

Mr. Chauvin, a white 19-year veteran, was captured on a graphic video on May 25 kneeling for almost nine minutes on the neck of Mr. Floyd, who was African-American, as the other three officers aided in the arrest.

Mr. Chauvin, 44, who did not appear in court on Thursday, faces the most serious charges of the four men — second-degree murder and second-degree manslaughter.

In cases of excessive force, it is

HENNEPIN COUNTY JAIL

Clockwise from top left: Derek Chauvin, Tou Thao, Thomas Lane and J. Alexander Kueng.

not common for officers to break ranks, or cross what is often called the blue wall of silence. But little about this case is typical: Mr. Floyd's death has unleashed a movement, with demonstrations in more than 150 American cities against police brutality and systemic racism.

The hearing — which unfolded blocks from where Mr. Floyd was being remembered in a packed, emotional memorial service — was sparsely attended because of threats from the coronavirus. Lawyers for the defendants were flanked by National Guard sol-

Continued on Page A12

Biden Struggles for Diversity in His Brain Trust

By SHANE GOLDMACHER

Nearly five years ago, Joseph R. Biden Jr. gathered his closest advisers to decide whether he would run for president in 2016. This was a "final judgment" meeting, as he would later describe it in his memoir, and around the room were Mr. Biden's family and more than a half-dozen of his most trusted confidants.

It was his innermost circle. Everyone was white.

Today, as Mr. Biden makes his third bid for the presidency, his campaign manager is white. His chief strategist is white. His three chiefs of staff as vice president (all still key advisers) and four of the five people who have been deputy campaign managers are white, as are the leaders of his economic team.

Mr. Biden won the 2020 Demo-

cratic primary on the strength of a multiracial political coalition anchored by black voters who overwhelmingly rallied behind him, and he has pledged to build a diverse administration as president. But while some black advisers have cracked Mr. Biden's upper echelon and his team is racing to expand, the people setting strategy still skew heavily white, with limited Latino and even less

Continued on Page A22

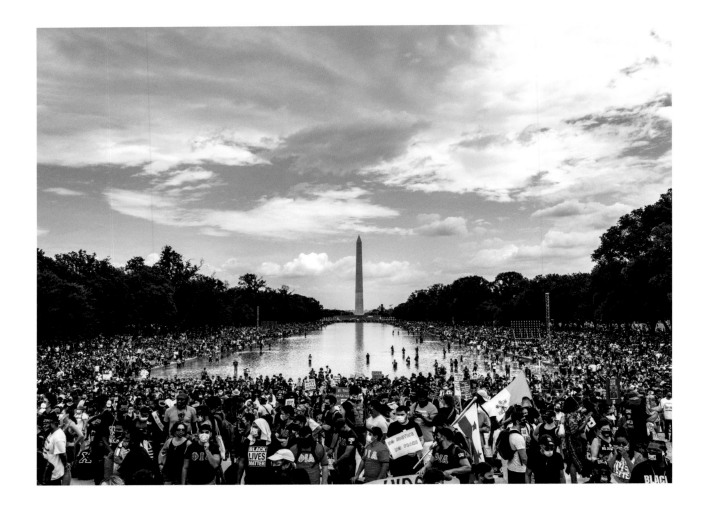

2.20 Joshua Rashaad McFadden for *National Geographic*. On August 28, 2020, thousands of people gathered on the National Mall for the Commitment March in Washington, D.C., which occurred on the 57th anniversary of the 1963 March on Washington for Jobs and Freedom. At the Commitment March, the crowd stretched from the Lincoln Memorial almost to the Washington Monument. Many participants pledged to continue advancing the march's mission of police and criminal justice reform.

was paying attention to the cries during these protests. And when I heard that whisper, I knew I had to go.

I immediately started making plans. I was still really tired; I was tired because I couldn't sleep knowing what happened to George Floyd. So I just went and got an oil change in my car, went home, packed a bag. I only packed enough clothes for about three days because I didn't know what I was going to do—bring my camera and just a bag? My grandmother was sitting at the table in the kitchen. When I came back to leave out the door, she said, "Where are you going?" And I said, "I'm going to Minneapolis." And at this time it was still all over the news what happened to Floyd. And she said, "Okay."

LAH: She just said, "Okay"?

JRM: Said, "Okay." Usually, people will try to talk you out of it without trying to talk you out of it. They'll say, "Oh, it's dangerous," or "You sure you wanna go?" But this time she said, "Okay." And I said, "I'll be okay," and she said, "I know . . . I know you will."

LAH: Oh beautiful, beautiful.

JRM: So, I left, got in my car. It was already about 6 or 7 p.m., so I knew
I was going to be driving through the middle of the night, and it was over
a thousand miles away. But I just started driving. Around maybe 2 a.m., a friend
of mine gave me a call and said, "What you doing?" I said, "I'm on the road
to Minneapolis." And this friend, who is in Texas, said, "I'm gonna meet you
there." So this friend drove up from Texas. They said, "I don't want you there
feeling like you're alone." They're not a photographer, they just said, "I'm gonna
come even if it's for mental support."

I drove through the night, got there in the morning or afternoon, found
a hotel. At this time hotels weren't shut down in Minneapolis, but they were
struggling, you know? But they had rooms. They were also starting to house
people who were experiencing housing instability. I remember that distinctly.
I thought that was amazing. So they'd had almost a sense of a community at the
hotel. And when I got there, they were all talking about what happened;
you could just see it on everybody's face.

LAH: What was the climate like? Because eventually, they began to shut down
the city. You followed your impulse and got there before they actually shut
down, before things had escalated.

2.21 Joshua Rashaad McFadden for *The
Atlantic*. Left: Mayor Steven Reed at Martin
Luther King Jr.'s old house in Montgomery,
Alabama, on June 30, 2020. The house was
once bombed by segregationists in retaliation
for the city's bus boycott. Right: Mayor
Randall Woodfin at the Civil Rights National
Monument in Birmingham, Alabama, on
June 26, 2020. Behind him, a statue of MLK
stands in front of the 16th Street Baptist
Church, which was bombed by the Ku Klux
Klan in 1963.

JRM: Yes, I got there just as they were shutting things down. When I arrived, I just dropped off my bag in my hotel room that I got for two days, got in my car again, and drove—just started driving. I tried to look up the area that Floyd was murdered in. Still wasn't quite sure, but I just figured I'd drive straight, and as I went towards the area where he was murdered, I started to see windows that were boarded up from the protests and the riots that were happening. You could see people boarding up their windows on the street as the sun began to set. And I ended up on the main road where most of the unrest occurred initially. I saw a group of people boarding up this business window and I got out of the car and I said, "Where are the protests happening?" And they said, "You just need to drive that way." And they just pointed me where to go. I got back in the car and as I traveled further down the street, I saw the crowds beginning to grow; there were more people and more people and more people. So, I got out of my parked car somewhere and began to photograph (fig. 2.22).

But for me, the feeling was a feeling that I had to go. It was all a feeling of purpose that I couldn't ignore. That's it. It wasn't an assignment or job from a publication. It wasn't a story that I was shooting for someone. I knew that I was going not only to document for the purpose of the archive and the work that I do, but also to bear witness and be a part of the movement.

LAH: Yes, beautiful. How were you feeling? What were some of those emotions as you're driving for that long? Getting out and seeing the protests—I'm curious as to how that entire build-up was for you.

JRM: Yes, well, getting out of the car, there wasn't any nervousness actually. I wasn't nervous. Maybe a little restless. I think there was a bit of adrenaline because I didn't get tired [or] even though I was tired, I didn't feel it. At that point, I was on a mission.

LAH: There was something even more chilling about the sadism in the execution of George Floyd. And the fact the whole world had been shut down by COVID; it was like a de-escalation of movement in terms of people sheltering. A correlation also revealed itself: between COVID, a respiratory disease of the lungs, and a police officer extracting breath. It was almost like a visceral reaction that people had. It was intense.

I think, again, with Breonna Taylor: the fact that a frontline worker who was resting, whose very body was saving people, had her body totally destroyed by the very people who were supposed to be protecting her.

JRM: What you were saying reminded me why people keep saying the Floyd murder felt different. The Floyd video was very much a public lynching.

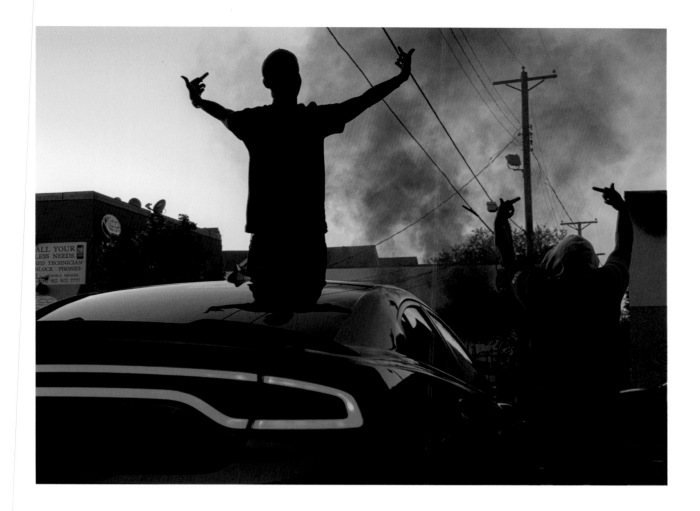

The police officer just used his knee instead of a noose.

LAH: Yes, without question.

JRM: It meant that everybody had an opportunity to witness the murder, more so because we were shut down due to COVID.

LAH: And not just people in the US; it was witnessed globally. It's the undeniability of the visceral, sadistic white supremacist violence of it, to deny another's sense of humanity. Everything was laid bare, right there. This was mobilizing. You being one among countless people who descended on Minneapolis. This ignited an unprecedented social justice movement that coincided with the biggest death event of our lifetime. I kept thinking that it was sooner to the beginning of COVID in the US, but it was four months afterward.

• • •

JRM: This is a photograph from a story that I worked on with the *New York Times Magazine*, called *A Lynching's Long Shadow*, about 28-year-old Elwood Higginbotham, [who] was murdered by a mob in 1935 (fig. 2.23). But what is

2.22 *Righteous Anger (Minneapolis, Minnesota)*, 2020. From *Unrest in America: George Floyd.*

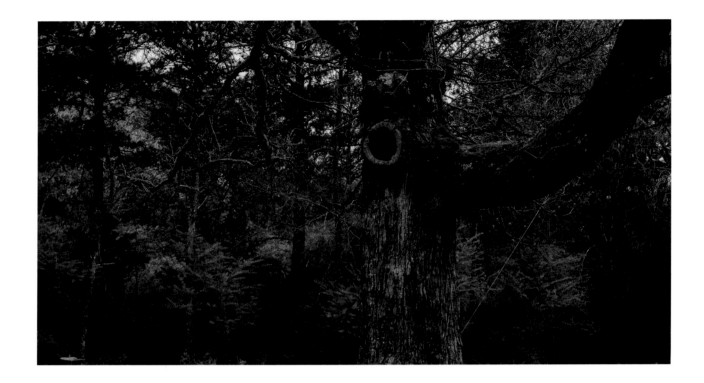

significant to note here is that Elwood Higginbotham was kidnapped from a jail and lynched by a mob. Higginbotham was accused of a crime and was going to trial. Before the trial was over, he was kidnapped by a lynch mob. From a jail. Assuming that the officers let him be kidnapped. He was lynched by a mob, and there were people to bear witness to this lynching of a Black man who was accused of a crime. And so now when we arrive at George Floyd's case, it is the same thing. When we see the video, it was not only the police that were there; this was in a public place near a corner store called Cup Foods, which was described as a staple in that community.

LAH: Wow.

JRM: It was described as a staple in the community, yet it was the people at the store that initially called the police on George Floyd, accusing him of a crime that he may or may not have committed. But guess what? He was lynched, and I'm calling it a lynching because the police officer had his knee on his neck for over eight minutes in front of the public, and murdered him—murdered him as people watched. Murdered him as people watched and pleaded that the police officer take his knee off his neck. The police officer heard the cries of "I can't breathe" and heard Floyd call for his deceased mother. And the other police officers stood by and protected their colleague. This officer was on a mission to make this incident a public spectacle lynching. And lynching has been a spectacle for white people; for example, the Equal Justice Initiative cites that "in 1920, 10,000 whites attended the lynchings of three Black circus workers in Duluth, Minnesota."[3]

2.23 *To Bear Witness*, 2018. From *A Lynching's Long Shadow.*

So I really see no difference between *A Lynching's Long Shadow* with Elwood Higginbotham and George Floyd. And I believe it was the dramatization of that video—the fact that it's over eight minutes, it's in broad daylight, it's on a holiday or near a holiday, and it's in front of a store that many of the community members frequent—that makes me draw this conclusion. The police were set out to terrorize the community.

LAH: Yes, what is coming to mind is the idea of the spectacle of death in relation to the history of lynching in the US and the psychic and physical terror it enacts on the communities that witness it. The killing of George Floyd was a display of sadism. His sadistic execution was meant to send a message. It was terrorism, to the degree that lynchings function in the South, or in the North for that matter. If we think about the infamous murder in Jasper, Texas. There's, in fact, a renowned Belgian filmmaker, Chantal Akerman, who in her documentary *South* (1999) went there to interview people in Texas. They spoke about the killers dragging the body of James Byrd to the point that his body parts were found along the way.

It's not just the act of killing someone, it's more about the spectacle of terror. And I think clearly the policeman was, whether unconsciously or not, as you're suggesting, in that tradition of violence surrounding the spectacle of violence in relation to Black bodies. It's about terror; it's about terrorizing.

• • •

LAH: [In Minneapolis, where George Floyd was killed,] was this a working-class, middle-class neighborhood? What was it?

JRM: Yes, this neighborhood was working class, a community that I definitely am familiar with—a corner store where people go, and they may play lotto, they may pick up food, snacks, and household items (fig. 2.24). Imagine a bodega in New York City—it's that. So this brings to mind Eric Garner, because his situation mirrors that, and it's also the familiarity of "I can't breathe," and it's a direct repetition of that (fig. 2.25). Now you have this image of "I can't breathe" and Eric Garner's mother. And George Floyd, who called out for his mother and also said, "I can't breathe." George Floyd's mother was already deceased.

LAH: Let's just talk a little bit about that, because there was something about the fact that you had this young man that was snuffed out in his own terror, calling on his mother. It was such a visceral, emotional, disturbing moment, and there was something about the sadism that was so present. Thinking generationally, there was a time where these murders of innocent people of

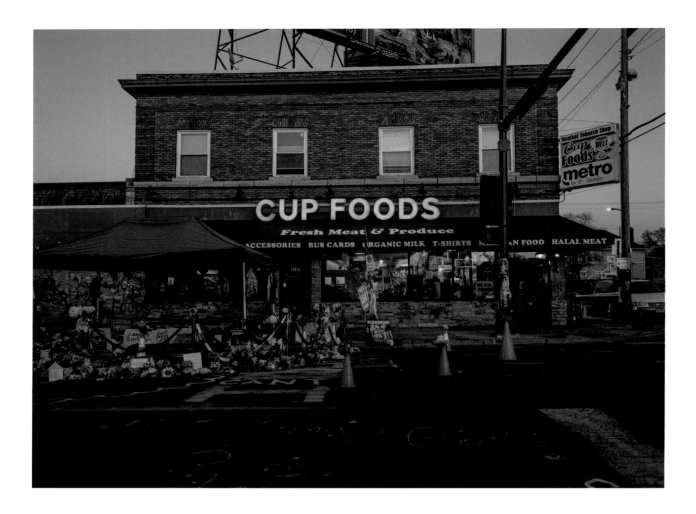

2.24 *George Floyd Memorial Site #2, Election 2020, Cup Foods Re-Opens (Minneapolis, Minnesota)*, 2020. From *Unrest in America: George Floyd.*

color—Black, Latino, not to mention First Nations—would go with impunity, not being tried in court, or found guilty, experiencing neglect from the wider community. It's inexcusable.

Now, what has happened since in terms of the expansion of Black Lives Matter, the challenging and removing of monuments, the global gaze to this particular situation that we're in right now, and how your work has contributed intensely to that documentation and framing the language around that. It's an historic period, and it's amazing that you're a part of it. You are on the front line. You are not part of what started ten years ago. I'm not saying that there haven't been social movements before—there always have been. But now your images, and those of others, are being added to our collective consciousness in features in the *New York Times, Vanity Fair,* and so on. Just think about *Vanity Fair* featuring Amy Sherald's portrait of Breonna Taylor on their cover.

It's not just the policemen. Let's be clear about that. That's old Jim Crow, to say as long you are better than a nigger, you can still be poor and white. And that's what's happening, that's what's getting played out. Think January 6, 2021, and who orchestrated it.

JRM: I think it's a demand now. I think the younger [generations] are even more progressive and demanding of justice. There's really no time for respectability

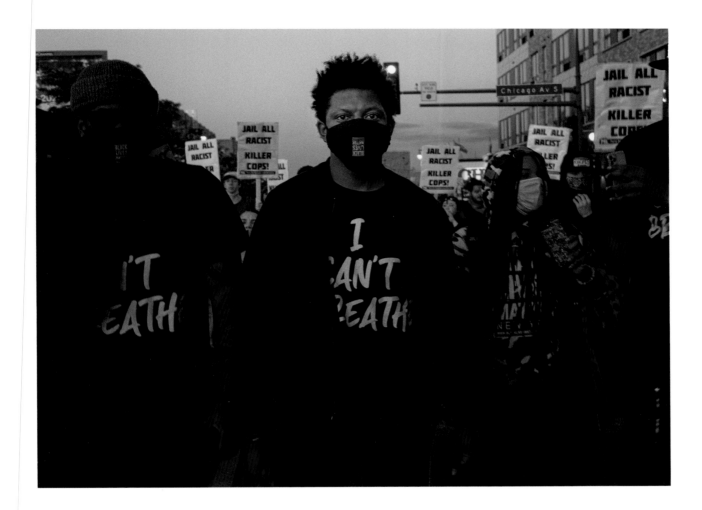

politics with them. I think that's where you're getting at. And there's also another sense of agency and urgency. For me, when I got up and left, immediately, it wasn't as if I was doing something on the computer or in my home. Not saying that doesn't help. However, there are people dying in the streets, and I think now it's time to be heavily involved and demand what you need and what you want. I think that's what we saw in Minneapolis, and people followed suit all over the world. We saw millions of people marching and demanding justice in the streets of London. All over the country—the *New York Times* reported that there were protests in all fifty states, and that's never happened before. We have to acknowledge that there is something different going on.

LAH: Oh, absolutely. So, why you, though? At what point do you realize, "Okay, there's a story here. I've come. I've had the impulse to come because I can't stand for this. I need to be out, I need to be active, I need to be engaged. I need to be a part of this movement." But at what point did you put on the photojournalist hat? At what point did you say, "Okay, well, I need to be getting these images out there"?

JRM: Good question. You know, so, I'll back up and say that I arrived [in Minneapolis] near the end of May. I was documenting already. Not on

2.25 *I Can't Breathe (Minneapolis, Minnesota),* 2020. From *Unrest in America: George Floyd.*

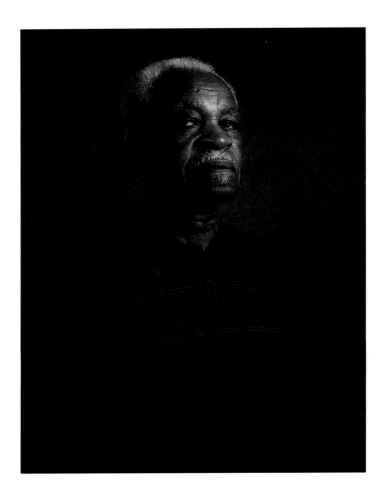

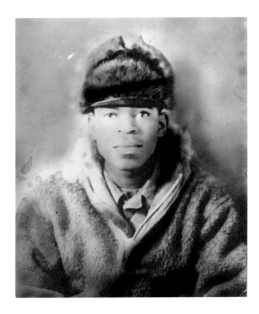

2.26 Joshua Rashaad McFadden for *Smithsonian* magazine. Elmore Nickelberry, 2018, above left; and Nickelberry, circa 1968, above right.

McFadden photographed survivors of the sanitization workers strike in Memphis, Tennessee. Elmore Nickelberry, who still works a Memphis sanitation route, was married with three children at the time of the strike. "But it got to the point," he recalls, "where we didn't have any choice." Referring to the tax-free payments from the city, Nickelberry says: "I don't think it's enough, but anything's better than nothing." Nickelberry, current day, above left; and Nickelberry, circa 1968, above right.

assignment. And I looked around and didn't see that many black photographers. I saw some, but not many.

LAH: Anyone you recognize?

JRM: No. Nobody I recognized when I first arrived. So I said that this story does need to be told in a publication, but I don't know if I am the one to do that. I was saying to myself that I didn't know any editors that would be interested, and I haven't photographed *like this* for a publication. Those thoughts came to my head.

LAH: So you had not done an editorial documentary for a publication before?

JRM: Not reportage, but I'd done portraits for publications. I hadn't done reportage for a newspaper, especially not for a protest or unrest. But I said to myself that I came here for a reason. I'm here for a reason. I received that call for a reason. And I started to reach out to the editors that I'd worked with for editorial stories in magazines, my portrait projects.

I reached out to my editor Jeff Campagna at *Smithsonian* magazine, whom I worked with on the *I Am A Man* project in 2017–2018, about the [1968 Memphis] sanitation workers strike (figs. 2.26 and 2.27). He said, "We don't usually publish

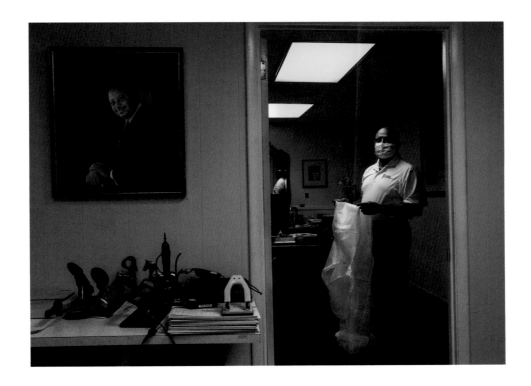

things like a protest." They're a history magazine and they don't do anything heavily political. He said he was going to run it by his editor and tell a few people that I was there. I continued to document. He reached out to Brent Lewis, one of the editors at the *New York Times*, a Black photo editor for whom I've made portraits in the past. Brent contacted me and said, "Oh, you're in Minneapolis? . . . I'll tell my colleagues that you're there."

A day later, I believe, I got an email from Crista Chapman, editor at the *New York Times*. And she said, "You're there in Minneapolis, checked in, are you safe?" Things of that nature. She put me on the story to cover the George Floyd memorial service for the *Times*. Caroline Smith at *The Atlantic* also had me cover the protest for their magazine.

LAH: So that's one of the first stories you were doing for the *Times*?

JRM: Right. That's one of the first stories that I did for the *New York Times* that summer. Then *The Atlantic* reached out, put me on a story with Wesley Lowery—he's a Pulitzer Prize–winning journalist. Black journalist. So, that was my first goal on June 3, 4, and 5, doing assignment work, and from then on, I was on assignment, mostly with the *New York Times*.

LAH: What kind of assignments would they give you?

JRM: It would be reportage, meaning I'm around the city, documenting what's going on. I may be interviewing people, on the scene, and reporting back and filing photographs of what's happening.

2.27 Joshua Rashaad McFadden for the *New York Times*. Thomas Falls Jr. holds a protective suit at his cleaning business's office in Birmingham, Alabama, June 30, 2020.

Falls used the federal loan program to help pay workers at his family's commercial cleaning company, Falls Facility Services. Thomas L. Falls Jr. said, "My dad started this business in 1959. He had a dream that he wanted his own business, so he ventured out with a $100 loan from his father. My father and my mother started this business together. My dad would sell contracts during the day and clean at night, and he and my mother were doing that for years. He worked up until the mid-'90s until health issues would not allow. After my father's second stroke, my mother needed assistance with the business. So, I returned home from school to help, and have been here ever since." His father, Thomas L. Falls Sr., is depicted in the framed photograph on the wall to the left as Thomas L. Falls Jr. holds his hazmat suit in preparation to continue the legacy his parents built.

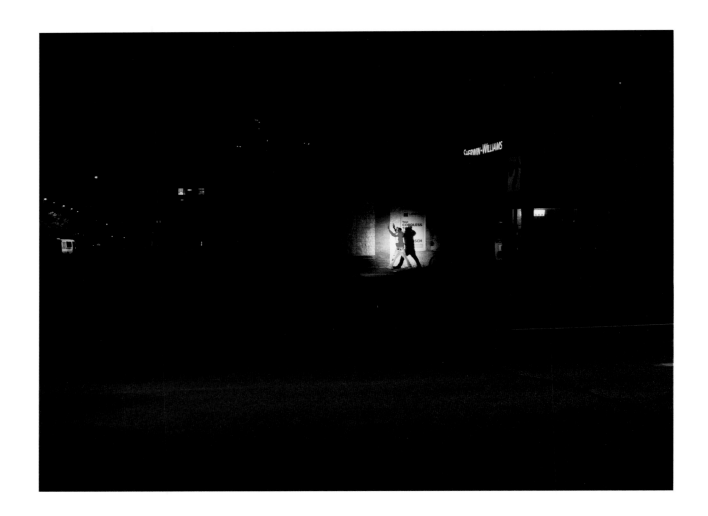

LAH: When you're doing that, are you sending photographs on a daily basis?

JRM: Yes, I would get up very early in the morning. I would go out, photograph near the memorial site. I would interview people, photograph them, all day, and I would check in and have to file images throughout the day on certain deadlines.

I would try to eat here and there. At this time, COVID is still going on, so open restaurants were scarce. It's like, if I hadn't eaten before 5 p.m., I was out of luck. But I would try to stock up on food in my hotel room. I would call you, and you would say, "Did you eat?" And I'd say, "Well, I was looking for some food." And you would say, "Is there a refrigerator in your hotel?" And I said, "No." [*laughs*] And you'd say, "Well, you need to switch hotels," and things like that. I was trying to stay aware of those things as I'm documenting.

But every night as the sun set, protests would pick up, and it was very devastating, and yes, I was exhausted. Every day, protests are going on all day. Protests were almost 24/7 during that time, but they would really pick up at night, around 11 p.m. or so, and then they would go through the middle of the night (fig. 2.28). Sometimes [I was] not getting in until 3 a.m. or 4 a.m.

2.28 *Target #2 (Minneapolis, Minnesota),* 2020. From *Unrest in America: George Floyd.*

LAH: Let's talk a little bit about that. Why did it really kick off right at night?

JRM: Because it's [after] sunset; it's dark. It's dark outside and more people would come to participate, whether or not they had to work during the day, that's just when people came to participate. You had certain people that participated during the day and others during the nighttime.

LAH: And so often we think about the idea of night as a cover, a shade. We think of Harriet Tubman, the Underground Railroad. They used the cover of darkness as a cover against hypervisibility, using the shadow as a way to somehow resist, if that makes any sense.

JRM: Yes. Yes, for sure.

LAH: Now you're also working for a national newspaper. How do you balance that?

JRM: Good question. At first, my assignment was to photograph the memorial service, which was more of a controlled circumstance. It was a memorial service at a church, but even navigating that was difficult. I had my camera, but I needed to rent another camera and borrow a camera because I was unsure of the lighting situation and how far back I'd be, and I knew I had to get the shot. There was limited access for photographers, so I was the only *New York Times* photographer inside the building. I borrowed a camera from another photographer who covered outside the memorial service. She allowed me to borrow her extra camera with the long lens so that, just in case [I was] far back, I [could] get a shot easily in addition to the shots I captured on my camera, which I had a fixed 63 lens on, equivalent to 50mm. Also, the questioning: security always questioned whether I was supposed to be there, questioned whether I was on assignment.

LAH: The *New York Times*, did they email you something, like a press credential or letter?

JRM: Yes. I had my credentials, I was on the list. I had all of that. But it didn't matter because I was still Black. I was constantly questioned. I was constantly questioned, and it came to a point where one of the security guards almost kicked me out. They didn't give any of the white photographers that energy.

LAH: Are you serious?

JRM: I'm very serious. I'm very serious. And that was an ongoing issue that I've had, and I learned later on that's a very common thing that happens to

Black photojournalists and journalists, that their credibility, assignment, and who they are working for is constantly called into question. I experienced that immediately on the first assignment. So that became an experience that is now attached to my creating, right?

LAH: So, say more. What do you mean by that?

JRM: Well, before, as a photographer who was not on assignment, I was like anyone else participating in the protest, documenting yet also protesting because I'm in the crowd. Many times in these situations you see photographers on the sideline, moved up together, almost over-photographing what's going on. But I find myself in the crowd.

LAH: Yes.

JRM: And that direct gaze is amazing. So, this engagement in my work is different from many photographs you'll see from these protests. This was before I was on assignment; I made *I Can't Breathe (Minneapolis, Minnesota)* the first night I arrived (see fig. 2.25).

LAH: The impulse that led you to go there and drive fifteen hours to be part of the protest—the resistance gave you a level of agency, but then you moved over to official business as photojournalist. With that move, a whole other paradigm of caste emerges. The fact is, it's almost like the colonialism of the press, or the structure, or even in who gets to document, who gets to officiate, who gets to participate in the massive narrative, how this is gonna get printed.

JRM: Exactly, and so the moment at the church actually helped me see and truly understand how the colonialism of the press, or the structure of gatekeeping, works, because if it were a white photographer, of course there would be no issue, right? It's an idea of access and who's telling the story. And so now we have the blatant act of them saying, "No," that I could not be here as a Black photographer because they did not believe I was on assignment.

I had to purposefully get up almost at 4 a.m. to get there early. I was the first one there because I already knew that something like that might happen. So I was the first one there to receive my badge, yet the funeral didn't start until about 7 or 8 a.m. I went early so there would be no issue, then there was still an issue.

LAH: Does the *New York Times* know that?

JRM: Oh, yes, I told them.

LAH: What did they say?

JRM: They said, "Well, who do I need to call?"

LAH: I think about the 2019 *New York Times* profile on the 14th Secretary of the Smithsonian Institution, Lonnie Bunch III. The photograph of him was large on the page (fig. 2.29). Prior to Black Lives Matter, even if he had had that same title, that never would have happened, having that kind of real estate on the page. These major newspapers now have been radically transformed in how they visualize and amplify Black images. Just in terms of the type of imagery, not only in terms of the repetition, the images, or the bundle of images in the magazines and newspapers, but the scale and the size. These newspapers are not neutral. Who gets to photograph? Who gets to write and frame the discourse? That's why the *New York Times Magazine*'s legendary 1619 Project was critical in reframing the discourse. It's amazing that you as a thinker, as someone who is a compassionate person, who felt the impulse to go, to bear witness, to put your body on the line, to get gassed and hit with rubber pellets. To go from that to being a documentarian on-site, on assignment, and then having to deal with the apparatus of that old structure itself.

What were you experiencing on the ground versus what was being said in the media or on television?

JRM: I am not sure. I had very little time to tune in because I was actually there. I will say, I was there in Minneapolis when police arrested Black CNN reporter Omar Jimenez, who was reporting live on television. I knew for sure something like that could happen to me. I also know that the fires were real. I know that the anger and the sadness were all real. That was the atmosphere, and it was devastating—I do know that. And the people saying, "Oh, they're burning down their own community," that's like static to me. It was almost as if people were policing other people's anger. Here we are, everything is on fire. Everything is on fire, and it's so tragic. And I heard people say, "Burn *that* down instead. *Don't* burn *that* down."

This [photograph was made] toward the beginning, before I was on assignment, when I saw the gas, people running from the tear-gas bomb (fig. 2.30).

LAH: Who were these people, though?

JRM: I couldn't tell. People from Minneapolis—I don't think that actually even mattered at that point. How can you police someone else's anger? In this way, it's almost threatening to me, understanding that even a Black person, or

2 THEATER REVIEW
A cabana boy torn between father figures. BY JESSE GREEN

7 DANCE
Does ballet tiptoe into high camp? BY MADISON MAINWARING

NEWS | CRITICISM

Arts
The New York Times

Ron and Staci Schnell have a special affection for a Marvin Hamlisch musical — even after seeing it 25 times.

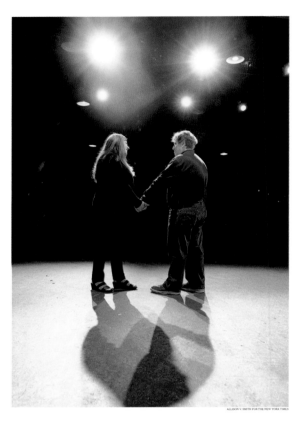

'Our Song' Is All Theirs

By LISA BIRNBACH

ARLINGTON, TEX. — This is a love story. It began in New York City and wended its way through eight states and 24 theaters, some of them on Broadway, before we end up at the 199-seat Theater Arlington here, a few minutes from the original Six Flags Over Texas amusement park.

Ron and Staci Schnell have come to see "They're Playing Our Song," the 25th time they've seen the musical together, and their first time seeing it in Texas. The Schnells love this show. It's about a boy and girl meeting cute, falling in love, falling out of love and finding each other again before the final curtain.

And *this* is a story of how two people — Ron and Staci Schnell (now 51 and 48) — fell in love, stayed in love and have scheduled their lives around performances of "They're Playing Our Song" wherever they may occur. That the Schnells have seen this one musical so many times doesn't make them peculiar; it puts them in the category now known as theater "superfans," not dis-

CONTINUED ON PAGE C3

Staci and Ron Schnell at the Theater Arlington in Arlington, Tex., before seeing "They're Playing Our Song" yet again.

ALLISON V. SMITH FOR THE NEW YORK TIMES

Smithsonian Turns to a Visionary

Lonnie G. Bunch III will be the institution's first black leader.

By GRAHAM BOWLEY

Lonnie G. Bunch III, the museum leader who opened the Smithsonian's National Museum of African American History and Culture to critical applause and huge crowds, will serve as the next secretary of the entire Smithsonian, the institution's most senior position.

Mr. Bunch, 66, will be the first historian and the first African-American to oversee the Smithsonian's 19 museums and galleries, the National Zoological Park and research centers. He will take over on June 16, the Smithsonian announced on Tuesday.

Mr. Bunch, who began his career in 1978 at the Smithsonian's Air and Space Museum, said in an interview that, as the

CONTINUED ON PAGE C3

J. SCOTT APPLEWHITE/ASSOCIATED PRESS

Lonnie G. Bunch III, the founding director of the National Museum of African American History and Culture, is the Smithsonian's new leader.

'The Perfection' Twists Into a #MeToo Statement

The Netflix horror film hits a nerve with women, offering a vicarious moment of catharsis.

By JULIE BLOOM

The gasps, shudders and yells at the screen could be heard straight from the Twitter scroll as one by one over the weekend viewers watched "The Perfection," Netflix's latest horror film to follow the success of "Bird Box." It's a movie designed for real-time online reaction and thus totally of the moment.

"The Perfection" stars Allison Williams ("Girls," "Get Out") and Logan Browning ("Dear White People") as young cello prodigies who, after connecting at a concert in Shanghai, return to their cutthroat music academy to seek revenge on an abusive

teacher. It's gruesome, violent, erotic and totally bonkers. The plot is almost impossible to describe without spoilers, but "Black Swan" and "The Fly" have both been invoked in reviews.

Directed by Richard Shepard, an alum of "Girls," and written by him, Eric C. Charmelo and Nicole Snyder, the film had its premiere last fall at the horror-themed Fantastic Fest and was quickly bought by Netflix.

#MeToo was very much on the minds of its creators, and it ends with a feminist exclamation point. Yet when the movie opens, you're immediately bombarded with the notion that it's not, Browning said, they wanted viewers to think "this is some jealous rivalry."

"Then you're immediately bombarded with the notion that it's not," she added. "Each plot twist is a feminist statement."

CONTINUED ON PAGE C4

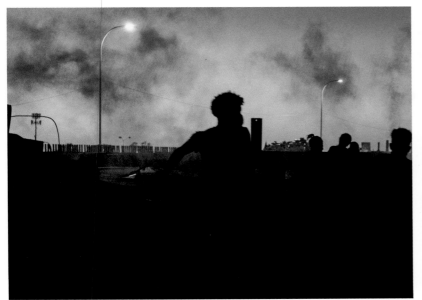

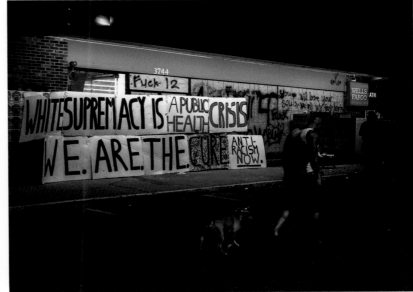

whoever's rage, would still be policed after your life was already threatened for no reason.

LAH: Yes, at all times.

JRM: At all times. I find that interesting. Here we are in devastation, and it's still being policed, yet the police officers are still getting off after murdering someone. The police officers were set free. So what does that really mean? What is it about the unjust system that causes people to try to always protect it, even if there is a fault on its part?

In Louisville, when I was there speaking to Breonna Taylor's mother, her boyfriend, her closest friends and family, they were saying that how they [had] *just* spoke[n] to Breonna, and now she's dead. And then to hear someone say, "But the people protesting were wrong," makes me question whether they are paying attention to what actually happened, and the fact that Breonna's dead? She shouldn't be dead. Her mother shouldn't have to be a public figure. She shouldn't have to be a Mother Till.[3] Right? That shouldn't even be.

Our questions are always geared towards how the oppressed react to oppression. We need to be addressing the oppression.

LAH: That's good. And why aren't they addressing the disease of racism and oppression?

JRM: And why not address white supremacy? That's the trick of it. That's the actual thing. That's how it operates, in every facet of those living in America, and then all over the world (fig. 2.31). It's all over the world. But, you know, living in America, we as a nation tend to divert from the actual problem by

2.29 From the *New York Times*, May 29, 2019.

2.30 *Tear Gas in Minneapolis (Minneapolis, Minnesota)*, 2020. The day closes on Minneapolis, now thick with the tear gas of local police, as protesters scramble to flee their own community.

2.31 *White Supremacy Is a Public Health Crisis (Minneapolis, Minnesota)*, 2020. From *Unrest in America: George Floyd*.

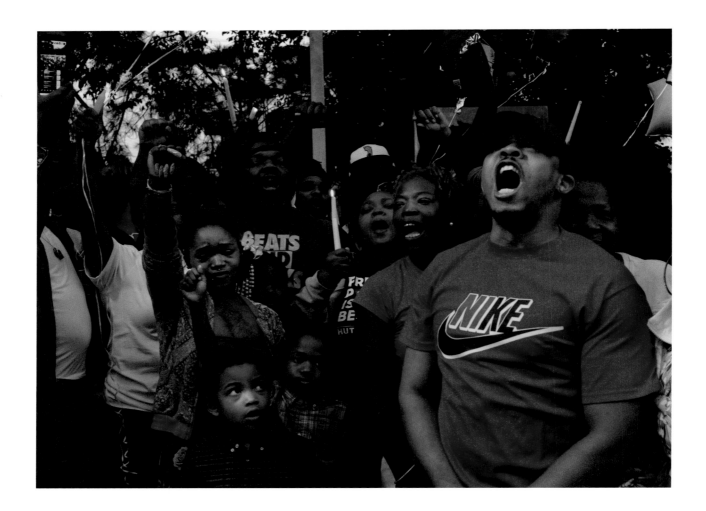

2.32 *The Family of Rayshard Brooks (Atlanta, Georgia)*, 2020. From *Unrest in America: Rayshard Brooks*.

saying, "Oh, well, you just need to document everything that happened to you." Then you document everything and the oppressor is let off the hook anyway.

• • •

JRM: In Breonna Taylor's case, that all happened before George Floyd. The story was suppressed. Breonna Taylor was killed by police officers on March 13, 2020, and Floyd, May 25.

LAH: During the early [part of the] pandemic, right as the country was shutting down, her murder occurred. Her murder was, I imagine, overshadowed not only by a cover-up but also by the pandemonium of the country coming to a halt. And, in a way, the murder of George Floyd on May 25 reignited the resistance to the cover-up of Breonna Taylor.

JRM: Right.

LAH: At what point did you, having traveled to document, have the impulse to travel to be part of the resistance and the demonstration, and at what point did you travel to go to the hometown of Breonna Taylor as that case reemerged?

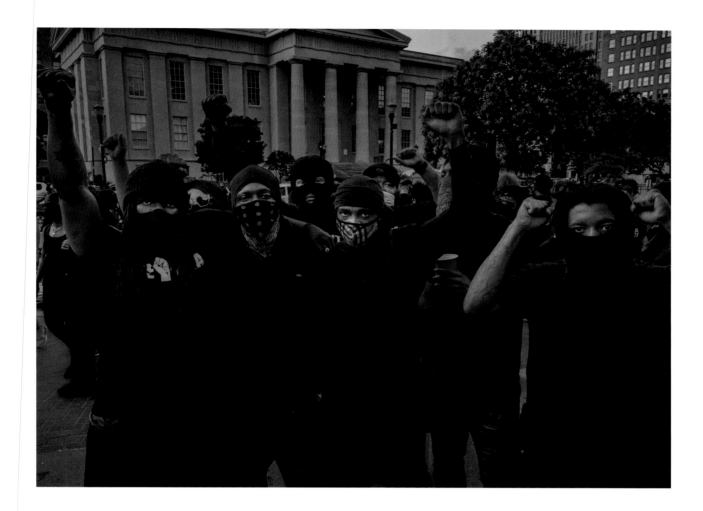

JRM: I had already left Minneapolis after photographing the unrest of the George Floyd police murder in June. I traveled to Atlanta, where then Rayshard Brooks was killed by police (fig. 2.32). I left Atlanta to go to Louisville, Kentucky, in July.

LAH: For Breonna. And what redirected, from your knowledge or experience, the media attention on Breonna Taylor? What reignited Say Her Name and the protest, and the national and international exposure of the murder of a frontline worker in her sleep?

JRM: Well, since George Floyd, we had seen tweets about the story of Breonna Taylor and what happened to her. However, it wasn't getting the same amount of attention. Especially not in May. So in July, people were tweeting about Breonna Taylor and Say Her Name, and her story began to go viral on the internet. Of course, with her story, there was no video like with George Floyd. Her case could have easily gone ignored and swept under the rug if it had not been for her friends, her family, the town, and the protesters in town making her story gain greater visibility.

LAH: When you went to Louisville to photograph her family, what was the climate of the town at that time?

2.33 *Protest at Jefferson Square Park (Louisville, Kentucky)*, 2020. From *Unrest in America: Breonna Taylor.*

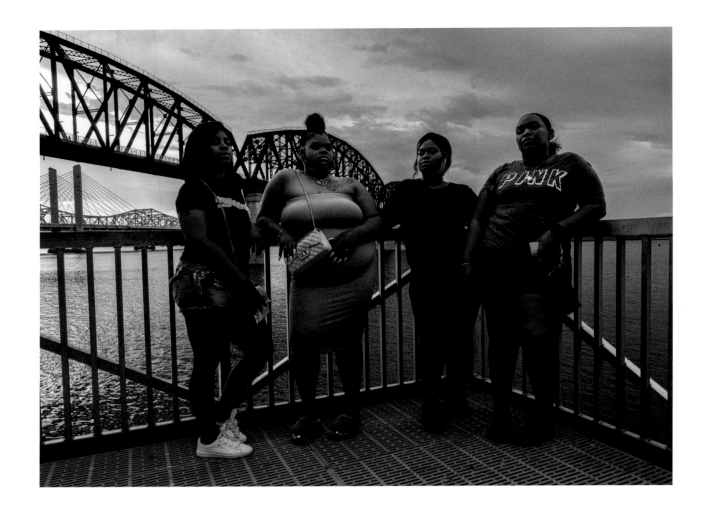

2.34 *Shadai Parr, Elysia Bowman, Erinicka Hunter, Shatanis Vaughn (Louisville, Kentucky),* 2020. From *Unrest in America: Breonna Taylor.*

JRM: When I arrived, there were protests already occurring every day (fig. 2.33). It was a bit different than, let's say, Minneapolis or even Atlanta. It was a strong group of protesters but a much smaller presence than [in those other cities]— a smaller group, and the same group every night. Night after night after night protesting for Breonna Taylor. It seemed much more intimate; I'm not sure if that was due to [Louisville being] a smaller city. But it was more of a close-knit group than what I'd seen that entire summer.

LAH: And you were there on assignment?

JRM: I was there on assignment, yes, for a cover story for the *New York Times*.

LAH: What happened, exactly, that the *Times* is redirecting energy towards the Breonna Taylor case?

JRM: Well, the story had been building, and now there was much, much more attention. By this time, celebrities and more high-profile activists were homing in on Louisville.

LAH: It's quite brilliant, quite amazing just thinking about the visual galvanizing

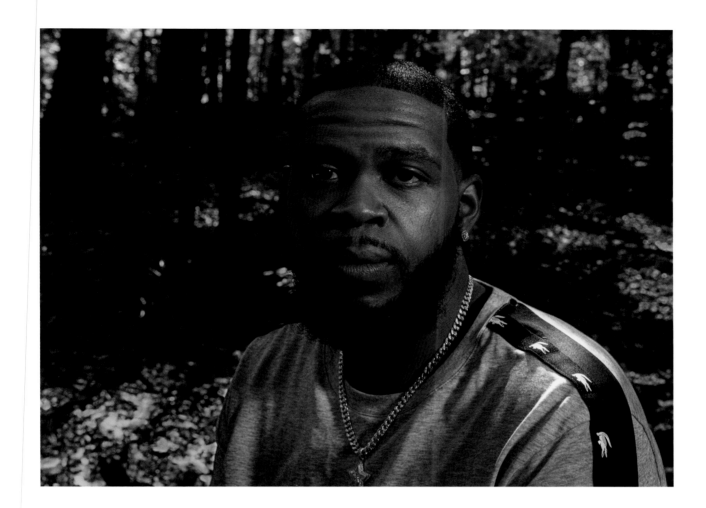

of energy and the collective spirit to redirect that energy. Just thinking about the wave of the national and international press. Her murder had been overshadowed by the catastrophe of COVID and the shutdown of the country.

What I find haunting about the photographs you took is there's a disquietness to these images, unlike some of the more direct protest images around George Floyd—for example, the "I can't breathe" images, or even the image of the mural of George Floyd with thousands of wreaths lying in front of the memorial site. There's something about the Breonna Taylor photographs for me which speaks to the body as memorializing.

I think of your very iconic portrait of her four friends, [or] the portrait you made of her partner, which is also beautiful (figs. 2.34 and 2.35). But there's something about the four friends, the iconography of the four women together at that site and how the photograph speaks to the absence of Breonna's presence here at the same time. The way they are looking directly at the camera, their gestures, their passion, their style—from the slippers to the handbag, to their tattoos, to the cutoff shorts, to the Pink T-shirt. You can see the woman on the far right with her phone, reflecting the use of technology, such as social media, as an act of resistance. There's something deeply embodied and noble in their stance and gaze. It's such a personal, yet iconic photograph.

2.35 *Kenneth Walker (Louisville, Kentucky),* 2020. From *Unrest in America: Breonna Taylor.*

It's not a mourning photograph, and in a certain sense, not traditional. We're not talking about an iconic photograph of Coretta Scott King or Jacqueline Kennedy in terms of their iconic dress. It's urban, self-possessed. Part of the sadness, the grief, is that for a viewer, the four figures corporeally speak to the grief of the absent one. Breonna was killed, and the afterlife, in a way, is this sort of memorialization that happens.

It's a beautiful photograph, a striking image, an historic image. Even more so than the oft-repeated images of Breonna on MSNBC or Democracy Now, in the paper, that kept repeating. This to me feels more chilling than the other image of Breonna, being a frontline worker, at the prime of her life. The repetition of those images almost neutralizes it for me. Whereas this image captures, "Oh, that really speaks to her absence."

JRM: Absolutely.

LAH: And this was [at the house] of the attorney general of Kentucky, who did not press charges—the reason the case was thrown (fig. 2.36).

2.36 *A Sit-in at Kentucky Attorney General Daniel Cameron's Home #1 (Louisville, Kentucky)*, 2020. From *Unrest in America: Breonna Taylor*.

JRM: Yes, Daniel Cameron, the attorney general. He did not bring any charges

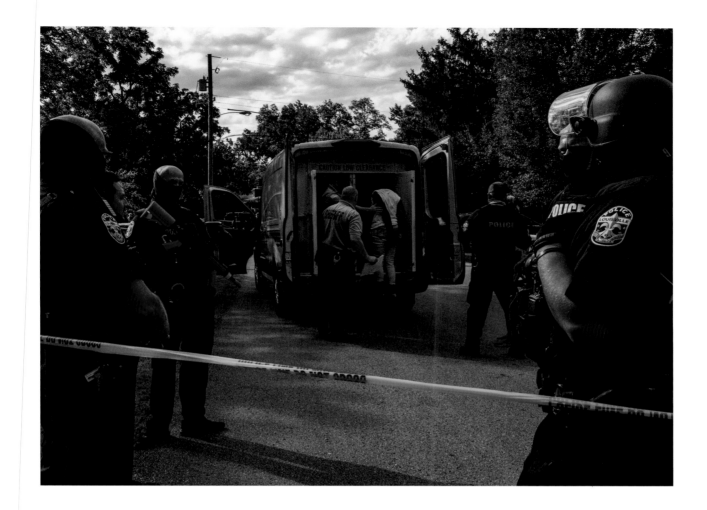

against the police officers who committed the crime. His only judgment was saying that the bullets the police officers shot entered into someone else's apartment, and the only police officer that was charged was the one that shot bullets into that apartment. The message Daniel Cameron relayed here is that the bullets that hit Breonna didn't matter.

LAH: Yes, it was this tactical error that prevented the police from being tried or being able to go forward with the case. As Tamika Mallory said [following the attorney general's press conference], "All of our skin folk ain't our kinfolk."

JRM: Right, so this image is from the day of the protests at Cameron's home (fig. 2.37). We actually didn't know that was going to occur. I knew that the same day I was to make a portrait of Breonna Taylor's mother, Tamika Palmer (fig. 2.38). And I had met her, of course, numerous times before then, during the time I was there. However, it wasn't time to make the formal portrait.

LAH: What does that mean when you say that it wasn't time?

JRM: For me and how I work, it's not about just going in and making the

2.37 *A Sit-in at Kentucky Attorney General Daniel Cameron's Home #2 (Louisville, Kentucky)*, 2020. From *Unrest in America: Breonna Taylor.*

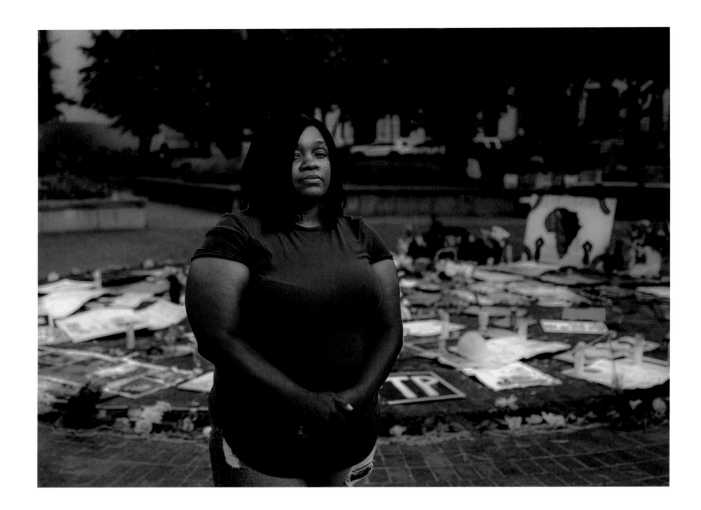

portrait. I want to try to begin to know the person, especially in this situation.

I made Tamika Palmer's portrait the last night I was in Louisville. It was in Jefferson Square Park, where the memorial to her daughter was.

LAH: I'm interested in the spheres of influence, or the spheres of intimacy, that you'll be within, as opposed to just running up and saying, "I need to photograph the mother"—rather, working your way into the space of intimacy with a community that is dealing with collective grief. What about the issues around intimacy and dealing with death? Some people are not sensitive to that. And I think your photographs, for me, speak to the level of intimacy. There might have been a very different reading of a photographer who did not have your sensitivity [in photographing] those four women.

JRM: When I did get the call to document the Breonna Taylor story, I knew that there was already a reporter there, and a film crew. However, with her story, the most significant point was that her story was ignored for too long. The main characters you see, the main persons in the story of Breonna Taylor, are her mother, friends, and boyfriend. It is a very intimate story, and I approached [them] like I would approach my family members.

2.38 *Tamika Palmer (Louisville, Kentucky),* 2020. From *Unrest in America: Breonna Taylor.*

LAH: So, your approach to this was like a gentle persuasion, and there's something noble about that going into the project. When I see that image [of Tamika Palmer], it's about Breonna Taylor's mother, but it's also about the countless Black mothers who have lost children over the decades—centuries—to state violence. [The] image [of Breonna Taylor's friends] speaks to how communities of color are impacted, and how that grief is not only present when the *New York Times* or NBC or Democracy Now is there for that brief fleeting moment, but the fact that it's within the collective body of these four women who also stand in for trauma.

This [photograph of Tamika Palmer] is super strong. I can't help but think about Ida B. Wells, Sojourner Truth, or Harriet Tubman. Their gaze is not just about them, but the act of resistance.

JRM: Oh, I agree.

LAH: We experience all this secondary trauma every time we see that damn image over and over and over. And then all of a sudden—*poof*—it's all gone, we're on to something else. The photographs for me speak to the lasting legacy, the fact that grief is still there. At the same time, there is community. And I respect that you gave time and energy to this portraiture process; with it, you are speaking through the heart and acting through the heart, and that's what I see.

JRM: Oh, yes. And that was definitely [the case with] this instance, because more than anything, I knew the pain—because, like you said, we've seen it countless times. It's Breonna Taylor's mother—and all the Black mothers she represents, our mothers—who now has to stand, and continue to stand, even though she's the one who lost a child to police brutality and has been thrust into this new life of freedom fighter in a way that she could've never imagined.

LAH: Yes, yes. She's a reflection of all the mothers who are worried about their kids going outside.

JRM: Right. Going outside, worrying about what kind of toys they play with . . .

LAH: Speak.

JRM: What schools they're going to. Whether or not you teach your child to comply, get out of the car when a police officer pulls you over or not. On top of that, for them to experience patriarchy throughout their lives and have to be quiet about it, or felt like they had to be quiet about it for all these years. I can only imagine the thoughts going through Tamika Palmer's mind here in this

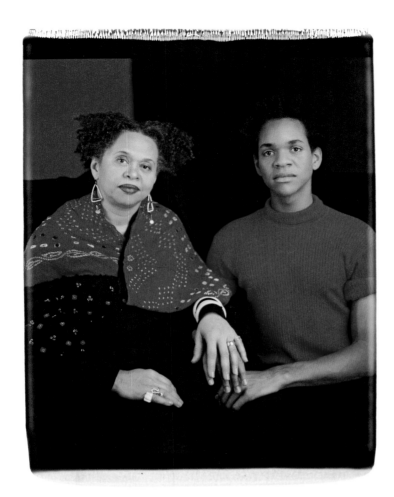

2.39 and **2.40** Lyle Ashton Harris (American, b. 1965).

Madonna and Child, 1994. From *The Good Life*. Polaroid print, 24 x 20 in.

Portrait of Harris's mother, Germantown, Pennsylvania, 2021.

image. All I could do at that moment was to approach her with a respect that I knew she was not getting from many other photographers. I knew she could only say "Yes" because she wanted her daughter's story to be told.

LAH: Yes, there's a nobility to the photograph of Tamika Palmer. It is something about how she comes to the center stage. It's not about the hype of the media. It's not about the high-power lawyer working on the Taylor case, though I respect him tremendously. It's not about how much she received. There's just a quietness to this and to these photographs, overall. I love that it links to the nonhierarchical circle in various Native cultures. Its softness is discernible, in the flowers, the candles, and yet—the hard hat.

Palmer is also not what might be pictured as a typical mother. You think about a certain representation of mothers, historically, of a certain age, whether that's from representations of the Madonna or even my mother (figs. 2.39 and 2.40). Visibly in her style, you see Palmer is from a younger generation of mothers. However, there's something that almost echoes the painfulness of her youth, to have the premature death of her daughter. All of that comes to mind here, and I think it's beautiful.

JRM: Thank you. All of that that you're bringing up, it's nearly the way I create.

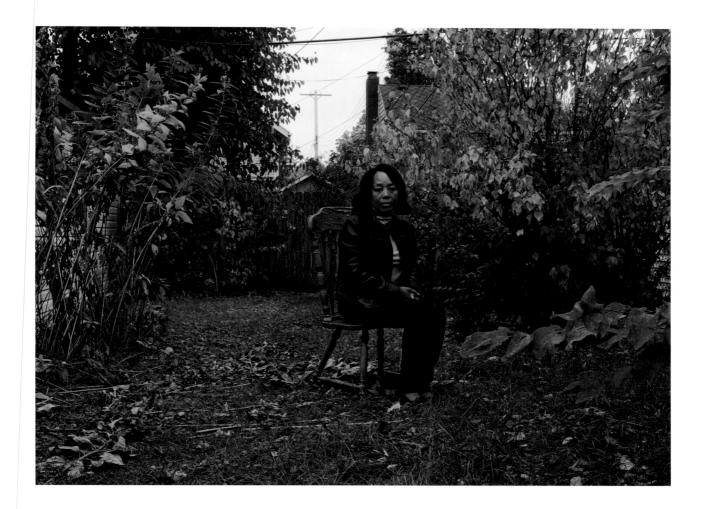

LAH: Oh, you do. That's the whole point.

JRM: I'm glad we're talking about this because it was different. The Breonna Taylor work was different. I knew that I had to approach it in a different way. With this portrait, I made sure Tamika Palmer knew there was nobody immediately in the background. We talked on the way over. Way before I brought her over, I just made sure that no one was there to impede her at this moment, because I wanted it to be about her, and about her daughter.

LAH: The reality is that we are at a difficult period of time with the deaths of George Floyd and Breonna Taylor. This may be the biggest social movement of our lifetimes that parallels other great movements. And the fact that her daughter becomes synonymous with a level of state violence is surely unfathomable to her. This mother is certainly like the Madonna.

JRM: This is the Madonna, but with a daughter. I may not have realized how much is on her shoulders as the mother. Many times we talk about the father, Black fatherhood, Black men, Black men in the community. However, how much of that relied on the mother?

And so here I have my mother for my project *Love Without Justice* (fig. 2.41).

2.41 *Come Ye Disconsolate Wherever Ye Languish*, 2019. From *Love Without Justice.*

LAH: Beautiful. Oh my gosh, I love that photo. Where was your mother living when this photograph was taken?

JRM: In Lansing, Michigan.

LAH: It's a beautiful photograph. It's a photograph of a mother taken by her son. Let's talk about how you and your mother arrived at this particular image. It's about a mother, a mother grieving the loss of her own mother and coming into the matriarchy. But it's also about the home that she returned to after the dissolution of her family life that she knew at that time. I think it's very beautiful. It's super elegant. When was this taken?

JRM: Thank you, I made this portrait of my mother in mid to late fall.

LAH: What does it mean to go back to this home of your grandmother after your mother had returned there several years before? When was the last time you had been to visit your mother there?

JRM: The last time I'd been back was my grandmother's funeral. The time before that was when my grandmother was living with my mother. My mother was my grandmother's caretaker.

LAH: Now, thinking about the financial meltdown of 2008 and how often minority communities were disproportionately affected, how black women were disproportionately affected. In this image, your mother represents another face of grief. And this is different from Breonna Taylor's mother, as your mother is suffering the loss of her own mother, her own matriarchy.

2.42 Family photograph. The floodlight outside of Joshua Rashaad McFadden's childhood bedroom window, Rochester, New York, 2004.

Nonetheless, I love the image. I love the situation of the figure on an interior chair brought outside. This is not a lawn chair; this is a chair that's actually brought out. The image is a construction of both urban and suburban elements in the autumn environment, your mother wearing a leather jacket.

Additionally, the photograph constitutes a certain regality. Having not seen an image of your mother before, I feel like, "Oh, I get the lineage. I get the resilience. I get the nobility." And there's something about the act of documenting grief that speaks to the collaborative nature of you and your mom and your relationship. Similarly to the way in which you photographed Tamika Palmer, you were able to create a scene in which to document your mother in a moment of grief, but also coming into her own as a matriarch.

Backing up, how old were you during the time of the financial crises of 2008?

JRM: I was in high school, and I was seventeen when all of our lives began to change drastically. Drastically. Like you said, with the economy in the state it was in, my parents were going through so much, and much of it I wasn't even aware of or didn't think I needed to be mindful of. I knew that we eventually lost our home, and our lives were never the same after that (figs. 2.42 and 2.43).

It ripped through our family, and I noticed how it changed my parents. It's a story that many Black families know. As a thirty-year-old, I now understand how this country has operated. I understand how the financial *crisis* disproportionately impacted African American families and minority groups. I now know how that has disproportionately affected Black women and how it ultimately shifted my mother's life in a way that I couldn't imagine.

So when I made this image of my mother the day we buried my grandmother, her mother, it was at a point of another significant shift (fig. 2.44). I saw

2.43 Family photograph. Craig B. McFadden photographed his sons Joshua, Craig, and Myles, before a road trip to a family reunion in New Jersey, 2001.

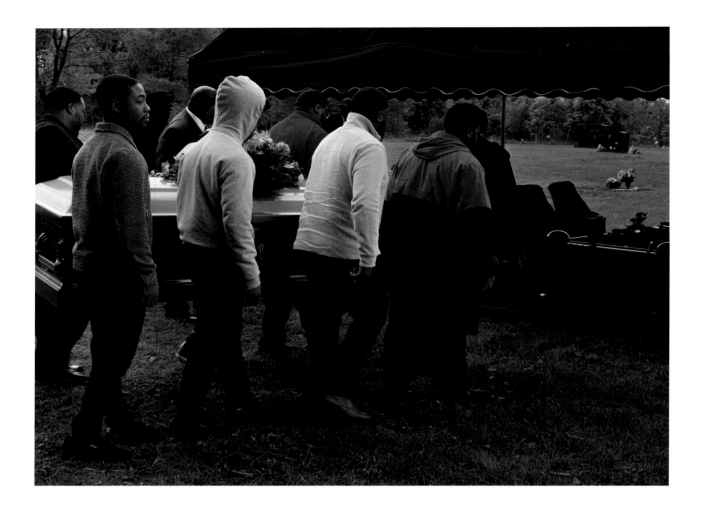

another weight of responsibility fall on her. I saw the needs that she cared about, the needs of her nieces and nephews, grandchildren, and children. I saw it. I saw it. And I started to question what the work was about. And that's why this project is called *Love Without Justice*. I said to myself, "I think I know what that truly means now." Because in the image, when I think about my mother's photograph, I see the love that she still gives, and I saw the justice that was not served.

LAH: Beautiful.

JRM: I read a book called *All About Love* by bell hooks, and she said that love can't exist without justice. So now I'm thinking—wow—George Floyd, Breonna Taylor, Breonna Taylor's mother, Tamika, and how her act of standing for the portrait was love without justice. And thinking about my mother, her act of taking on roles that were, in a sense, sometimes thankless roles.

LAH: Yes.

JRM: I realized the new generations are coming. The new generations are here (fig. 2.45). How long do we go without recognizing that we're not getting justice, and not doing ourselves justice?

2.44 *Earth Has No Sorrow That Heaven Cannot Heal*, 2019. From *Love Without Justice*.

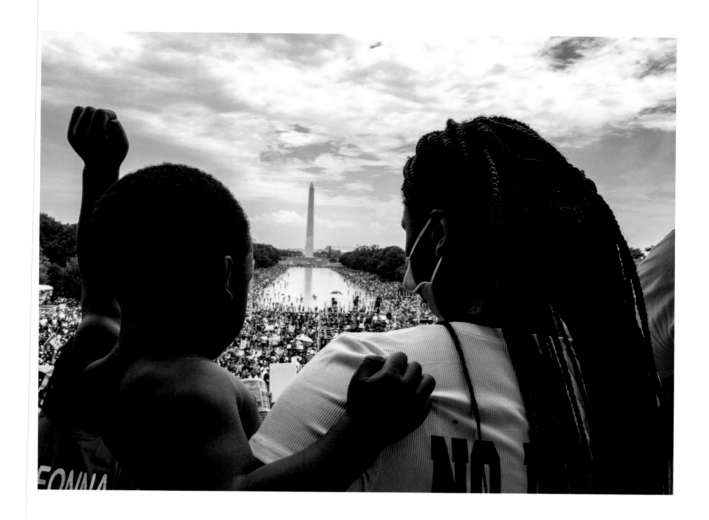

LAH: Well, I would argue that there's justice, going back to when your parents defended you and your siblings when they advocated for you in school.

I believe there was something instilled inside of you then, something that your parents passed down to you. Something that your ancestors had passed down to you. Because you might not have, in other circumstances, learned that. And that dissolution of the family structure as you knew it could have totally unraveled you all, but it didn't. The portrait of your mother and photograph of your family speaks to the *evidence* that that love ethic was instilled in you. That cannot be taken away. The very act that you were there to grieve the loss of your grandmother and witness and document your mother in her time of grief is a testimony to the elements that were placed there but may have felt ripped apart due to the fallout of the economic crisis. That grief could have also reignited her grief from when you left home for over ten years to get an education and make a life for yourself. And I feel in a way that the action of you coming back, being there, and documenting the existence of triumph is—

JRM: That is the justice.

2.45 *Alena Holds Her Son, Tamaj (Washington, D.C.)*, 2020. From *Unrest in America: March on Washington*.

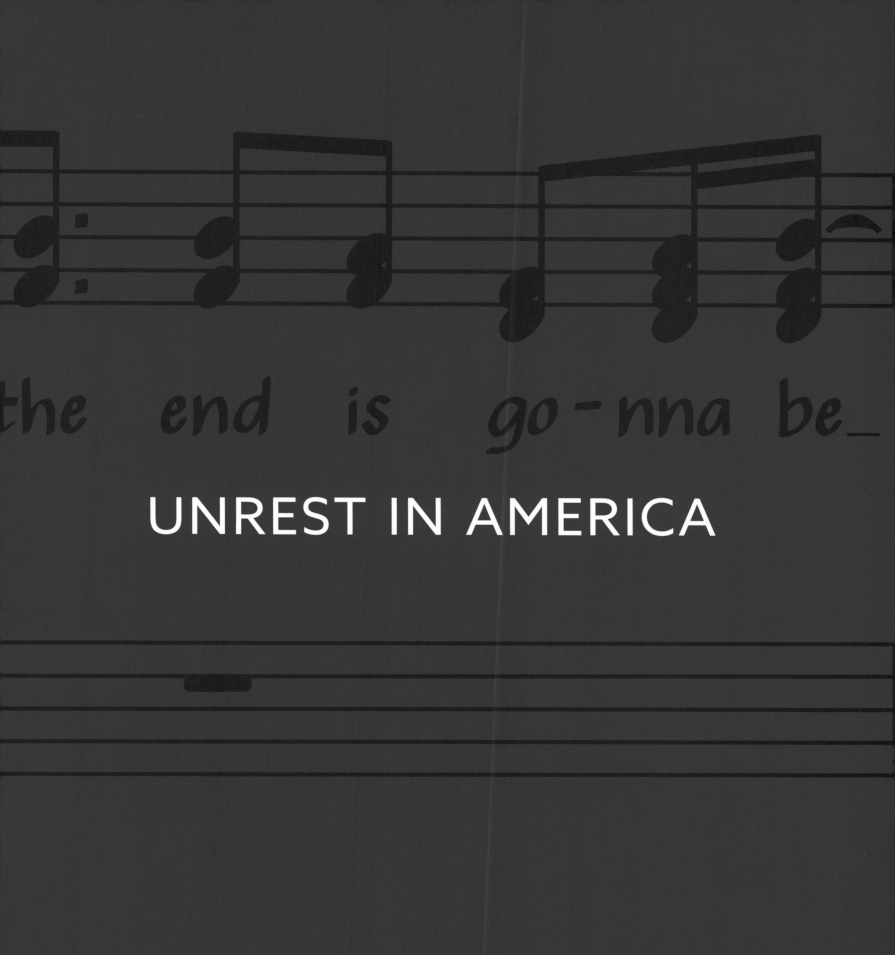

UNREST IN AMERICA

White Supremacy Is a Public Health Crisis (Minneapolis, Minnesota), 2020

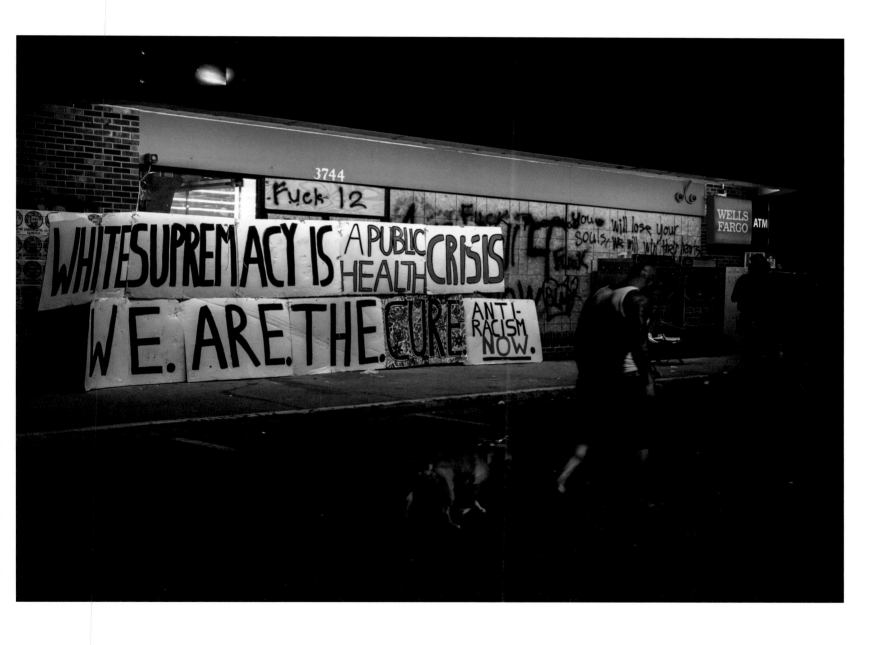

Breonna Taylor Park (Louisville, Kentucky), 2020

Protest at Jefferson Square Park (Louisville, Kentucky), 2020

Katrina Curry and Preonia Flakes (Louisville, Kentucky), 2020

Shadai Parr, Elysia Bowman, Erinicka Hunter, Shatanis Vaughn (Louisville, Kentucky), 2020

Breonna Taylor's Apartment (Louisville, Kentucky), 2020

Kenneth Walker (Louisville, Kentucky), 2020

A Sit-in at Kentucky Attorney General Daniel Cameron's Home #1 (Louisville, Kentucky), 2020

A Sit-in at Kentucky Attorney General Daniel Cameron's Home #2 (Louisville, Kentucky), 2020

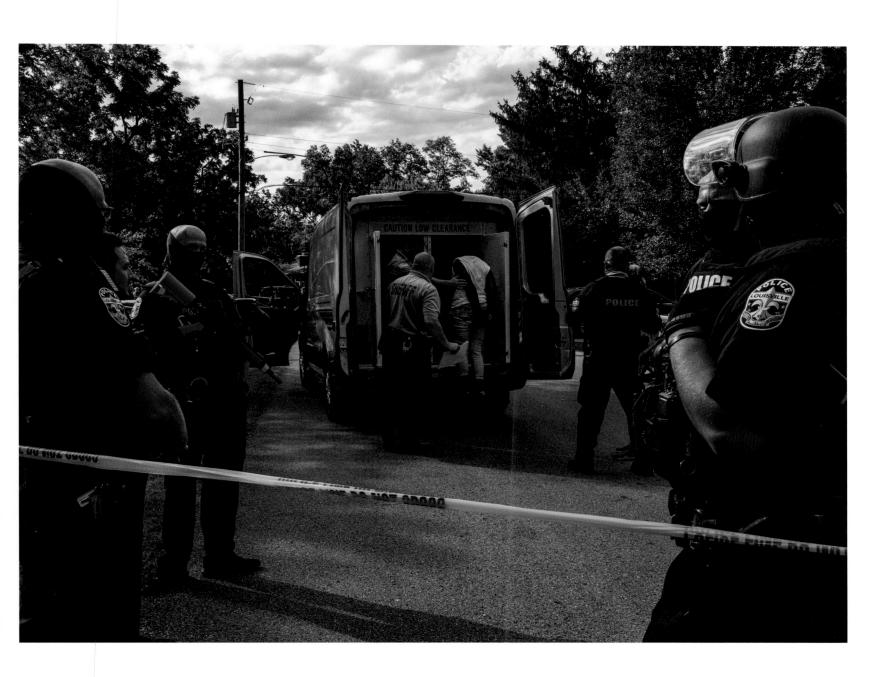

Surveillance, Misconceptions, and Accusations, 2020

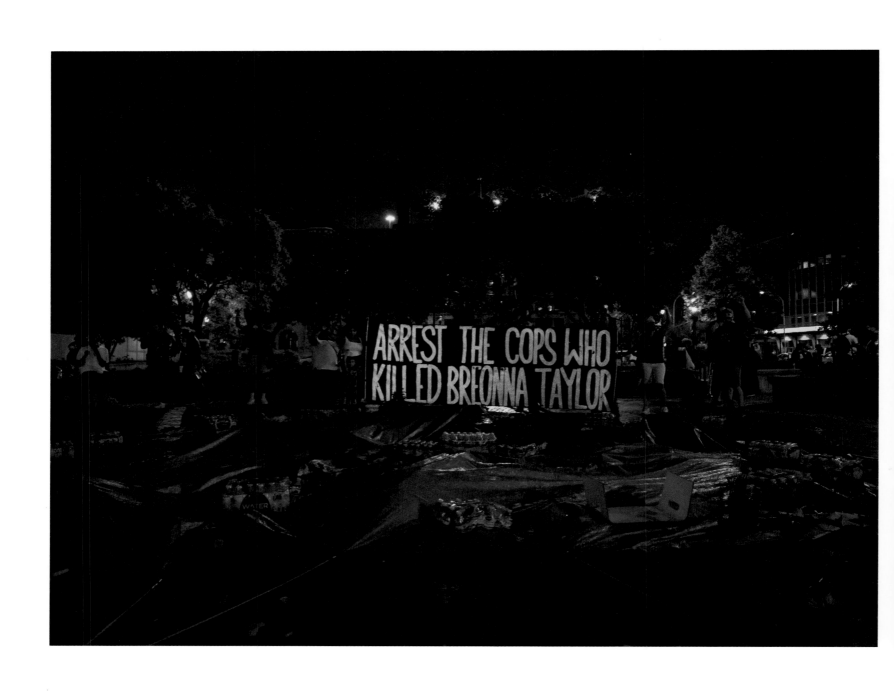

Arrest The Cops Who Killed Breonna Taylor (Louisville, Kentucky), 2020

Louisville in Protest, 2020

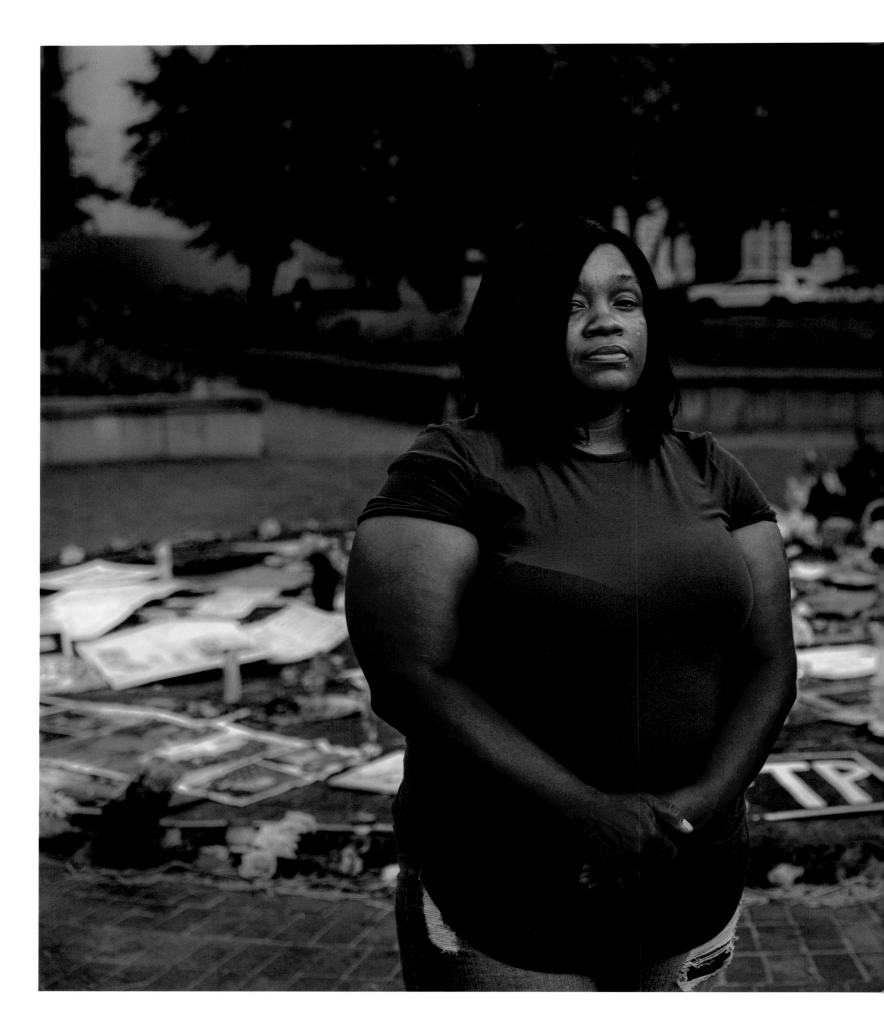

Tamika Palmer (Louisville, Kentucky), 2020

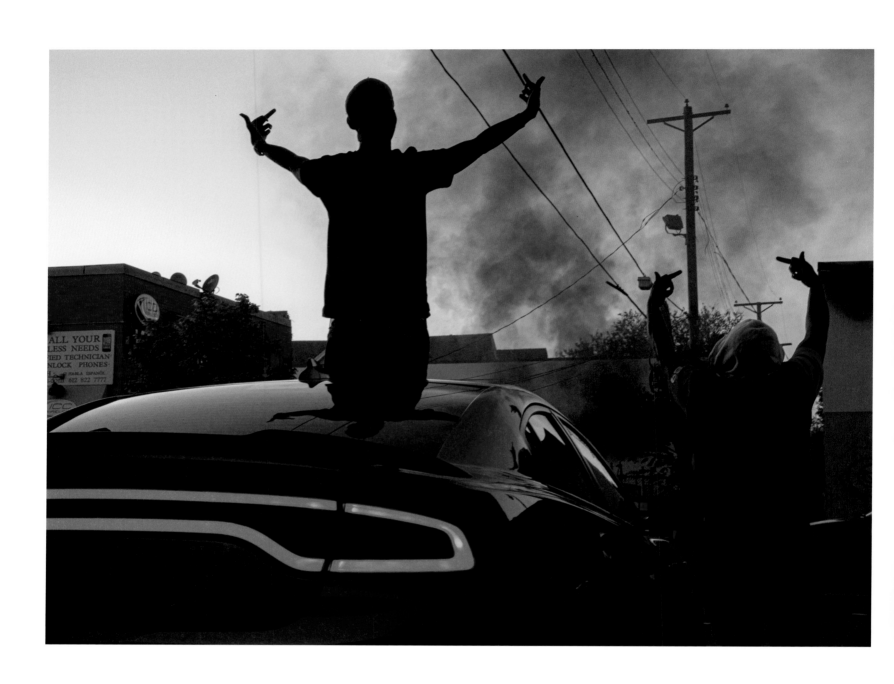

Righteous Anger (Minneapolis, Minnesota), 2020

R We Loud Enough? (Minneapolis, Minnesota), 2020

Target #2 (Minneapolis, Minnesota), 2020

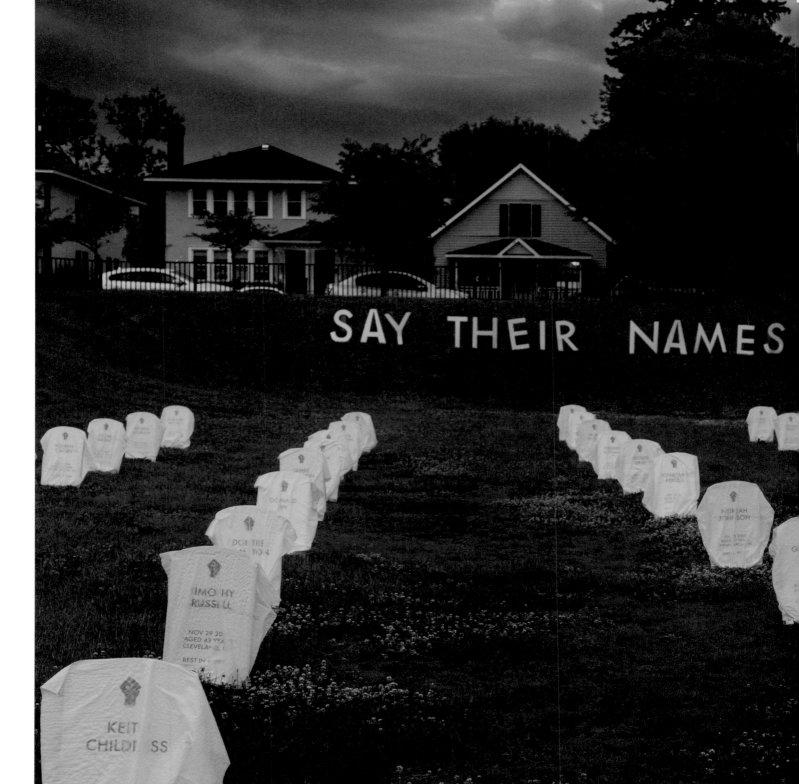

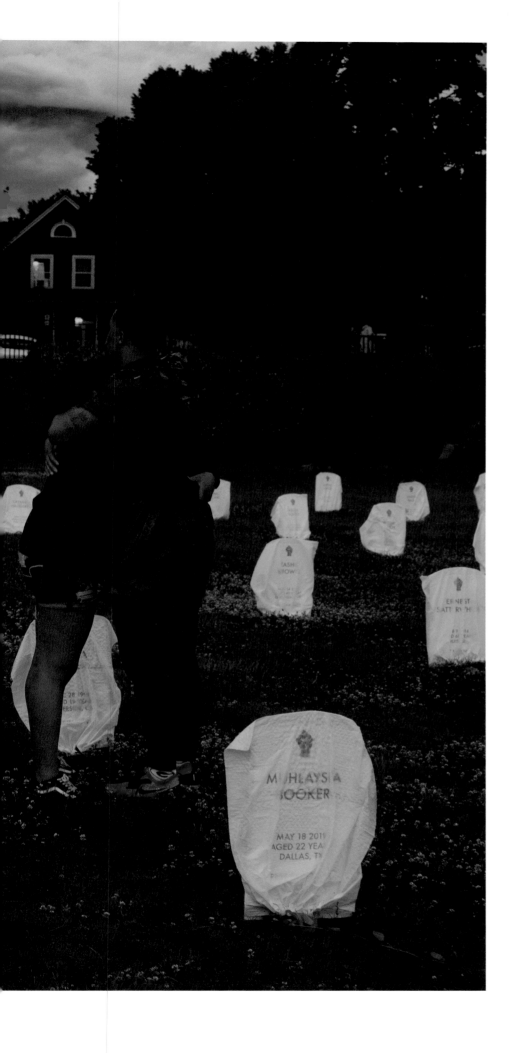

Say Their Names (Minneapolis, Minnesota), 2020

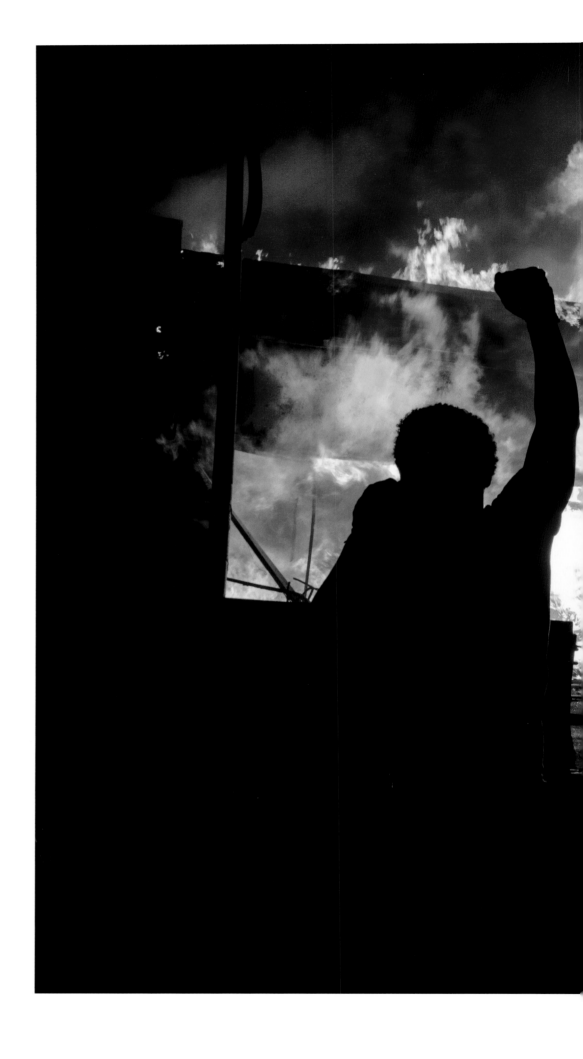

The Fires (Minneapolis, Minnesota), 2020

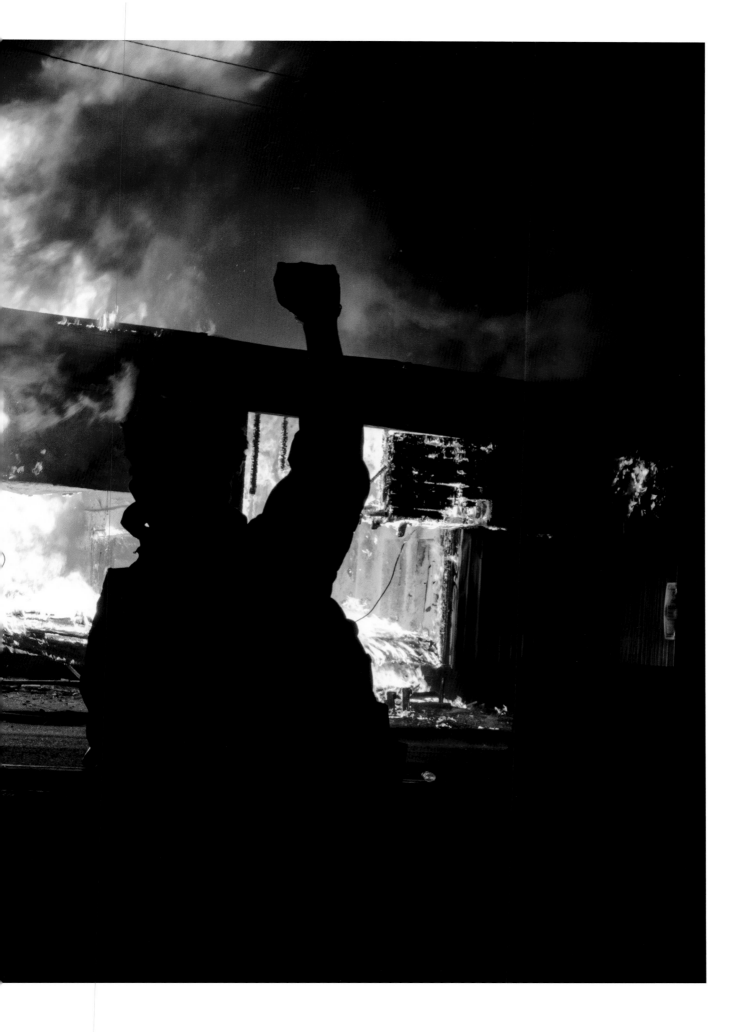

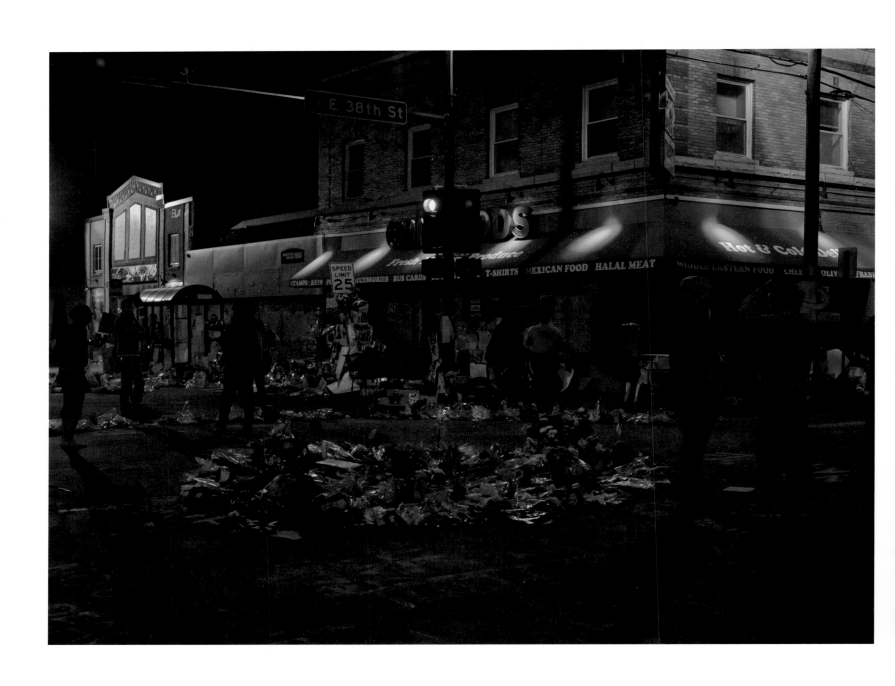

George Floyd Memorial Site #1, The Week George Floyd Was Murdered (Minneapolis, Minnesota), 2020

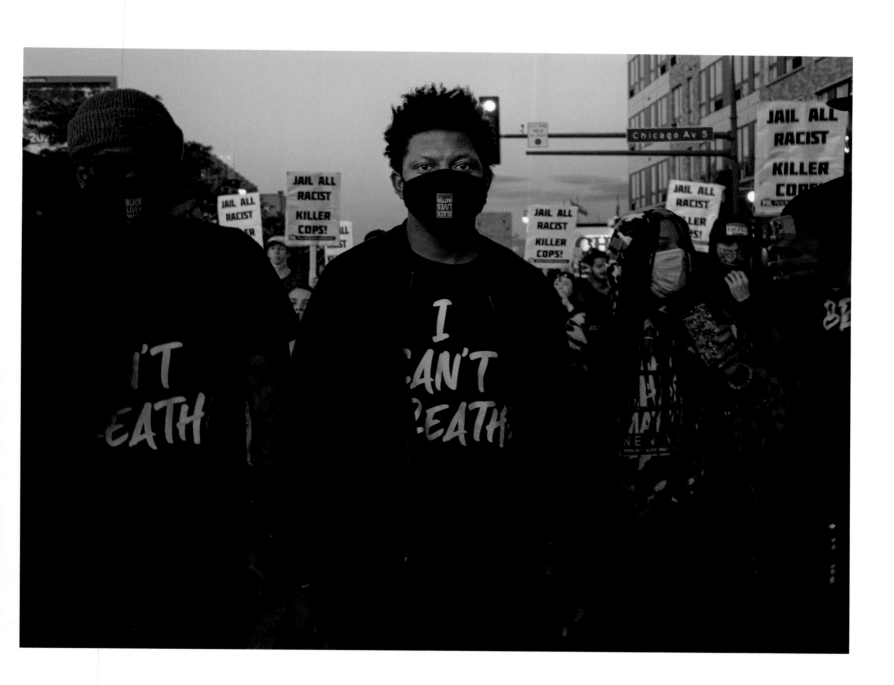

I Can't Breathe (Minneapolis, Minnesota), 2020

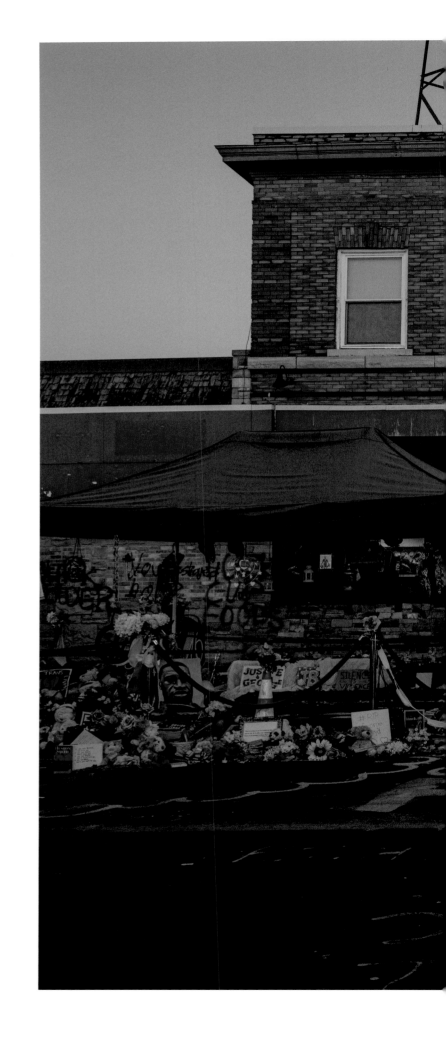

George Floyd Memorial Site #2, Election
2020, Cup Foods Re-Opens (Minneapolis,
Minnesota), 2020

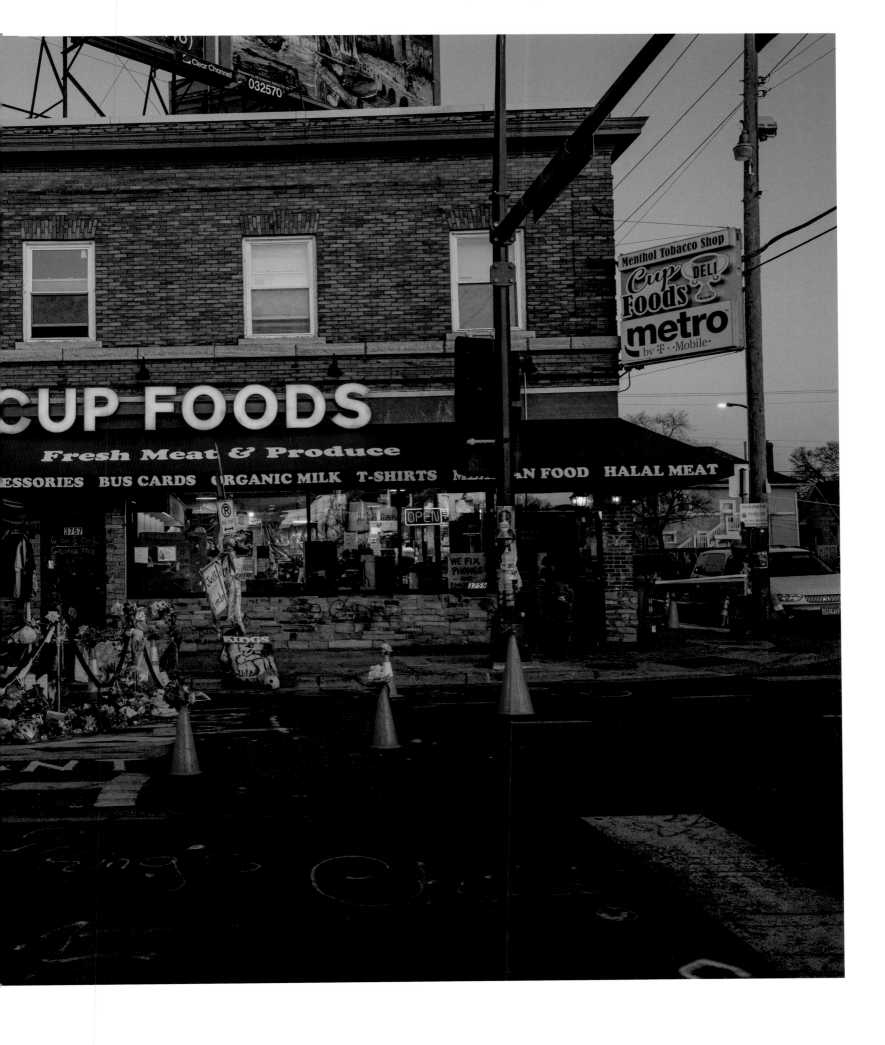

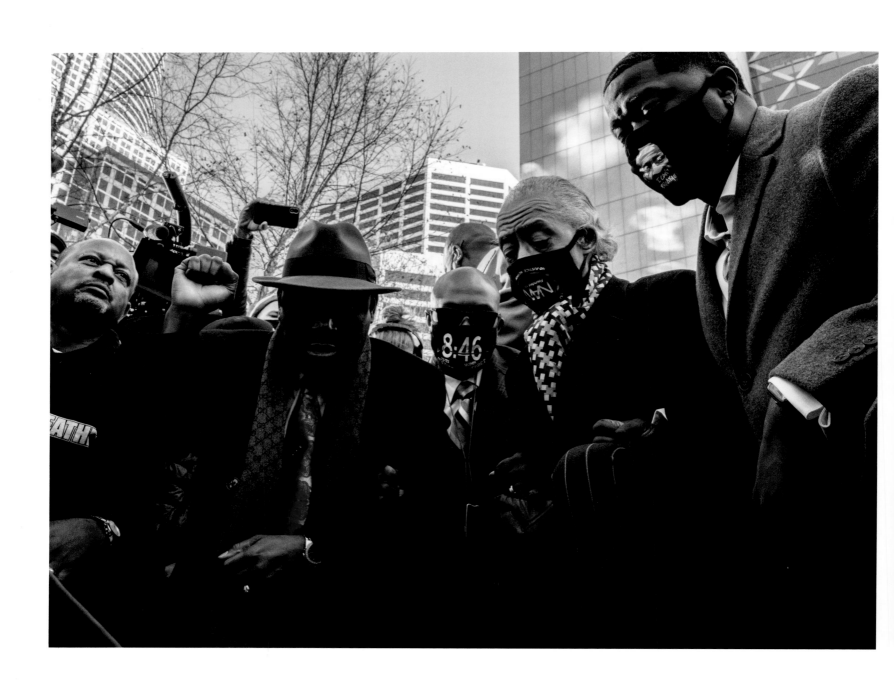

The First Day of the Derek Chauvin Trial (Minneapolis, Minnesota), 2021

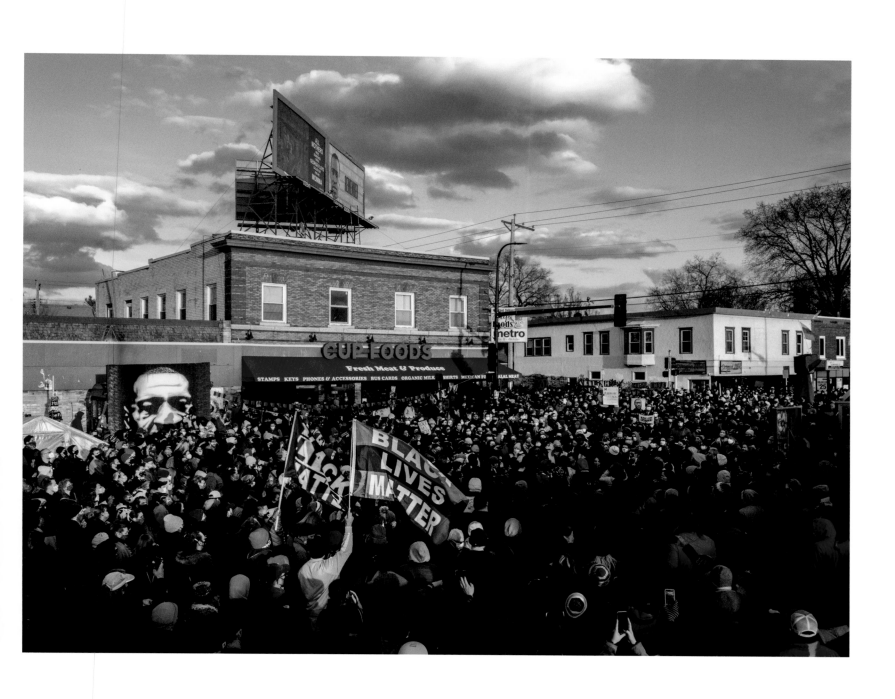

George Floyd Memorial Site #5, Derek Chauvin Found Guilty (Minneapolis, Minnesota), 2021

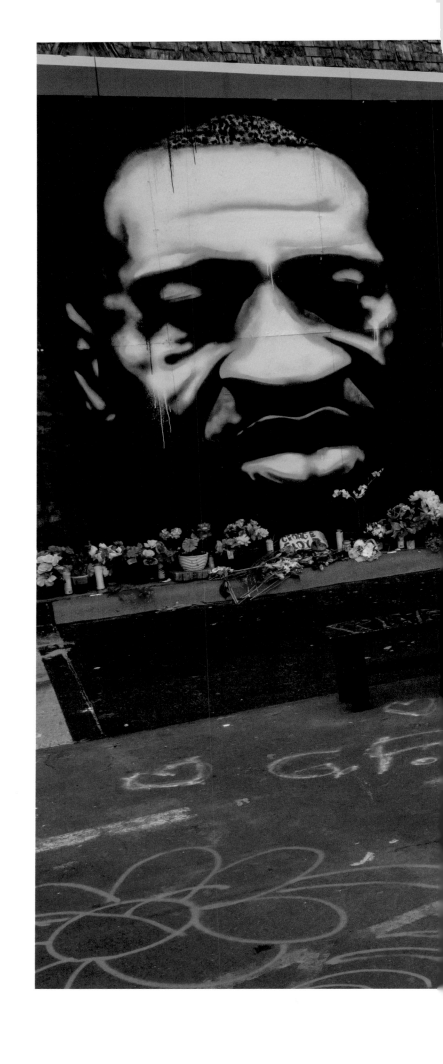

George Floyd Memorial Site #4, Justice for Daunte Wright
(Minneapolis, Minnesota), 2021

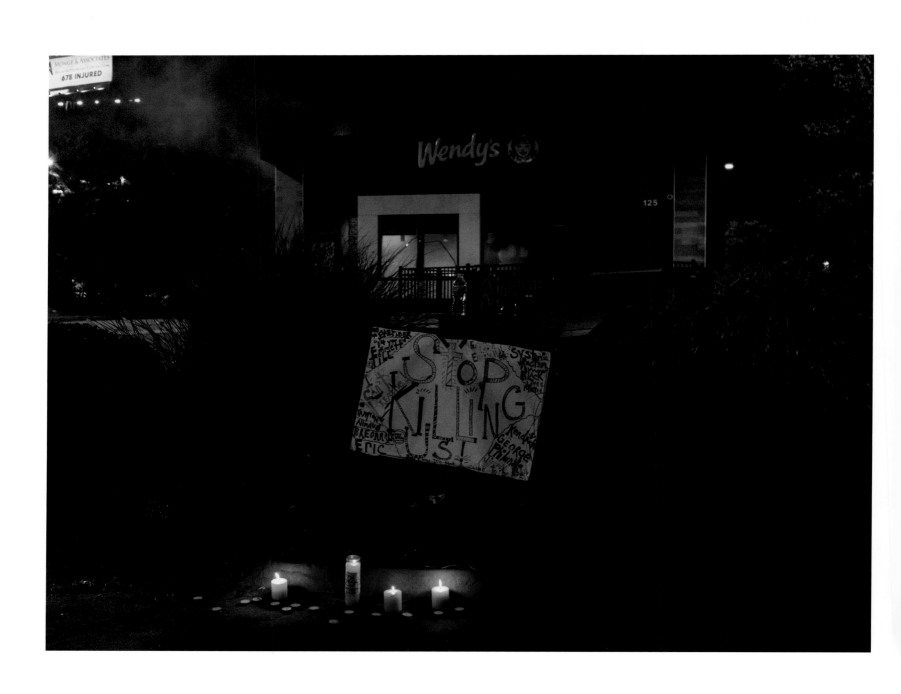

Rayshard Brooks Memorial Site (Atlanta, Georgia), 2020

Irony of Black Policeman (Atlanta, Georgia), 2020

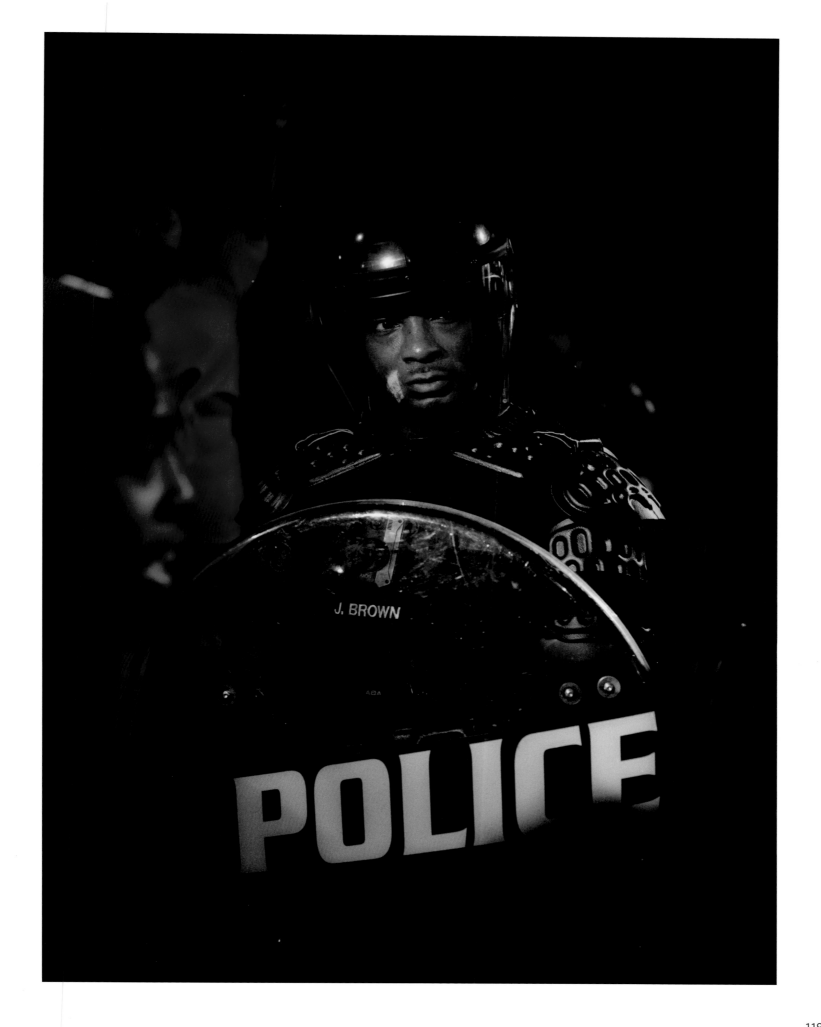

Die in (Say Her Name) (Atlanta, Georgia), 2020

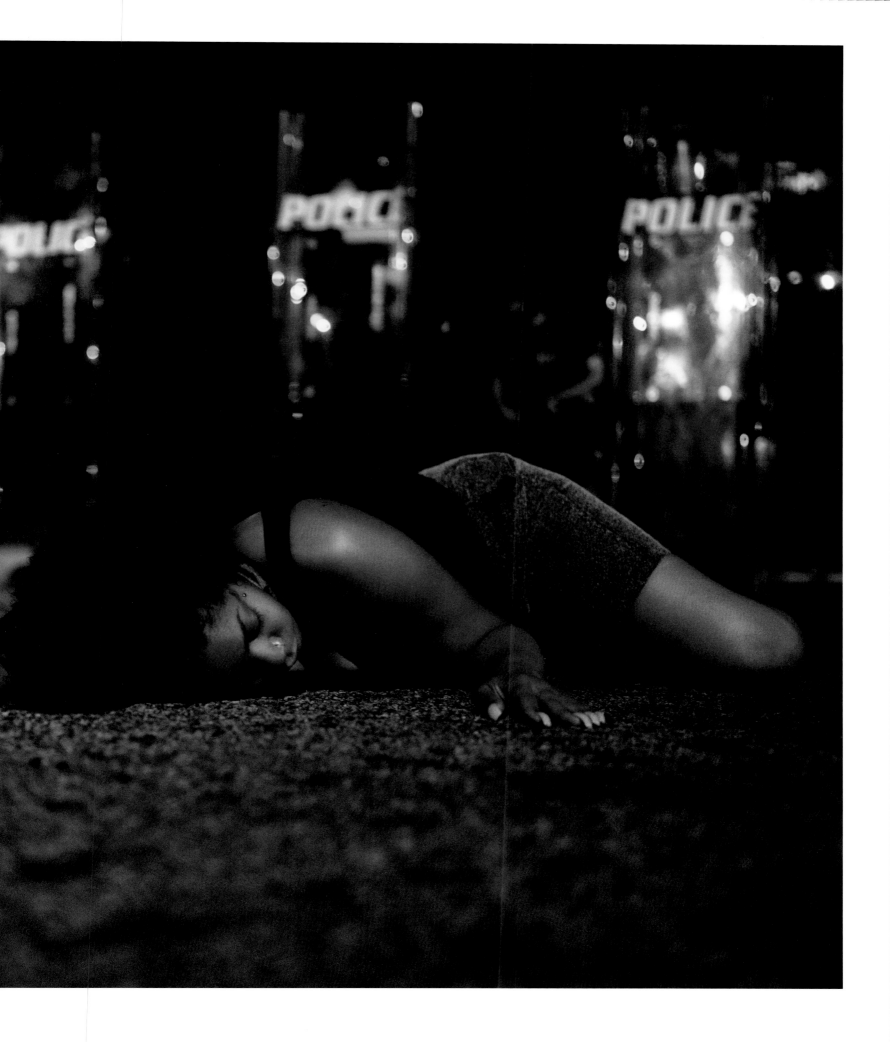

The Family of Rayshard Brooks (Atlanta, Georgia), 2020

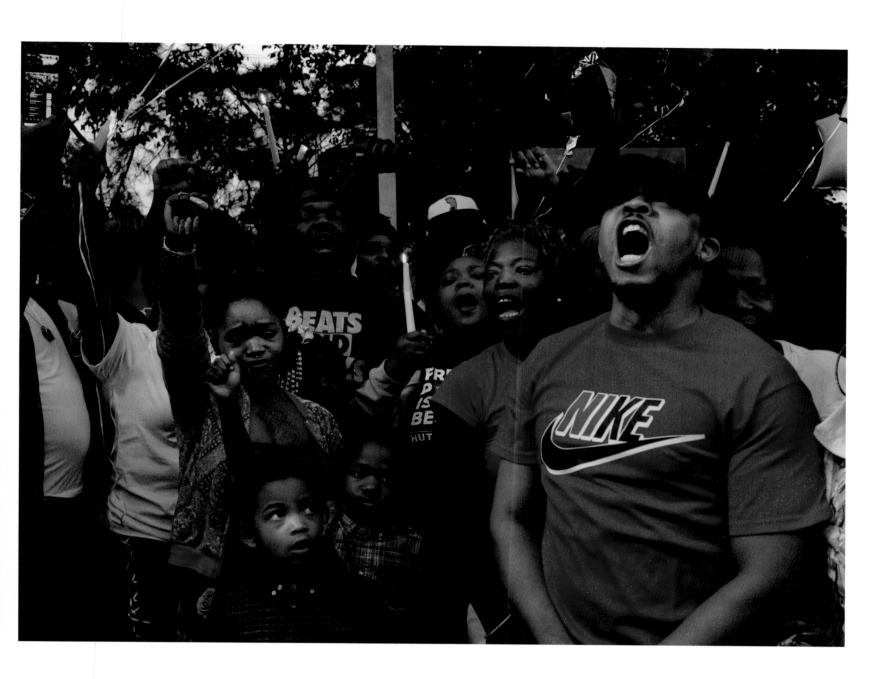

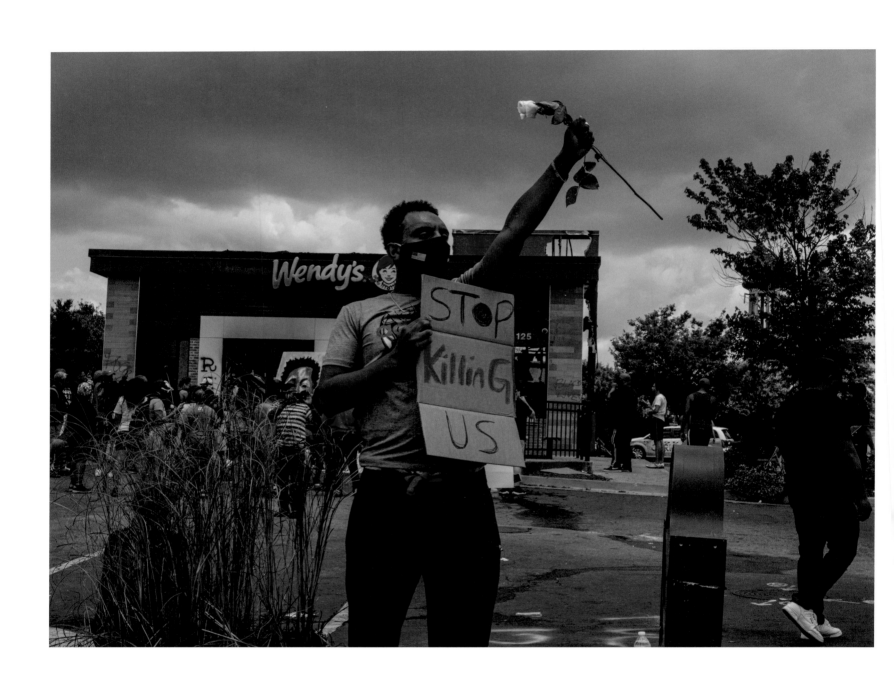

Stop Killing Us (Atlanta, Georgia), 2020

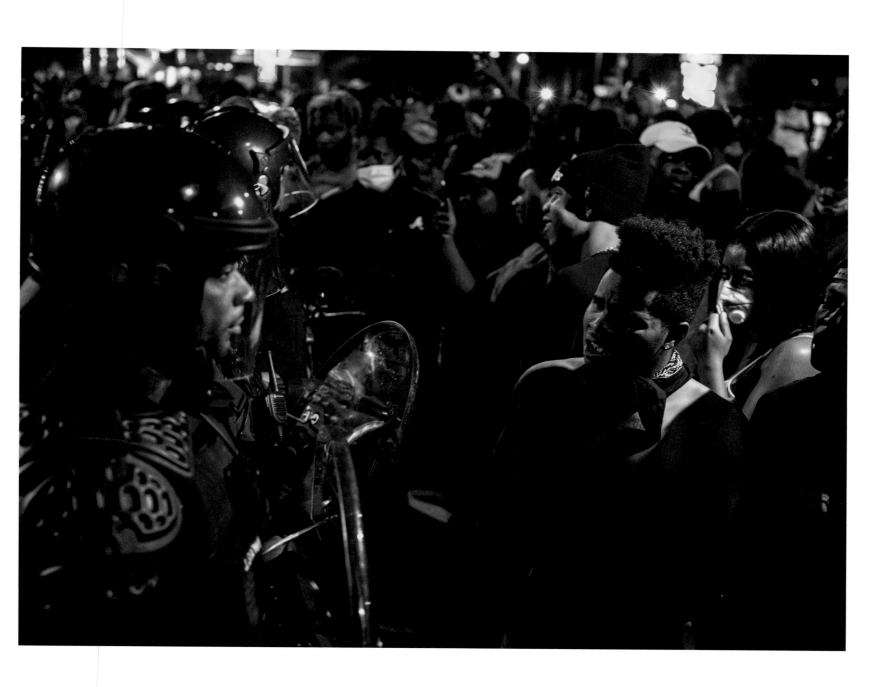

Confrontation (How Could You?) (Atlanta, Georgia), 2020

Tear Gas (Rochester, New York), 2020

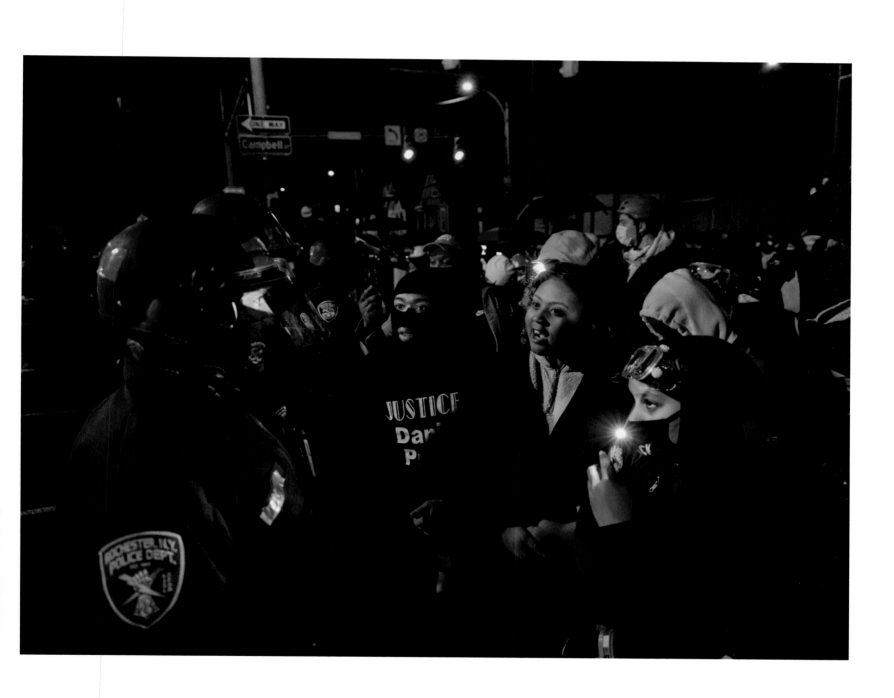

Rochester Police Not Charged (Rochester, New York), 2021

Rochester New York in Protest (Rochester, New York), 2020

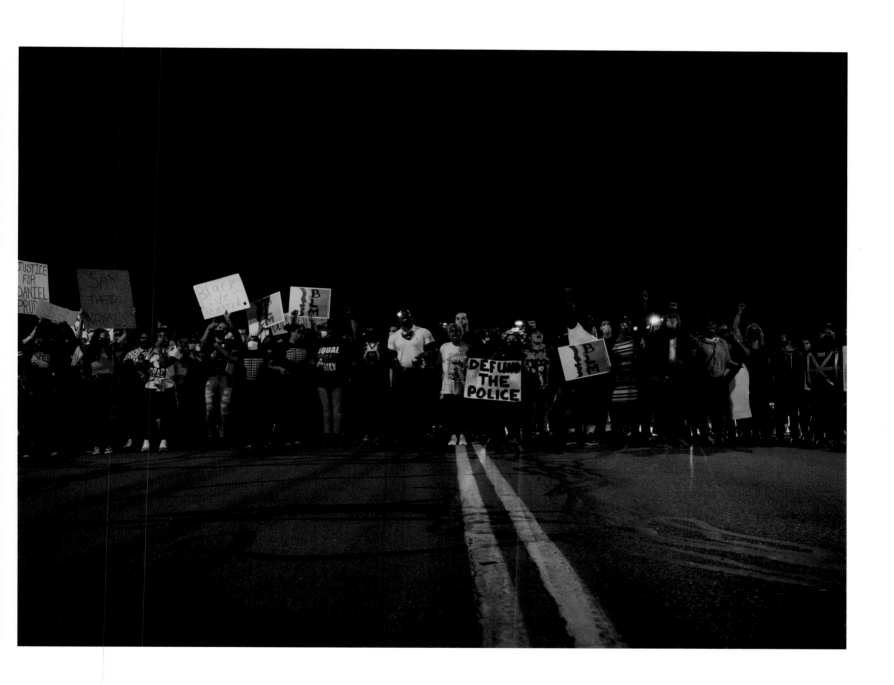

Daniel Prude Memorial Site (Rochester, New York), 2020

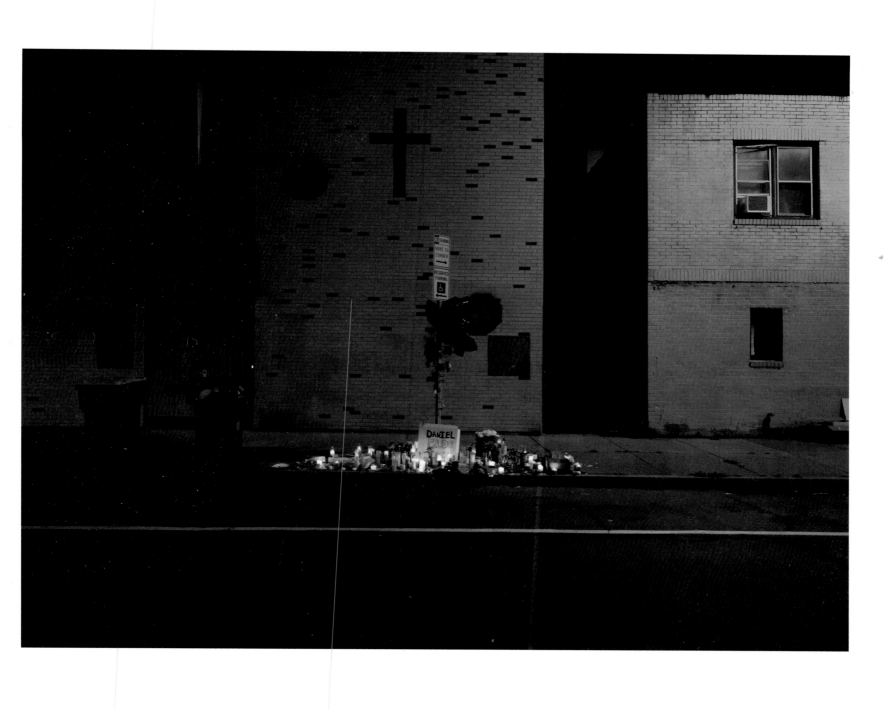

Black Power (Washington, D.C.), 2020

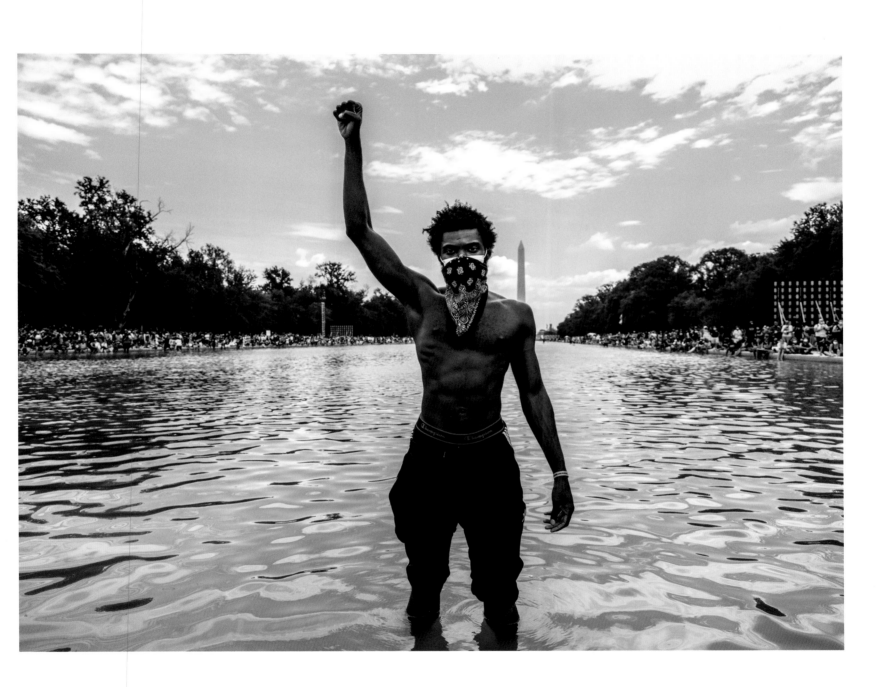

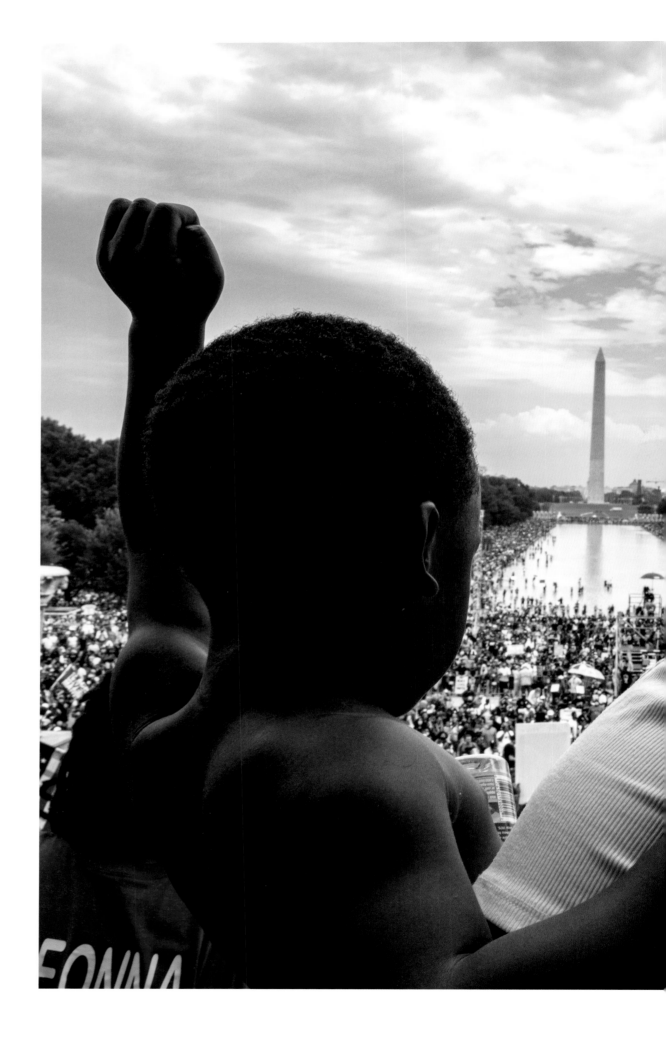

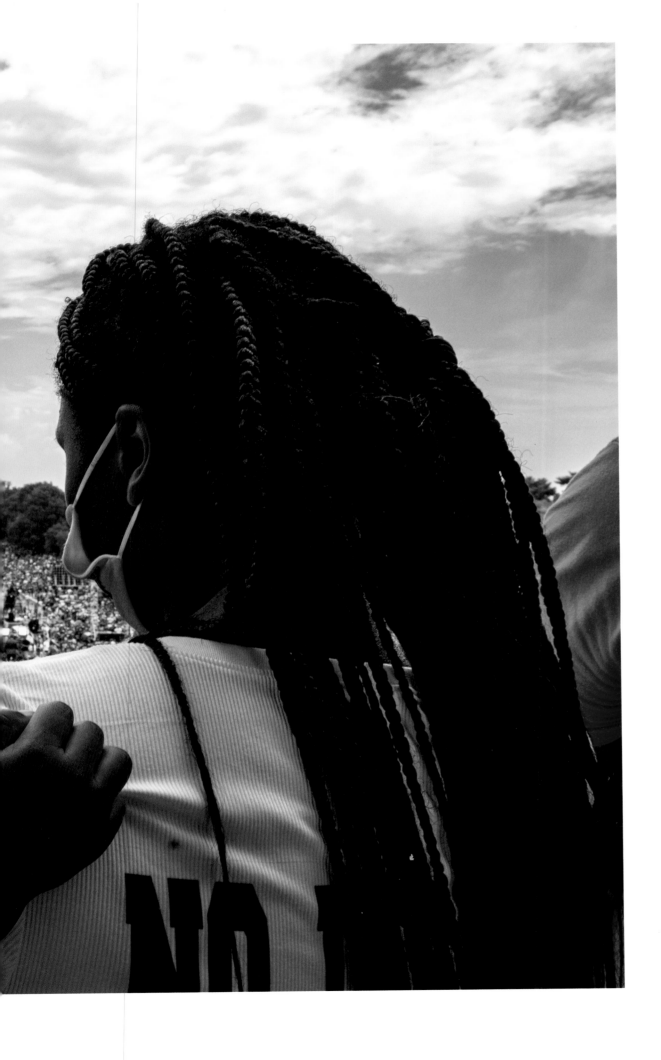

Alena Holds Her Son, Tamaj
(Washington, D.C.), 2020

A LYNCHING'S LONG SHADOW

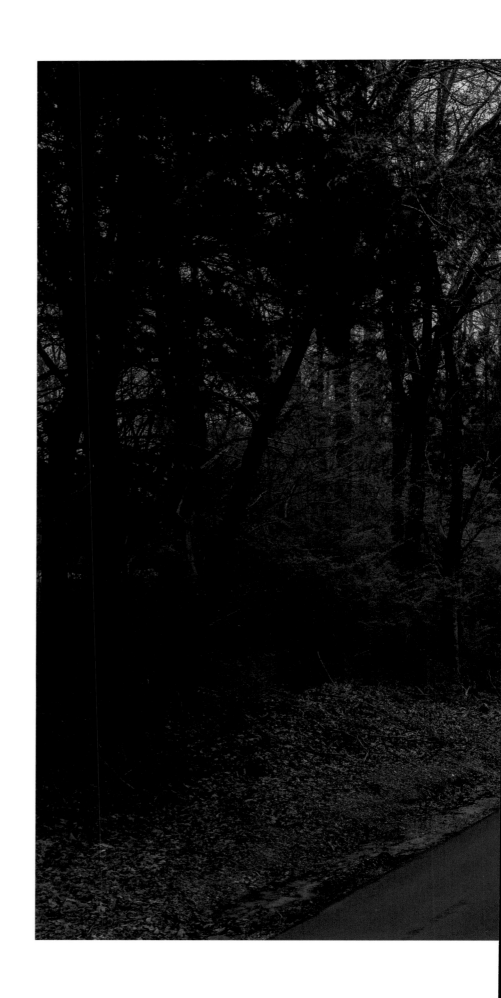

The Road to Oxford Mississippi, 2018

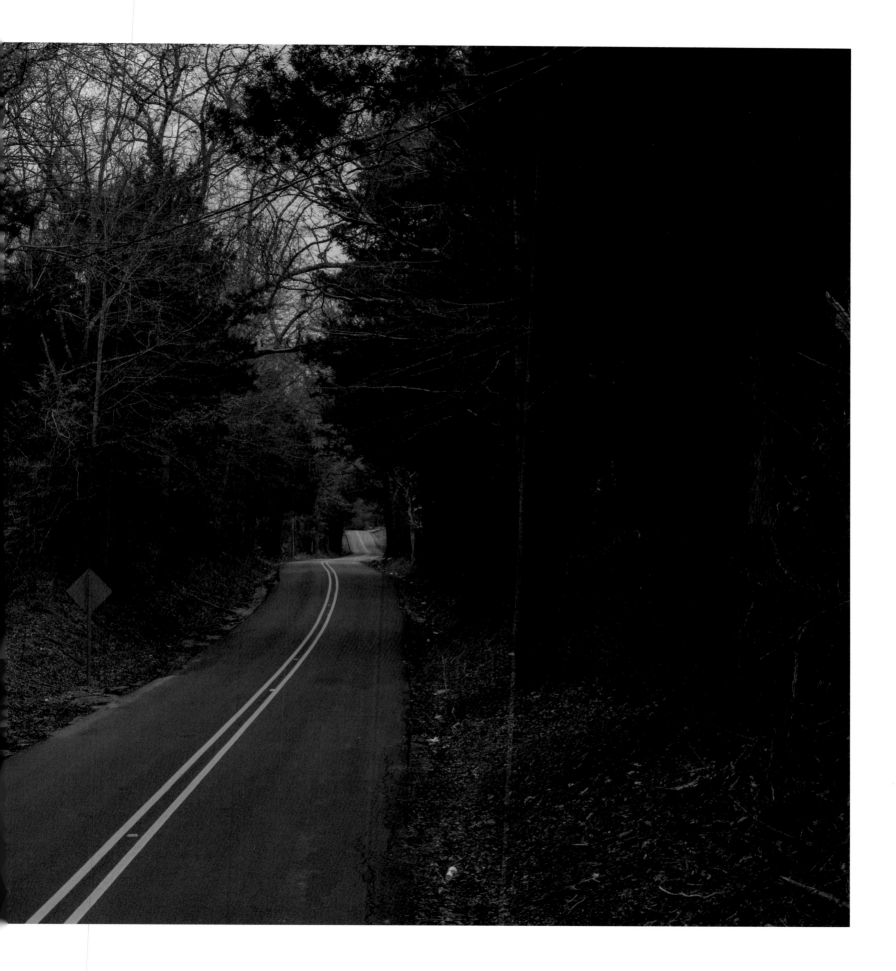

by refusing to enroll their children in the Hitler Youth, but the training offered under Dr. Rosenberg's supervision is now made compulsory.

Today's decree regulates the disorderly situation created by keeping part of the children in school six days a week and releasing part of them for Hitler Youth instruction Saturday.

MOB LYNCHES NEGRO.

Mississippi Prisoner Seized as Jury Debates Murder Case.

OXFORD, Miss., Sept. 18 (AP).— A mob lynched Ellwood Higginbotham, a 28-year-old Negro, near here last night while a jury was deliberating charges that he killed Glen Roberts, a white planter.

The screaming, terrified Negro was seized in the county jail by a crowd of between 100 and 150 persons and hanged to a tree two and a half miles from town.

The jury, which had been deliberating a verdict since late yesterday, was dismissed by Judge Taylor McElroy. It was not learned how the verdict stood, but the belief was expressed that the failure of the jury to return a quick verdict had prompted the lynching.

Members of the mob stormed the jail, overpowered Sheriff S. T. Lyles and three deputies and started smashing doors while the officers tried vainly to prevent seizure of the prisoner.

The body was left swinging from the tree. It was cut down later by the Sheriff and his aides.

Officers announced an investigation, but said none of the mob had been identified.

B. VAN BUREN ENDS LIFE.

Member of Old Jersey Family, 75, Was in Failing Health.

The body of Benjamin Van Buren, 75 years old, descendant of a family that has been in Jersey City for more than 100 years, was found yesterday afternoon in his apartment at 5 Bentley Avenue, Jersey



quired to
es. Cases
ional La-
view only

employ-
er it has
tional La-
ill result
d by the
Court of

THEFT.

ng $3,000
d Home.

old, of 23
ced at the
tion early
grand lar-
of taking
iture and
ry brown-
in June,

e firm of
e dealers
told the
o him as
rman had
241 East
e and July
s and the
en he re-
d.

rland fol-
Fifth Ave-
the Mc-
made the
olice said,
l hundred
found in
lso known
ng to de-
ge.
rprints at
said the
sted four
n larceny
been con-

IRNS.

th Beach
Morning.

TIMES.



Such Support Claim

Mr. Manson contended company had the whole support of Pacific Coast p a Shipping Board mem said this had not been p the board's satisfaction.

Documents attached to th included a memorandum that at least a quarter of t of the company was contro Chinese syndicate.

During the World War, v Shipping Board was disp vessels, Mr. Manson was critic of the board and a w Congressional investigation ing to pending bills, some o affected the Shipping Board

The defendants in his ac cluded John Barton Payne F. Carry of the Shipping Captain Rogers Welles of th Intelligence Bureau of the States Navy was made a de because of a report he ma cerning Mr. Manson's caree he sent to Mr. Carry, w Director of Operations of th ping Board.

Mr. Manson, who had that the government lost $ by the acts of officers of th ping Board, alleged that th actuated to injure him bec his charges.

On one occasion Mr. Man clared that the Shipping Bo been the "greatest failure Wilson administration."

HEARST ASKS TAX RE

He Also Asks Redetermina Two Federal Claims.

WASHINGTON, Sept. 18 William Randolph Hearst, paper publisher, petitione Board of Tax Appeals today redetermination of income ta ciency claims of $508,466 fo and $32,496 for 1930.

The petitioner claimed refu $99,239 for 1929 and $103,3 1930. His address was given Riverside Drive, New York.

The Bureau of Internal Re the petition said, made twel rors in computing the allege

Mob Lynches Negro, 2021

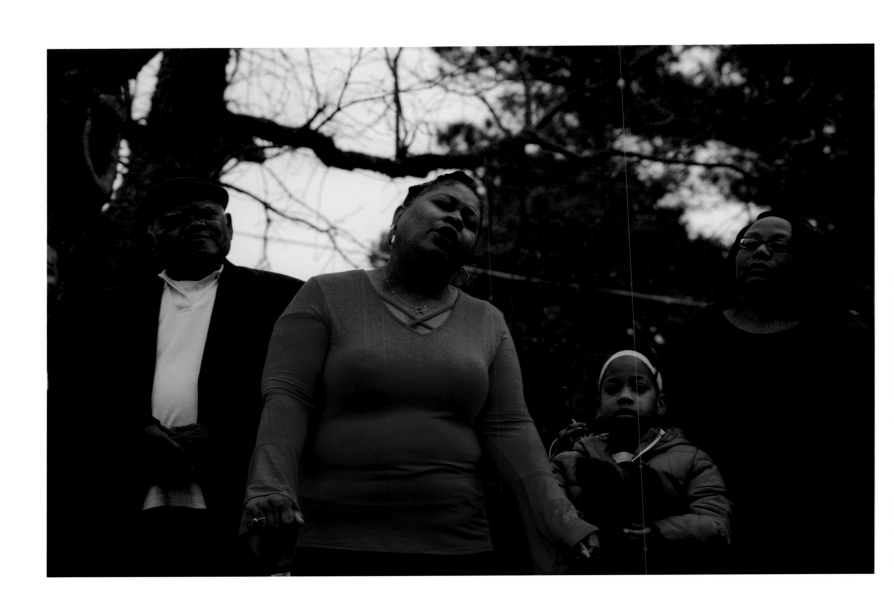

Descendants of Elwood Higginbotham, 2018

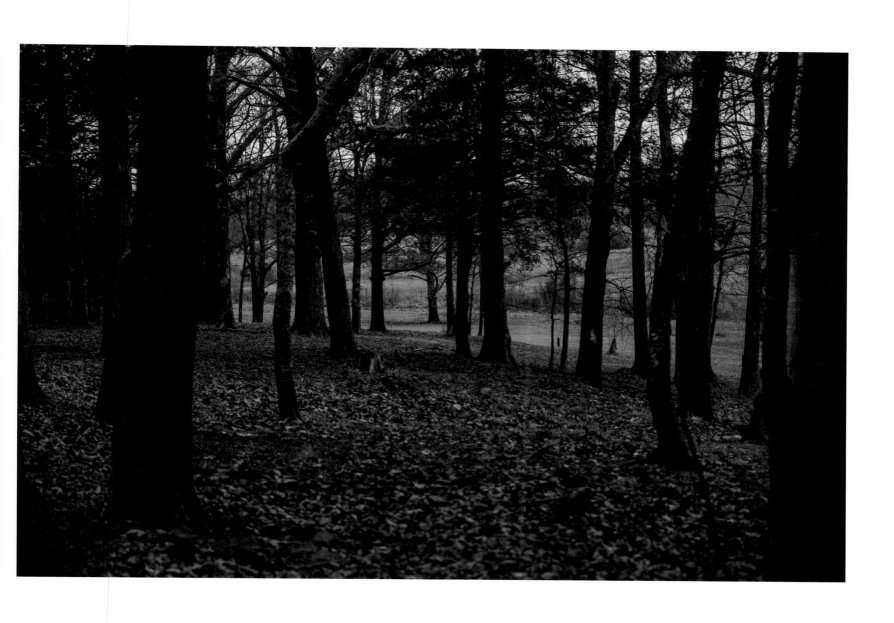

The Burial Site, 2018

And Blood at the Root, 2018

Blood on the Leaves, 2018

E. W. Higginbottom and Elwood Higginbotham, 2018

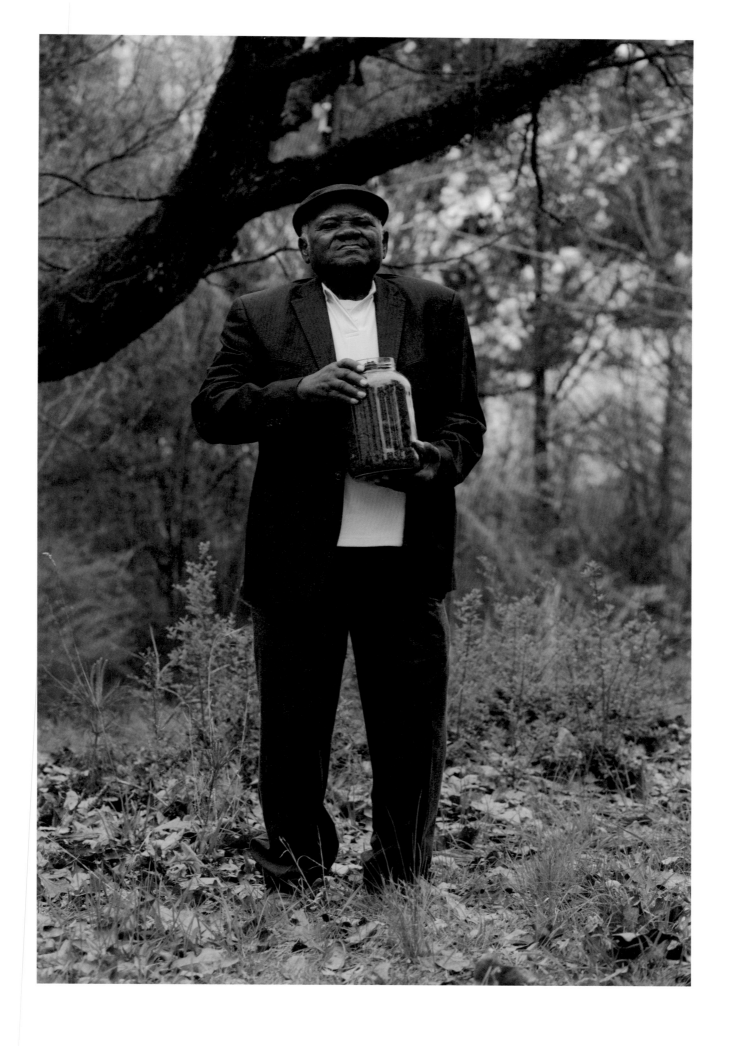

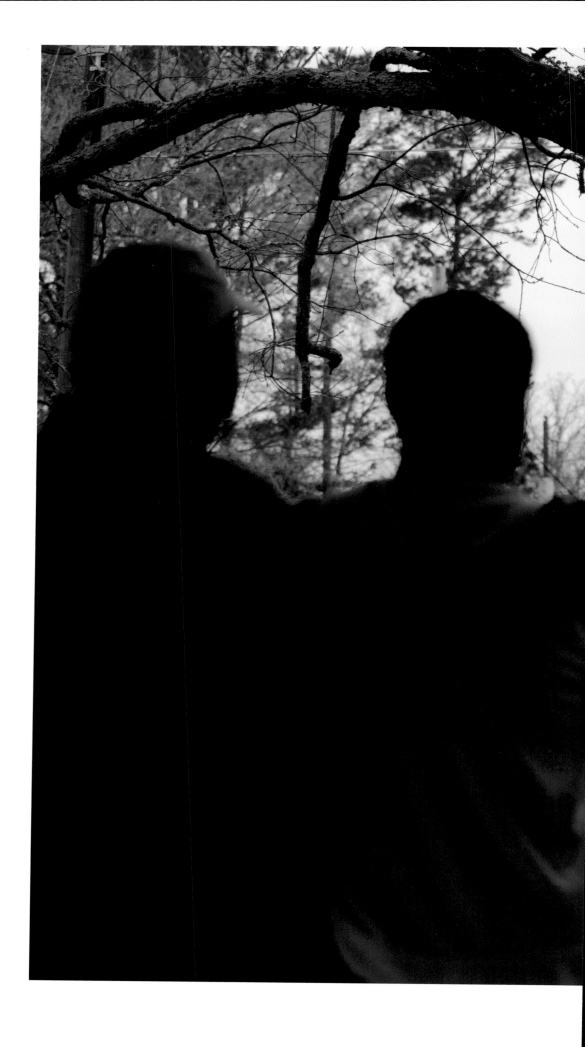

To Bear Witness, 2018

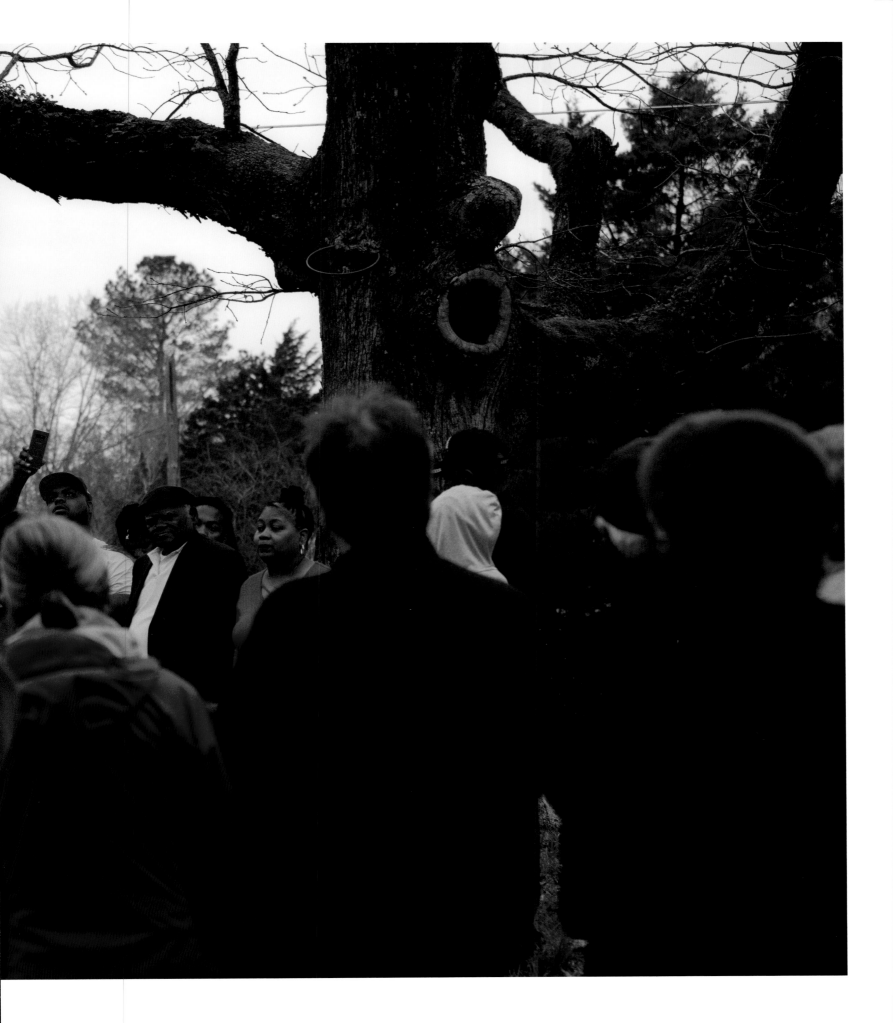

Southern Trees Bear a Strange Fruit, 2018

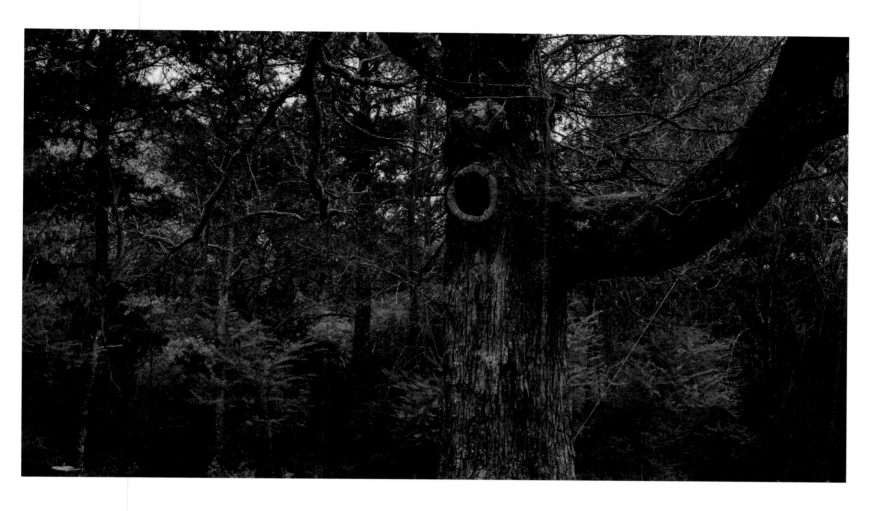

EVIDENCE

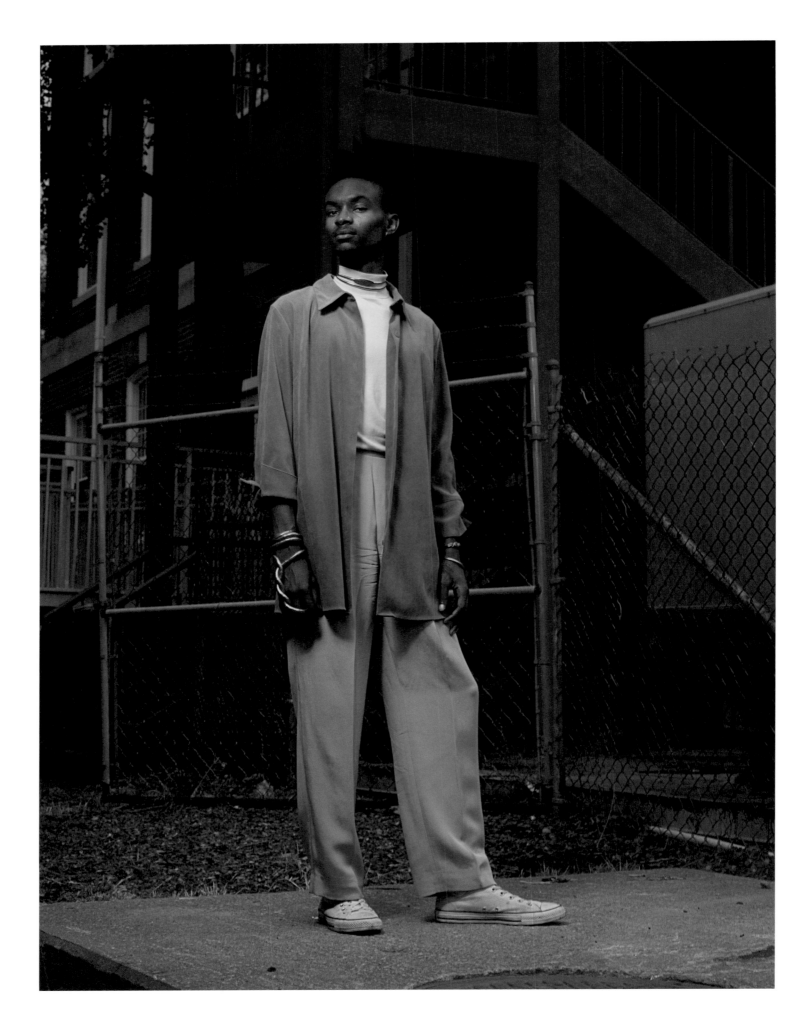

I'm a person.

~~My initial thought is why~~

Gender is this very interesting thing.
It's almost like a cage. When you
sit within its boundaries, perfectly and
do what is expected you have no problems.
But the minute that you dare to reach
outside of this cage or even question its
existence you slightly risk your life.
Whenever a cis-gendered male says this
statement I try to respond with "did anyone
ever ask you if you wanted to be a man?"
Most likely not. Many of our traditional
expectations are these imaginary social construction
that steal our individual autonomy to live
desire and present as we please.
So, to me, a Black person in Amerika I
see a forced "manhood" as an extension of
systemic & social oppression which denies
us our full freedom.

Avery Jackson, 2017

157

LaQuann Dawson, Jr., 2017

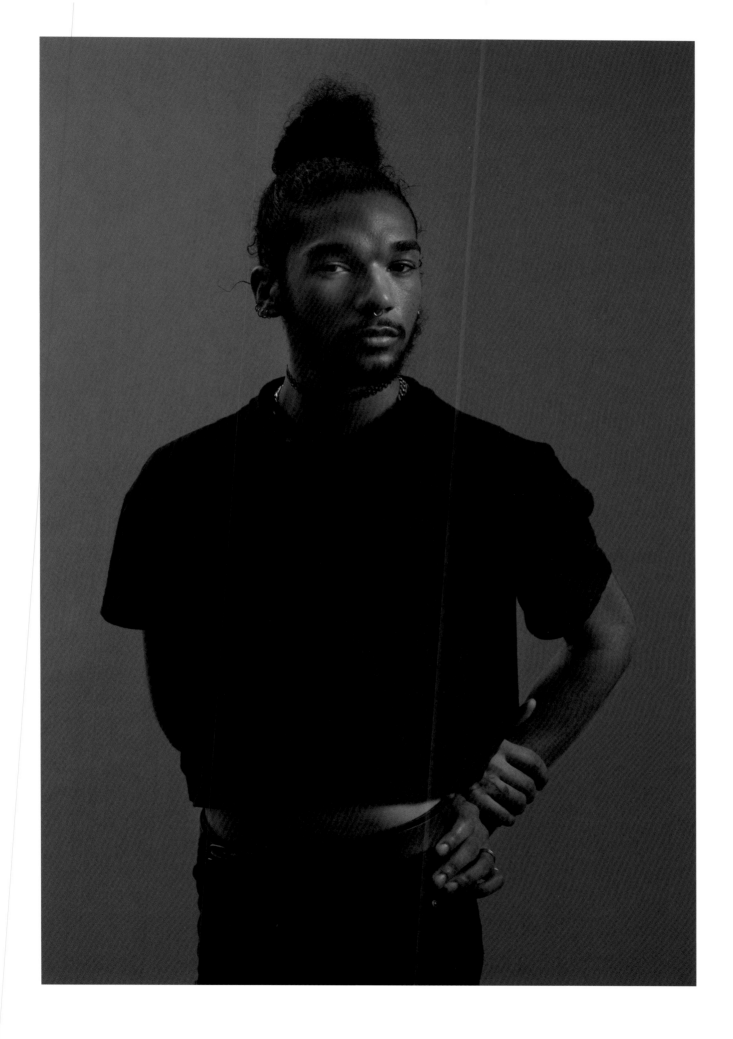

This statement feels like one that needs to be reclaimed by many of us in this country. For me specifically, being someone who has been told that I "was not" a man or "was supposed to be" a man, it genuinely feels like I need to take this statement and re-allow it to fit me and who I am today. Standing next to folks who are claimed to be more of a man than I am or than my best friend or boyfriend lover, I am still trying to understand just what the word man even means and where and when it becomes more fluid. This statement is actually a quote of mine directed toward my father during a visit back home. I purchased a rhinestone broach earlier in the day and after my daddy caught wind he came to me with insults. Without going into too much detail this encounter with me 'ol man forced me to think about what it means to be a man and why it is so important that I convince myself, my dad and anyone else that I am. "Men" by traditional standards are dangerous, oppressive creatures. "I am a man" is a statement that is worthy of living up to and I am still trying to understand why. The word "man" holds so much power and I think it always has. It is to be questioned why that is.

freedom / is holding hands with my
nigga all the way down
broadway / is holding hands
with my nigga in front of my
daddy at thanksgiving and not
wanting to run and hide / is
wearing a crop top to work
without stopping to buy som'in
more "appropriate" / is an
anxiety attack in bed and
long arms to catch me / is
falling in love / is the color
pink / is glitter and a fat ass
at afropunk / is undone hair /
is labor day off cause I.
ain't got no job / is a carton
of orange juice and frozen
donuts / is insecure on weekends
and project runway on thursdays
/ is fatass / 🏳️ on a
good day I can hold it /
kiss it / give it olive oil
massages / on wednesday I
can sit on the end write a
poem about it / freedom is.

LaQuann Dawson, Jr., 2017

Jermel Moody, 2017

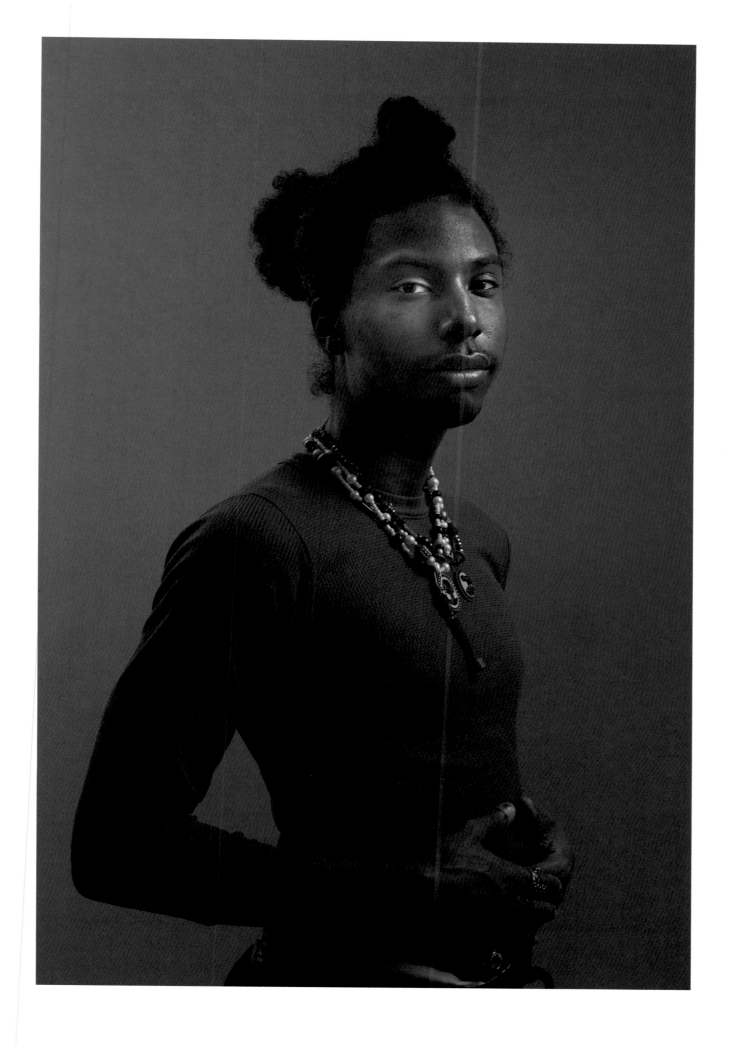

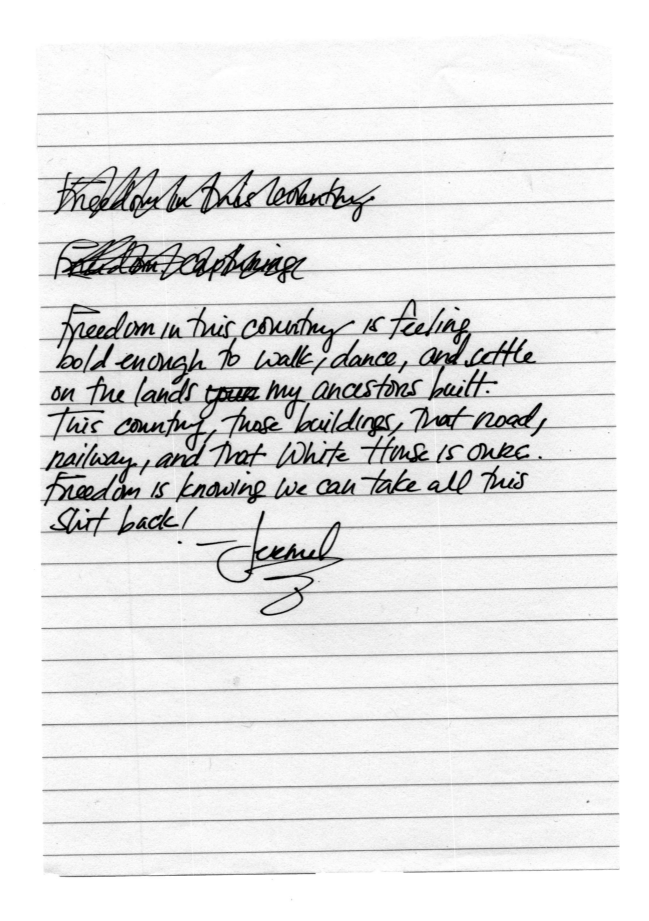

~~Freedom in this country~~

~~Freedom Captive~~

Freedom in this country is feeling
bold enough to walk, dance, and settle
on the lands ~~your~~ my ancestors built.
This country, those buildings, that road,
railway, and that White House is ours.
Freedom is knowing we can take all this
shit back!
— Jermel

Jermel Moody, 2017

164

I am a Man.

I've seen this phrase. I've heard this phrase. I do not feel this phrase, but I understand the history behind it, the meaning of its pain, the trauma, the need to self identify as a human. A human being, a living and breathing, human being. Not 3/5 of one, not the animalistic version, not the but a full being worthy of life. I don't feel this phrase on the basis of its gender conformist needs. What exactly is a man? Who are we proving ourselves to? I feel like this phrase doesn't include All black men; trans men femme boys, etc. Does the black boy with flowers on his tongue, count? Does the black boy with the golden finger nails, count? Does the black boy with Beyoncé in his walk, count? Who's left out. Black men want to be and feel "normal" but cis-hetero black men normally erase & ignore the intersections that come with being a black man. I feel like we are at a place now where we can simply say: "I AM." I am (period) I simply "Am." "I am a Man" in 2017 is a tad dated, our sense of self has changed, our genders (or lack thereof) have been more visible and allowed more space. This phrase could feel limited. Could feel triggering, exclusive. But "I Am." (period.)

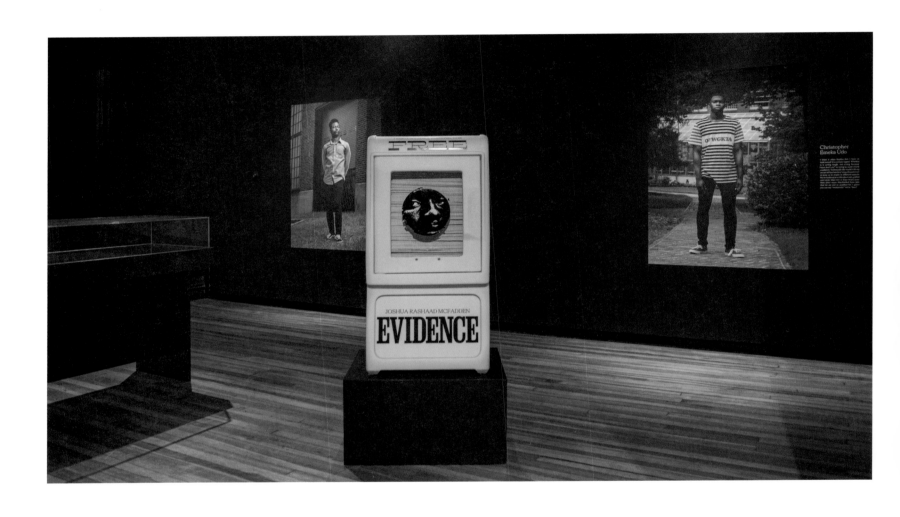

I Wish I Knew How It Would Feel To Be Free, 2020. *Evidence* publication presented in newspaper box for distribution.

Cover and interior pages, *Evidence*

Ernest Lee

VIII Morehouse College, 2017

When I think of the statement "I am a Man" I don't really consider myself as being apart of that, as people would expect me to say by identifying myself a "gay man" in a stereotypical world. But as an individual I feel like the statement doesn't apply to anyone specific. The statement "I am a man" refers to anyone, not a specific race neither a specific group. Sometimes women can follow under this statement. "I am a man" all comes from your actions and/or choices and decisions make in certain situations. Now pertaining to black men is the same as any other race, your amount of success and being comfortable in your skin can outshine any statement.

Javon Q. Minter

IX Brooklyn, NY, 2017

This is always a rough statement for me to make. It takes a lot of energy to say it, believe it and mean it. When I think of what it means to be a man, I think of all the times I was bullied, harassed, assaulted and abused because I didn't embody this concept that the world is constantly imposing on me. I'm not rough, I don't play sports and hanging around men alone usually gives me anxiety. I resent the concept of being a man. I don't hate men or being a man, but the fabric we've accepted or at least refused to deconstruct. For me, as a black man, I find escape from the concept of what it is to be a man. Blackness is so beautifully complex that I have found, through my blackness, for myself the man I am comfortable being. The black man I am comfortable being isn't antagonistic, proud, offensive, diminsive or small-minded – all of which I think is a poison that runs through the veins of this country. Who I have decided to be as a black man is in opposition to the toxic male concept peddled and defined in this country. I require myself to be patient, kind, not self-seeking or proud. I strive to listen and do the best I can. In a country that claims to be a nation [...] happen that is in direct opposition to the nation [...] not to be held to the toxic American [...]

FREE
Volume 1, 2020

JOSHUA RASHAAD MCFADDEN

EVIDENCE

COME TO SELFHOOD

I was raised in a Southern black home and was always taught to be proud of my blackness and accept who I am

They are fathers, brothers, friends hardworkers that push trough any difficult situation

Being a protector + provider knowing when to show strength and when to show the softer side

I would say the qualities + characteristics that I Identify as a black male in America would be my Intelligence my passion for the people I love and care for and my strength to persevere through hard times

Raheem Pounds, left, and his great-great grandfather, David Barr, 2016

Wow. It'd probably be a combination of people & traits I find impressive. My dad's super diligent, loving & one of the most intellegent people I know. My uncle Pete's always involved in his community as a leader. And my granddad Albert loved life & lived it to the fullest. He had this uncanny sharp memory, able to pick up a conversation at the exact point you left it. It's surprising when he had 7 kids & loads of grandchildren that he could give them all individual attention. I do have to thank my family for giving me a clearer picture of being a man.

I identify as a black male. I don't see being black as a negative thing. For me, I get to be a part of a rich legacy of struggle & triumph. I'm a part of one of the most creative groups of people on the planet & a real leader of change. I'm good with that. I'm not going to let others color the way I view myself, my family & my history.

We're extrordinary individuals regardless (and despite of) opression. Granted, if we wern't dealing with oppression we could accomplish a lot more in a shorter amount of time. We're not a morolithic group, but I find more of us tend to lead in our respective fields (arts, science, psychology, etc) with great results.

Jamel Jones, left, and his father,
James Jones, 2015

173

MOORE LARRY R
382 88 1492
95 06 15
CPL 71L10

I was told by my father at a young age that I was a black man, and my life would be harder because of it. I didn't understand that, I'm brown. Later I understood that our world operates in symbols and labels. Just as I am not litterally black, white people are not white. Black is the label on our ethnic and cultural background, and I am glad to be in it.

Role models played a very important role in my development. However, the majority of my role models growing up were women. My father's actions led me to an understanding of the "provider". Whoever I have brought into my life, or whoever is special in my life should be taken care of.

On the other side my mother showed me how I wanted to treat people. With compassion, love, understanding, grace, forgiveness etc. I didn't see enough of those traits in the men around me, and that bothered me deeply.

Lamarr Moore, left, and his father,
Larry Moore, 2016

Come to Selfhood (Italy: Ceiba Editions, 2016)

Christian Cody, left, and his father, Ywahnos Cody, 2016

Jonathan Marshall, left, and his father, John Marshall, 2016

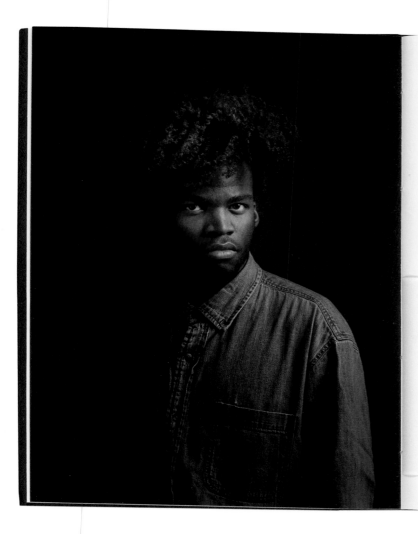

Andre 3000 came to mind first, so I'll use him as an example. I admire how he exists within the hip-hop world without selling himself to be the stereotypical rap icon. He has a strong sense of self-expression un-diluted by his surroundings. I like when men aren't afraid to show themselves.

To me black masculinity is a liquid, loose and easily manipulated. It can take many forms. I'd say what do my own so identify as a black male would be characterized by intelligent, hard-working, and loving. That is who I am and what I have experienced.

Christian Cody

9

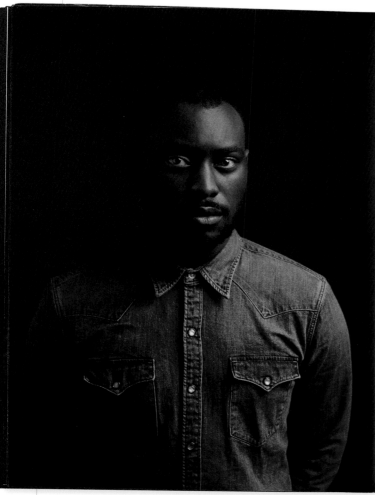

Human. Plain and Simple. We cry, laugh, fight, create, love, sympathize, dream, just like the rest of the human race.

My grandad is that figure of masculinity comes to me. I watched him work day to day, provide for our household and coach my uncles and cousins into adulthood. He was reserved, funny and confident in his masculinity.

Positive self talk, as well as setting goals have always helped me to ignore the bullshit America has to offer black men. Finding my place outside of having to rely on the dominate culture and relying on myself cements my positive identity.

Father

63

I have been afraid to express my true identity in the past because as a[ty] black man I could potentially be [threatened]/beat up, or killed. I've had friends who've been jumped & harassed because of their true identity. Not to say I'm ashamed of who I am but I have to protect myself. Being black is one thing, but being black & Queer poses a different topic of discussion. This has shaped me into not hiding who I am, & understanding that representation is important b/c you never know who you're helping by being you. No one should live timid & afraid because things they have no control over, such as skin color & sexual orientation. It's also shaped me to be fearless & fight for love vocally amongst the black community. Not talking about something doesn't erase its existance.

Jeremiah Thompson, left, and his father, Joseph Thompson, Sr., 2016

- only speak ebonics (slang)
- all grew up in poverty
- all have baby mothers
- all have violent criminal backgrounds

I watch people's first assumption of me dissappear the second I speak. Perceptions make people look at me like I'm dumb or illiterate. So many people are surprised to hear how intellectual I am after taking the time to get to know me.

My father is the ideal figure for black male masculinity. He works his ass off just to provide for his family. He's ~~married~~ been married for almost 25 years, had 3 kids, and never cheated on my mother. He's the most passionate person I know.

Kamall Browne, left, and his father,
Venzil Rawle Browne, 2016

181

SELFHOOD

K. B., 2016

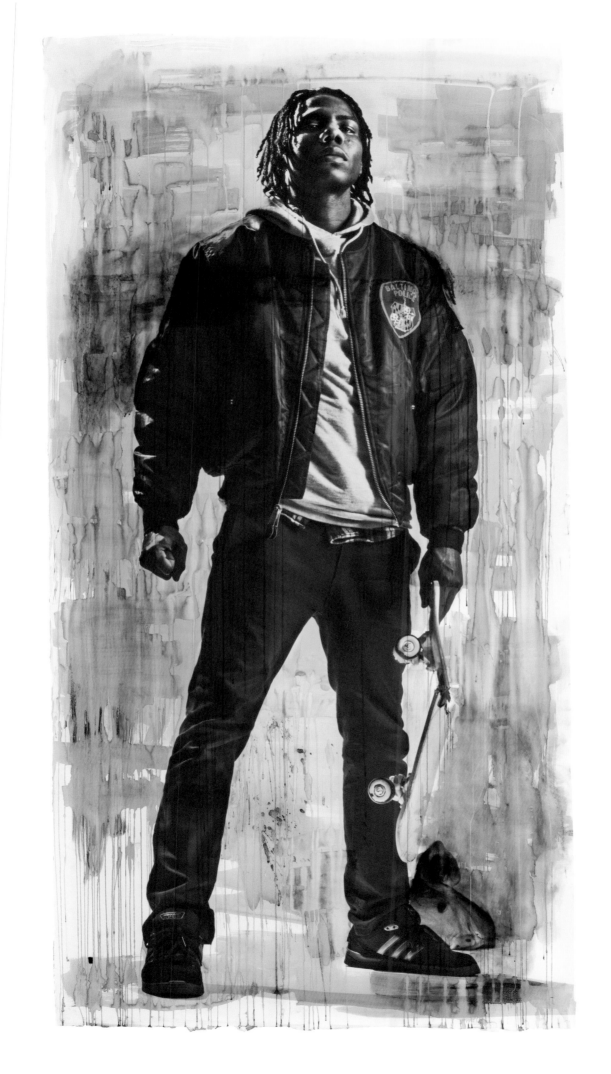

M. D., 2016

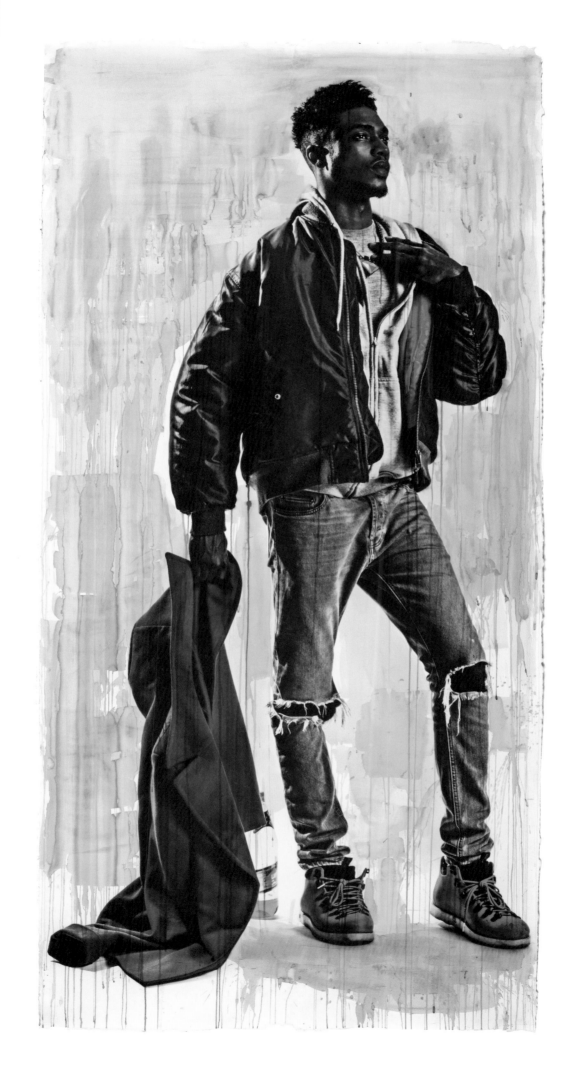

A. W., 2016

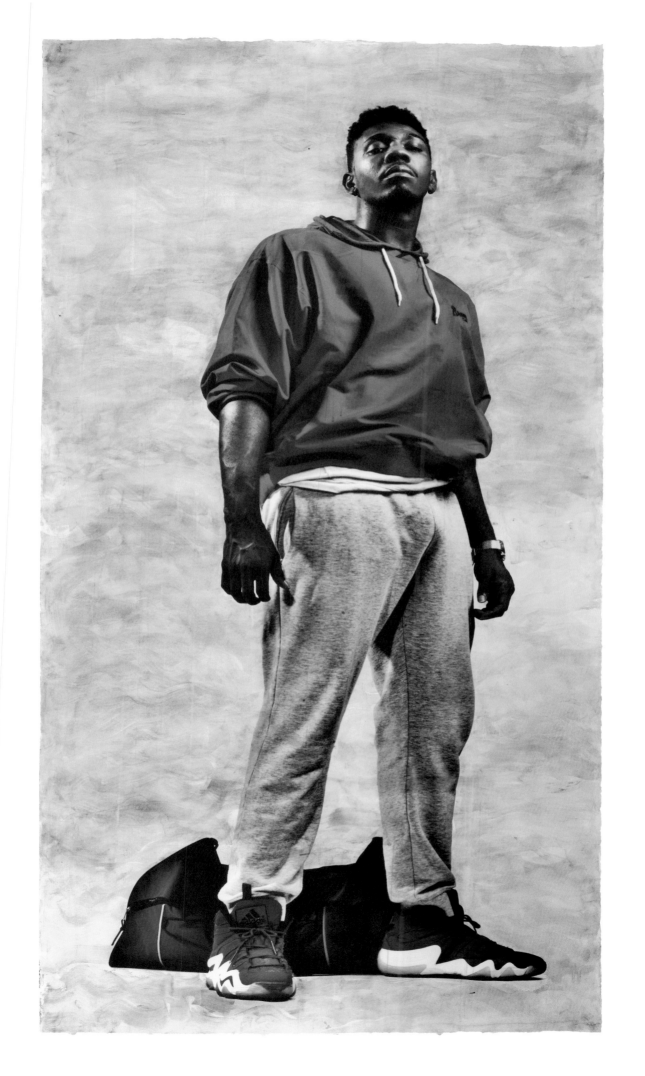

M. W., 2016

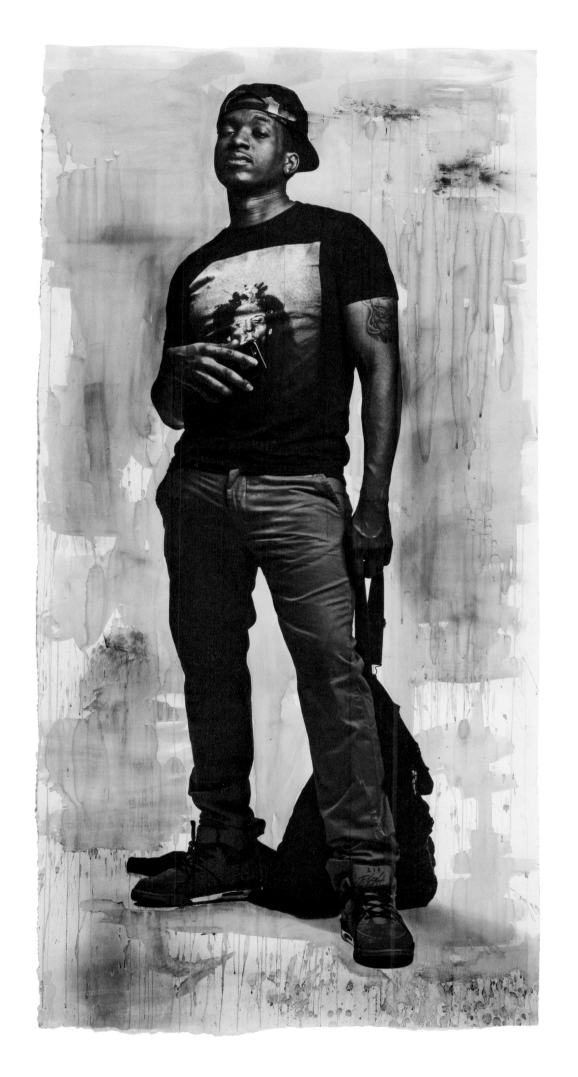

AFTER SELMA

The Road to Selma, 2015

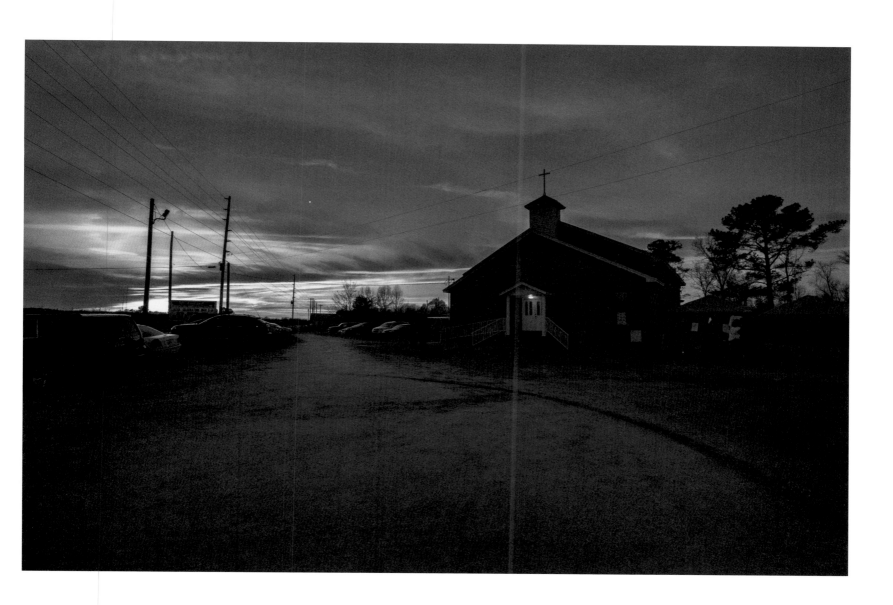

Gathering #2, 2015

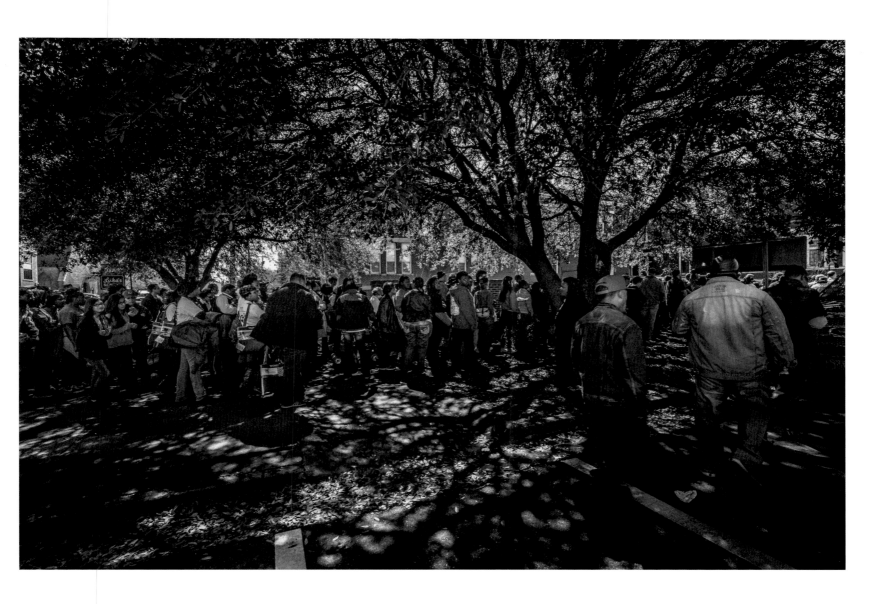

50 Years, 2015

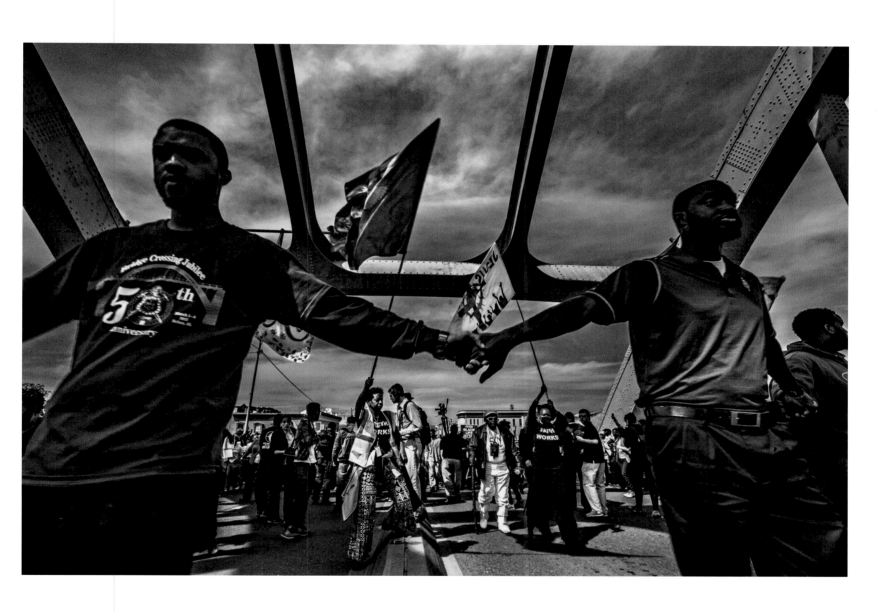

Little Girl Blue, 2015

Forward, 2015

Bearing Witness, 2015

Demand Justice, 2015

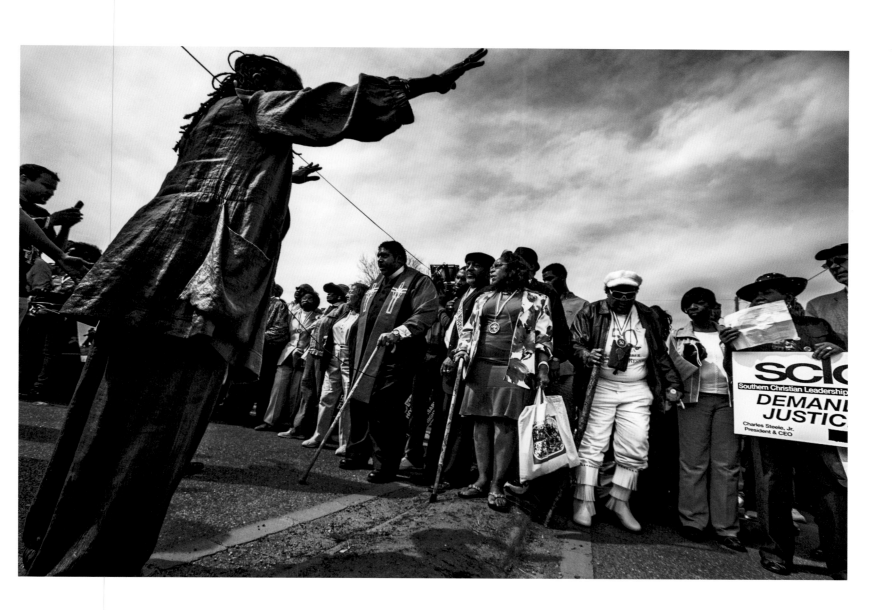

Gathering #1, 2015

Faith (Heaven Help Us All), 2015

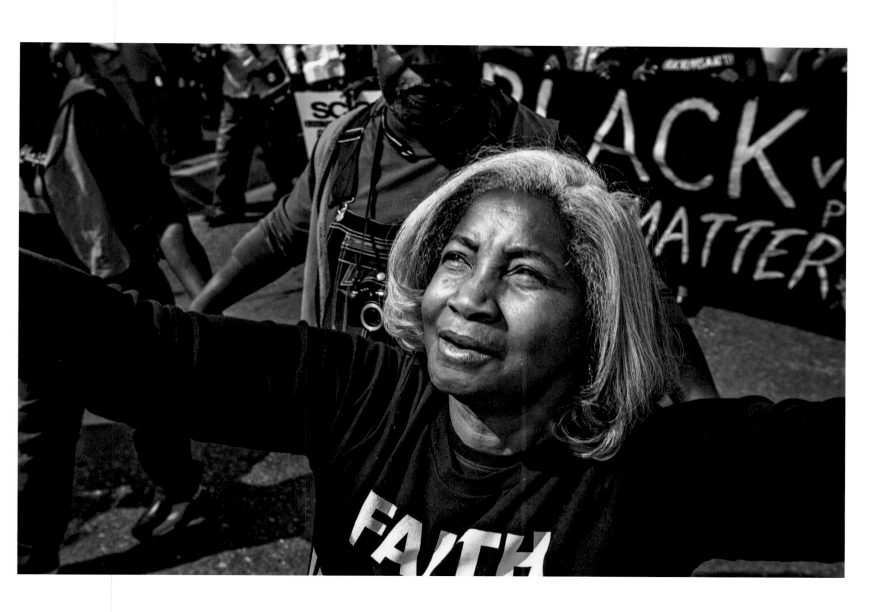

My Sons and I, 2015

212

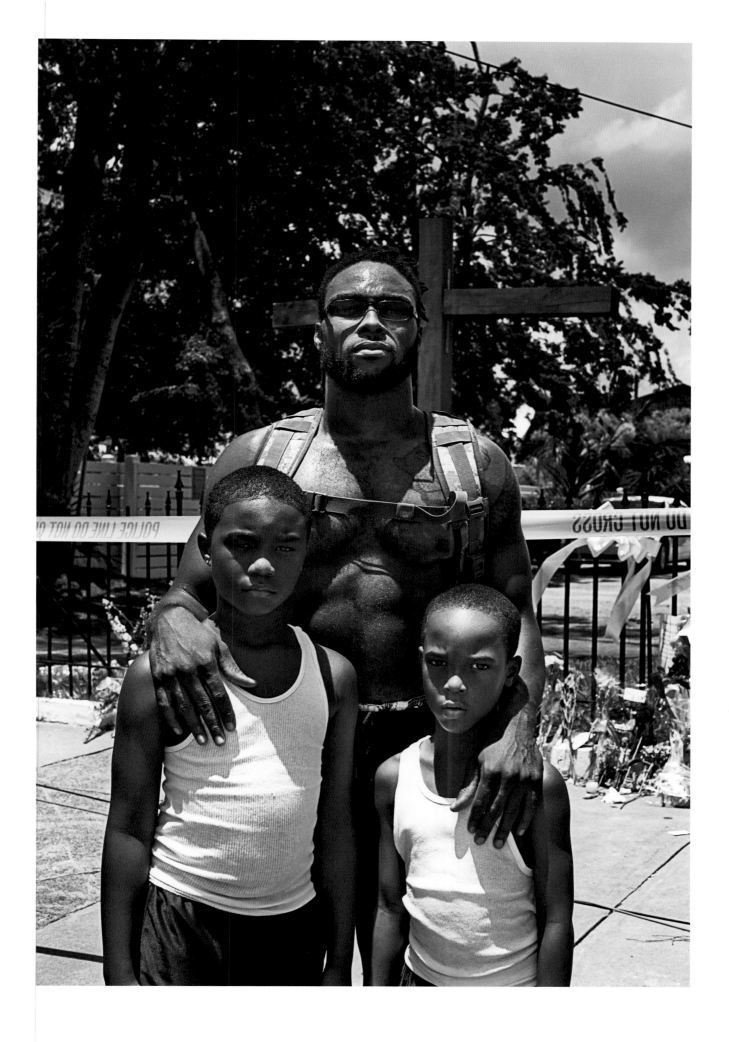

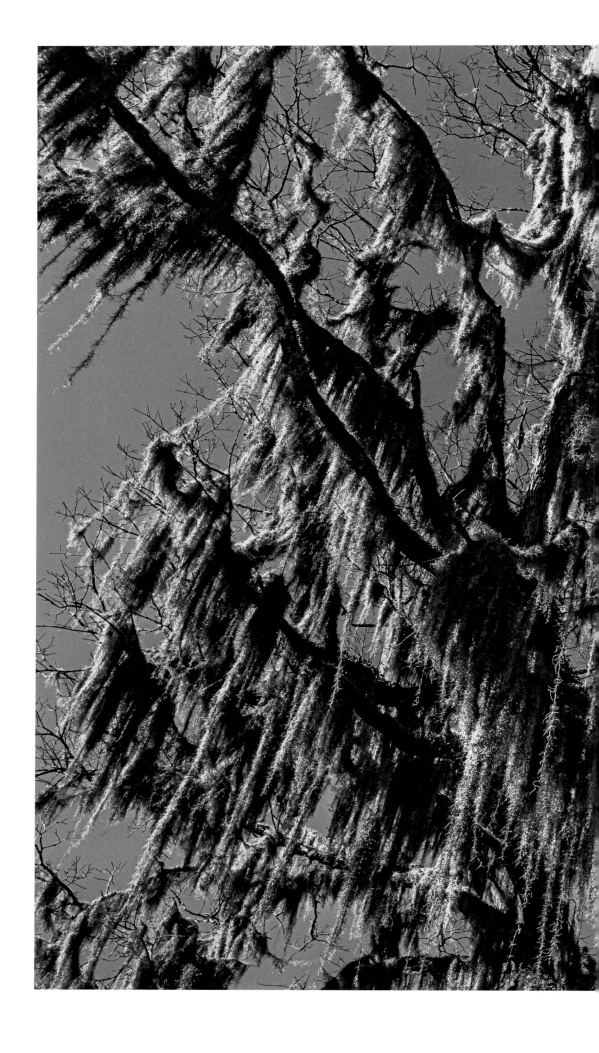

Southern Tree, 2015

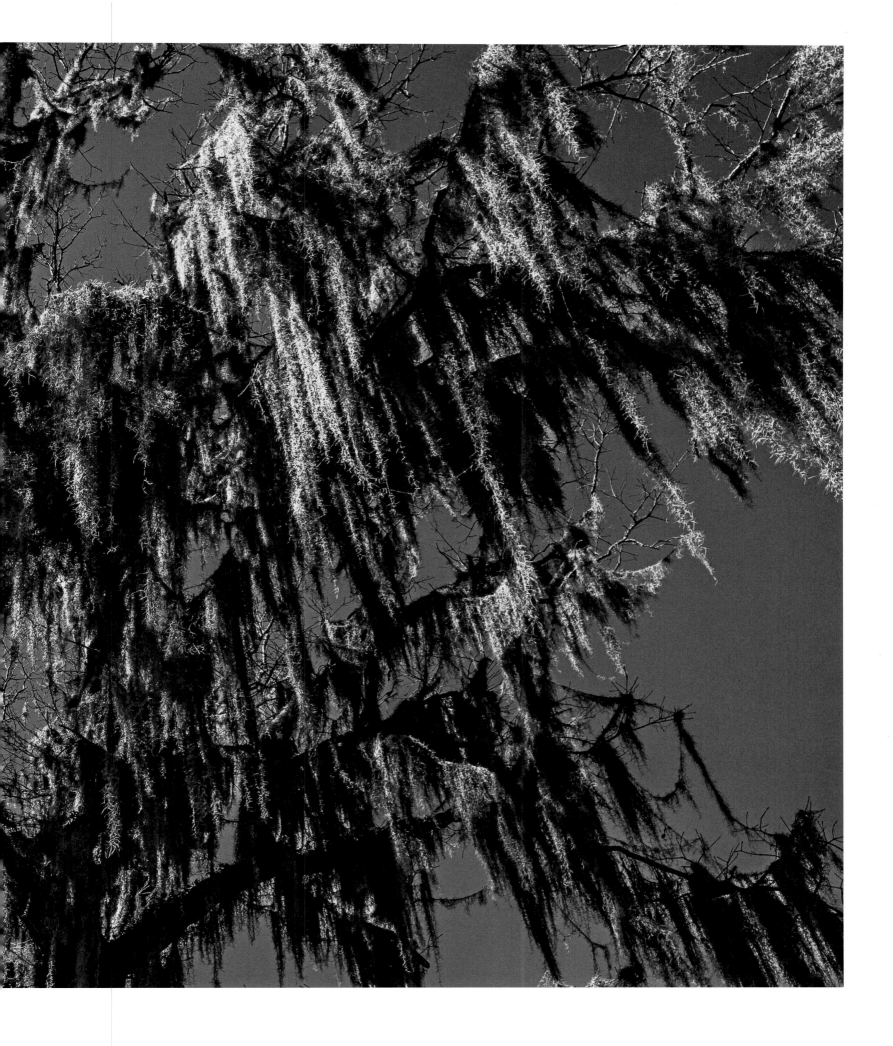

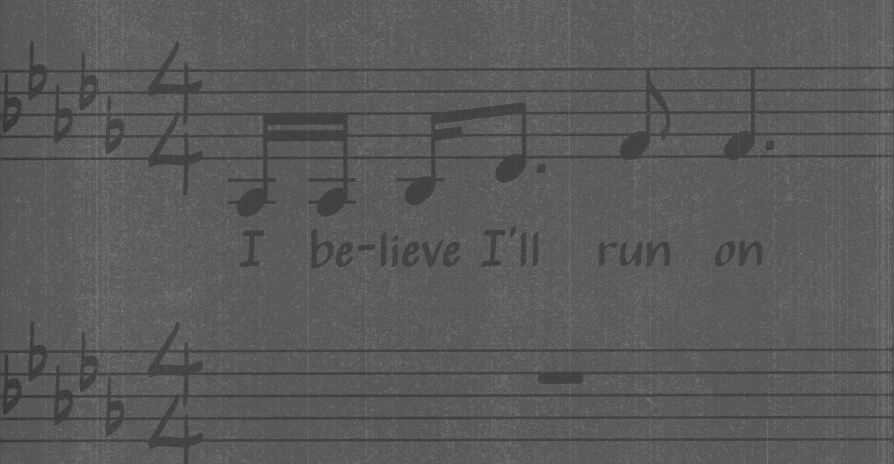

I be-lieve I'll run on

C° F

n On

Mighty Clouds of Joy

Bbm

LOVE WITHOUT JUSTICE

See what the end is gon-na be

Bbm Gb

Wisdom Is the Flame Who Will Carry Us into the Sun, 2018

Alternating with McFadden's original
photographs are a selection of the artist's family
photographs from his personal collection.
Photographers unknown.

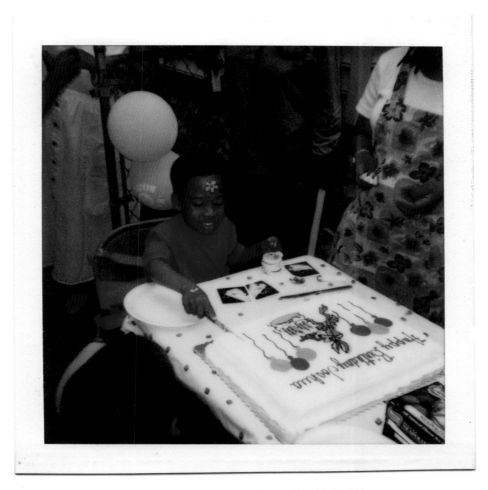

Joshua Rashaad McFadden's 6th birthday party, Rochester, New York, 1996

I Stand Before You Naked, 2018

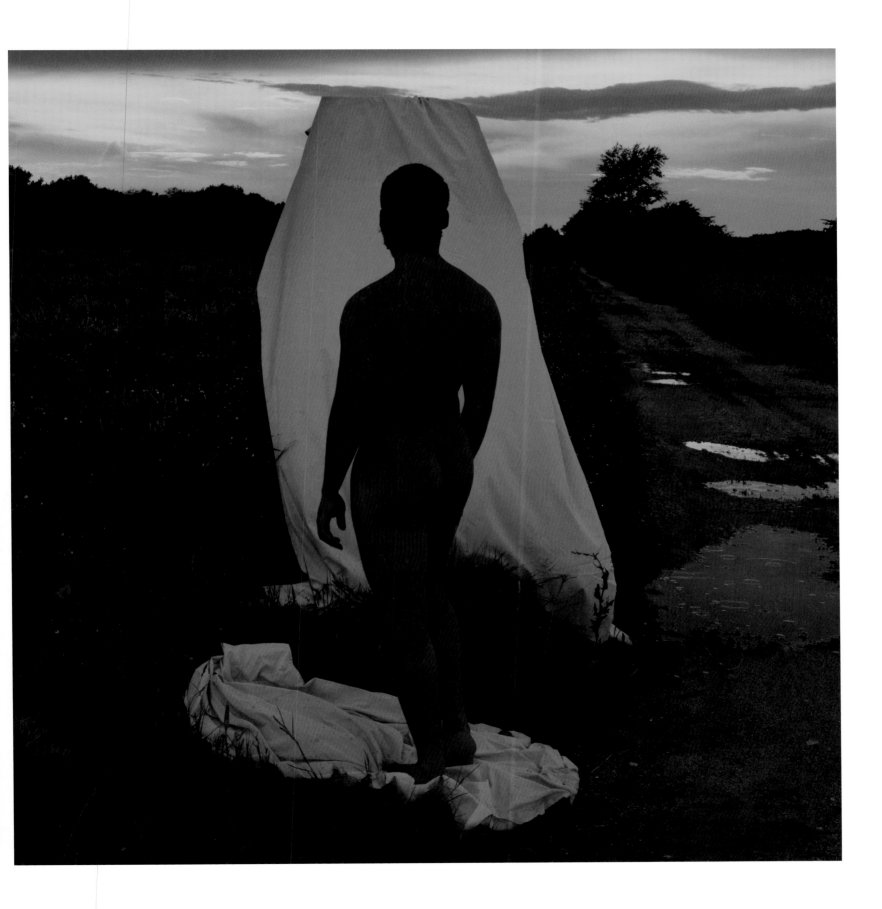

Family relatives Tina Beverly and Jessie Beverly, Camden, Alabama, 1950s

A relative's home, Camden, Alabama, 1950s

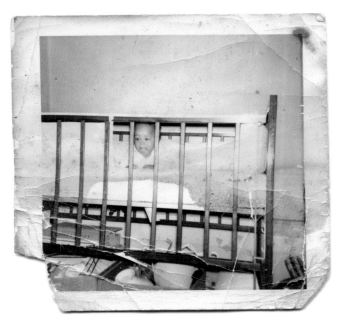

Joshua's mother (Mom), Jacqueline Coats (McFadden), New York City, New York, 1967

Mom and Uncle Charles Coats reading a book together, Lansing, Michigan, early 1970's

Everything Must Change, 2019

Grandma Josephine Lewis's photo wall, Lansing, Michigan, 2007

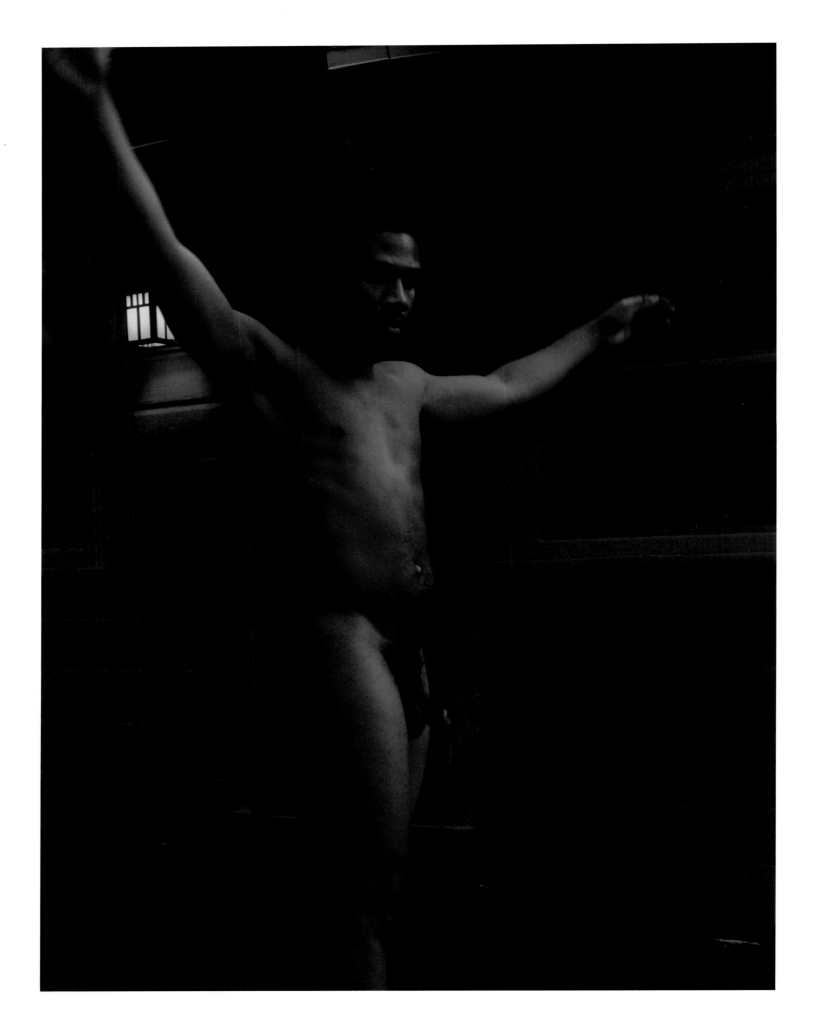

Let Me Not to Him Do as He Has unto Me, 2018

Still Water Run Deep Yes It Do, 2018

Front of Joshua's childhood home, Rochester, New York, 1997

Older brother Craig B. McFadden II, 1997

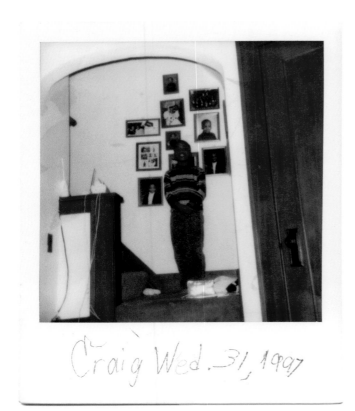

Craig, New Year's Eve, 1997

Back of childhood home, 1997

The floodlight outside of Joshua's childhood bedroom window, 2004

Craig in Joshua's bedroom, 2004

For Without Me Your Beautiful Brown Would Be Forever Gone (Peaches), 2020

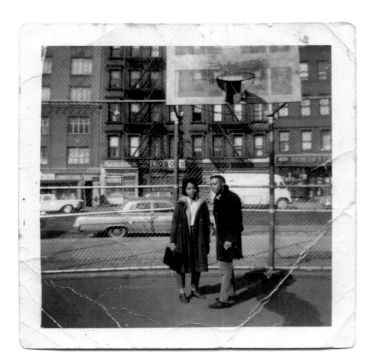

Grandparents Josephine (Lewis) and Roosevelt Coats, Harlem, New York City, New York, 1960s

Grandma Josephine's senior high school portrait, Camden, Alabama, 1957

For All We Know, 2019

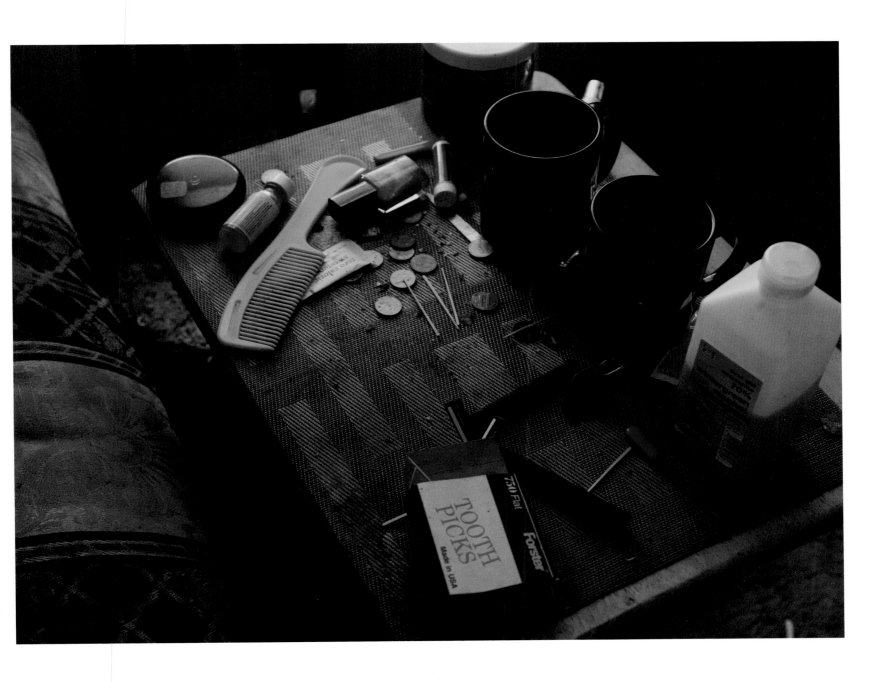

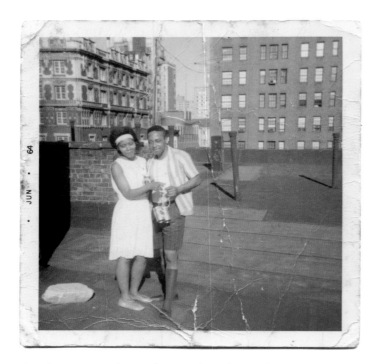

Grandparents Josephine and Roosevelt, Harlem rooftop, New York City, New York, 1964

Granddad Roosevelt, Lansing, Michigan, early 1970s

We Used Each Other to Escape Ourselves, 2018

Two-year-old Joshua standing near Mom at Grandma Josephine's house, Lansing, Michigan, 1992

Grandma Vira McFadden, Sanford, Florida, 1989

Aunt Angela Blue, portrait made at Neisner's variety store, Rochester, New York, 1973

Granddad Robert McFadden, Troop Street, Rochester, New York, mid-1970s

245

Mantra, 2021

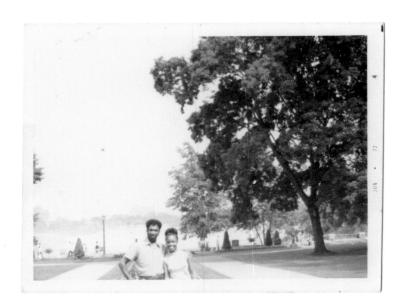

Grandparents Robert and Vira McFadden, Niagara Falls, Canada, 1971

Great-grandma Savannah Gilchrist on Joshua's parents' wedding day, Lansing, Michigan, 1989

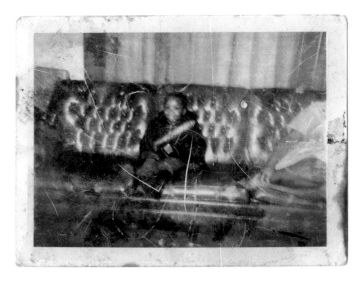

Joshua's father (Dad), Craig McFadden, Wilson Street, Rochester, New York, 1969

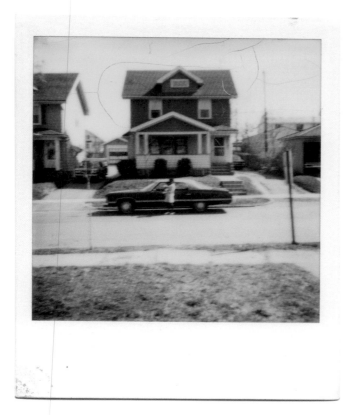

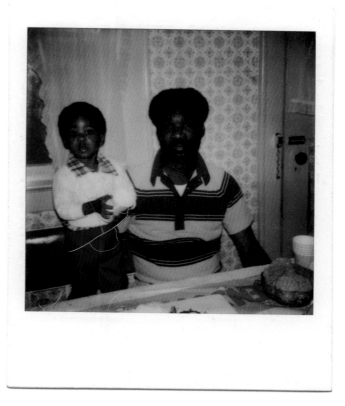

Aunt Angela holding baby Kevin Brown (Sr.), Easter Sunday, Rochester, New York, 1976

Uncle Robert Clayton "Clay" McFadden and Granddad Robert, Clay's 2nd birthday party, Rochester, New York, 1979

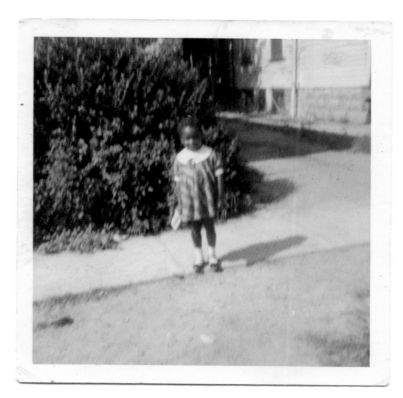

Aunt Angela, Moore Street, Rochester, New York, 1967

Hot Stuff and a Bit of Blow, 2018

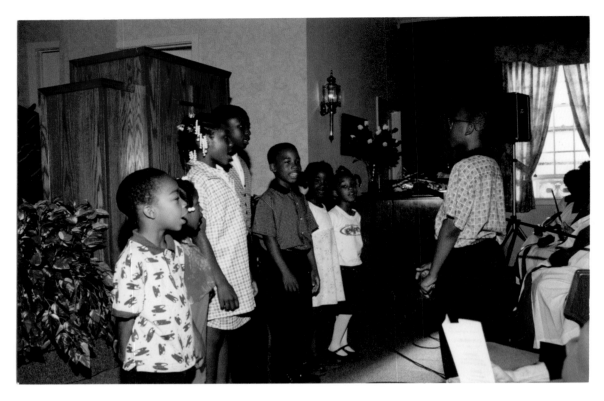

Joshua sings in the children's choir as his older brother Craig directs. Temple of God Church, Rochester, New York, 2001

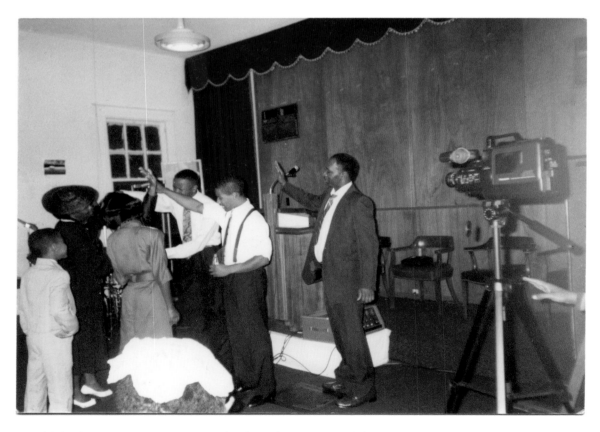

Granddad Robert, New Hope Deliverance Church, Rochester, New York, late 1980s

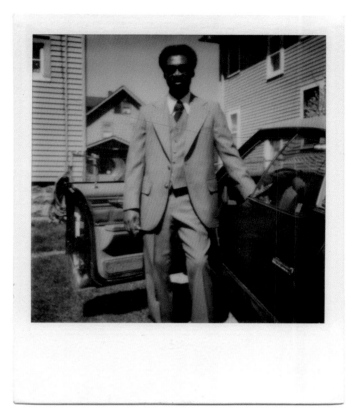

Granddad Robert, Rochester, New York, 1970s

Dad's high school senior portrait, Rochester, New York, 1985

Upon Our Beds to Rest, 2018

254

Joshua and Craig, Walt Disney World, Orlando, Florida, 1996

Joshua and Craig, Dumbo ride, Walt Disney World, 1996

Granddad Robert in dining room with butterflies reflected in mirror,
Rochester, New York, 1979

Dad, Rochester, New York, 1983

The Truth Needs No Proof, 2019

Tina Beverly and Jessie Beverly, Camden, Alabama, 1950s

Grandma Josephine, Lansing, Michigan, early 1970s

Grandma Josephine, Lansing, Michigan, 2007

Earth Has No Sorrow That Heaven Cannot Heal, 2019

Uncle Charles, Raggs the dog, and Mom, Lansing, Michigan, 1976

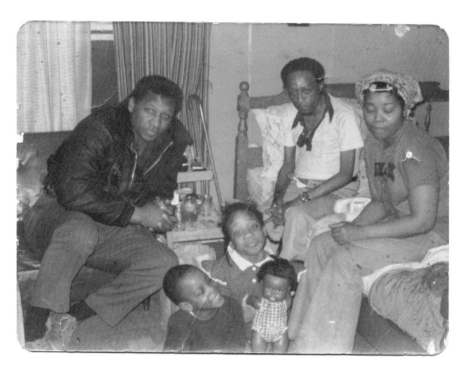

Family friend John "Big John" Hall, Uncle Charles, Mom, Granddad Roosevelt, and Grandma Josephine, Lansing, Michigan, late 1970s

Get Your House in Order, 2019

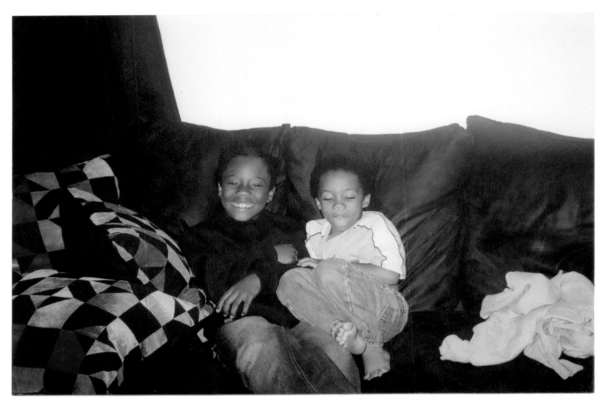

Little brothers Myles J. McFadden and Marcus J. McFadden, Rochester, New York, 2007

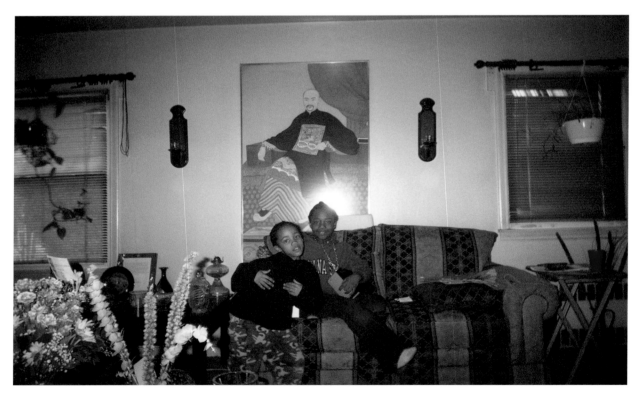

Myles and Marcus, Lansing, Michigan, 2007

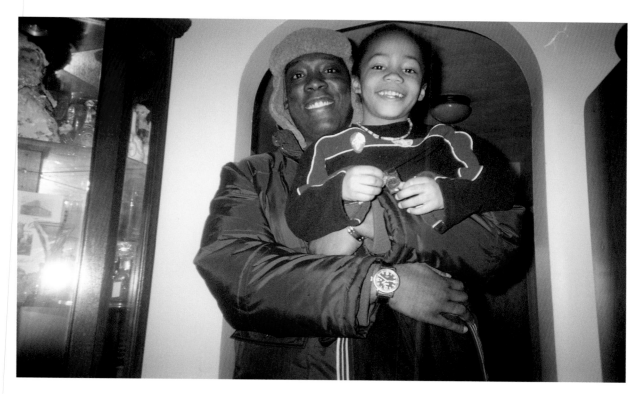

Uncle Charles and Marcus, Lansing, Michigan, 2007

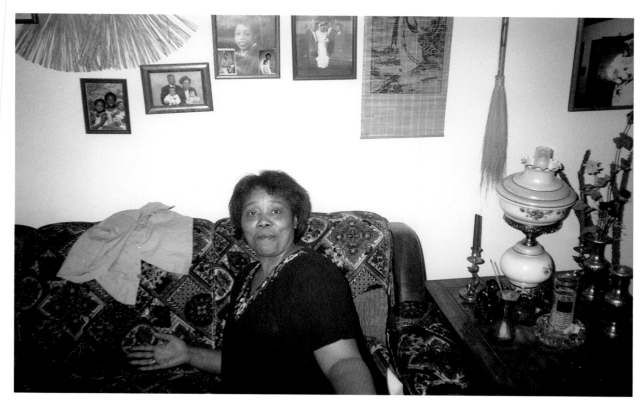

Grandma Josephine, Lansing Michigan, mid-1990s

Bring Your Wounded Heart and Tell Your Anguish, 2018

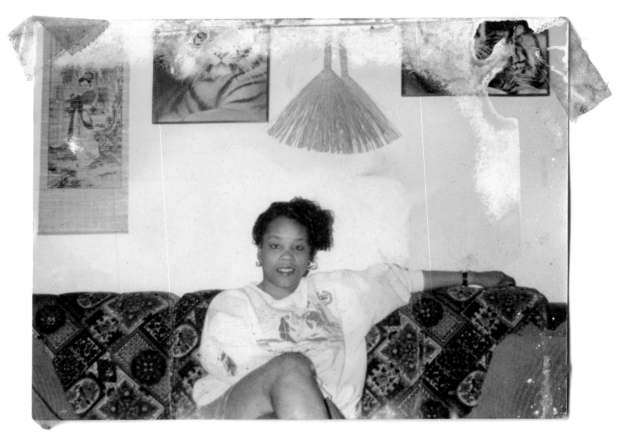

Mom, Lansing, Michigan, 1989

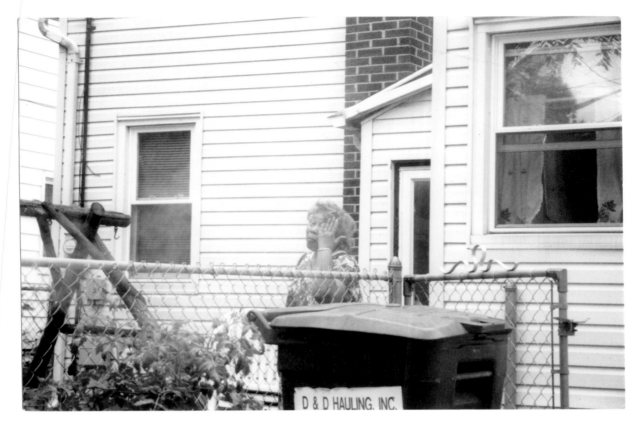

Grandma Josephine, Lansing, Michigan, 2007

John "Granddad John" Lewis, Lansing, Michigan, 2007

For the Stone Will Cry Out from the Wall, 2019

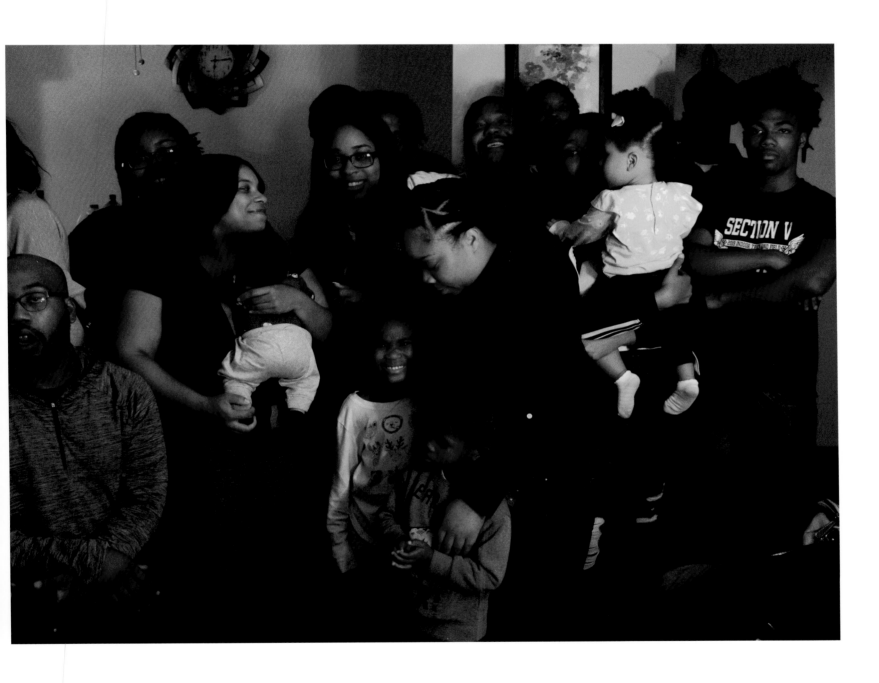

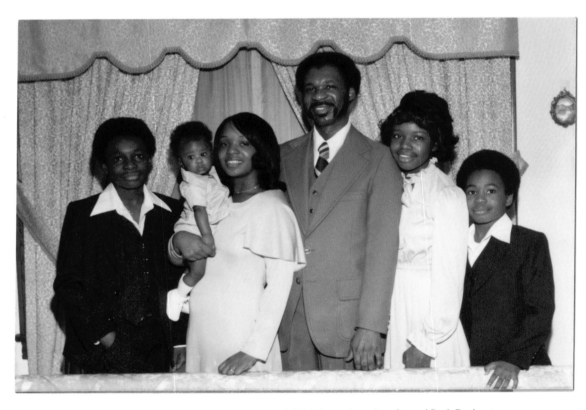

Uncle Dennis McFadden, Uncle Clay, Grandma Vira, Granddad Robert, Aunt Angela, and Dad, Rochester, New York, 1977

Relative Marie Johnson, Great-aunt Naomi Auston, Great-grandma Savannah, Great-aunt Robbi Evans, and Aunt Linda Gilchrist, Rochester, New York, ca. 1984

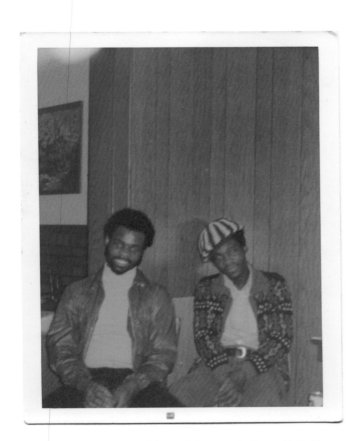

Great-uncle William McFadden and Great-uncle Moses McFadden, Rochester, New York, 1972

Family friend Ms. Eloise, Great-uncle Roy Lee Gilchrist, and Great-grandma Savannah at a James Brown concert, Rochester, New York, late 1960s

Marcus, 2019

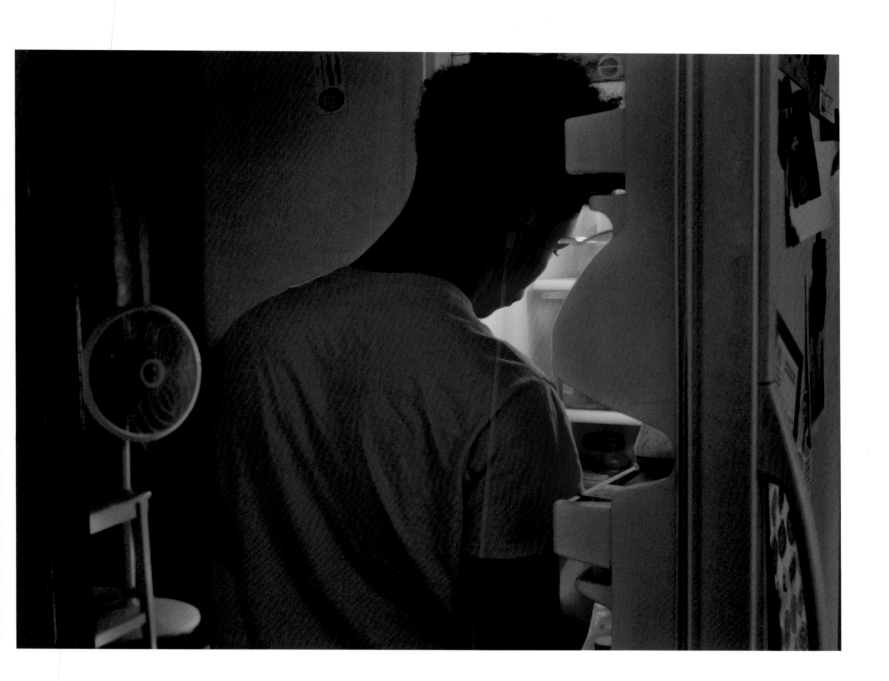

Mom, Rochester, New York, 1989

Joshua's 6th birthday party, Rochester, New York, 1996

Granddad Robert's garden in the backyard, Rochester, New York, early 1970's

Joshua's grandparents' backyard on the day of his birthday party, 1994

Set Me Free, 2019

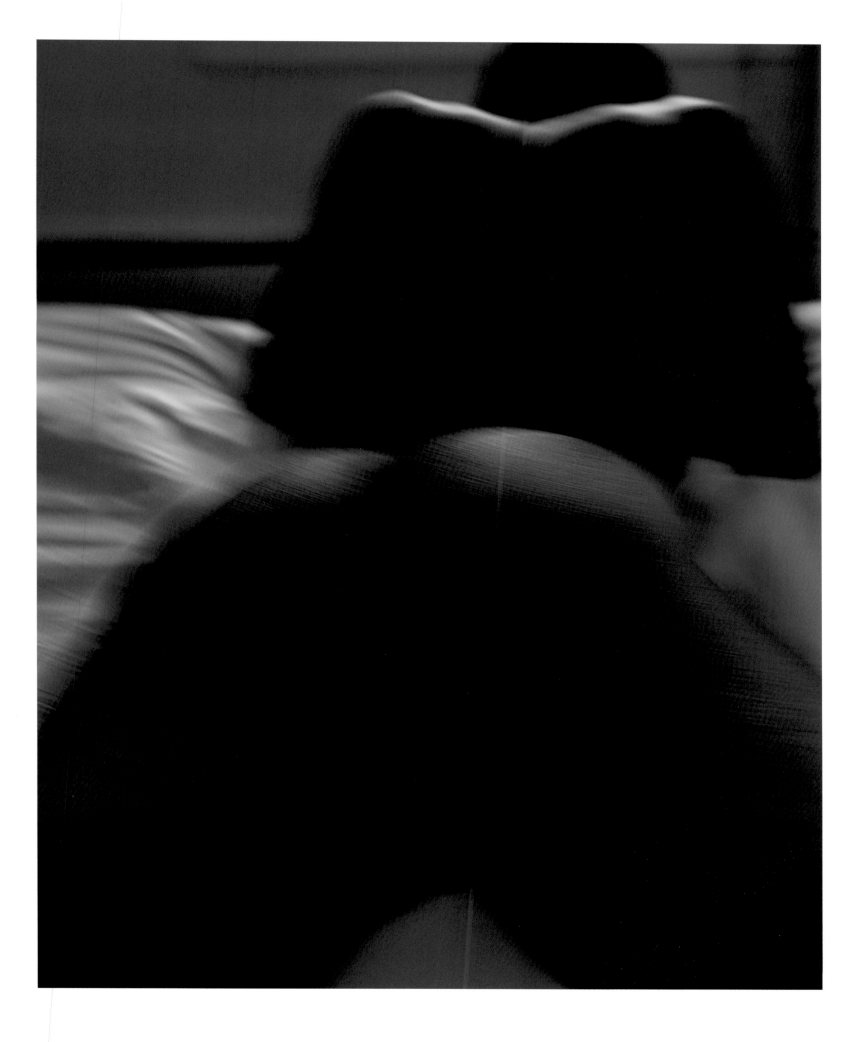

Aunt Patricia Coats, Uncle Charles, and Mom holding 2-year-old Joshua, Lansing, Michigan, April 1992

Dad, Mom holding Myles, Craig, and Joshua, family portrait made at Olan Mills Portrait Studios, Rochester, New York, 1999

Tenderly Speaks the Comforter, 2020

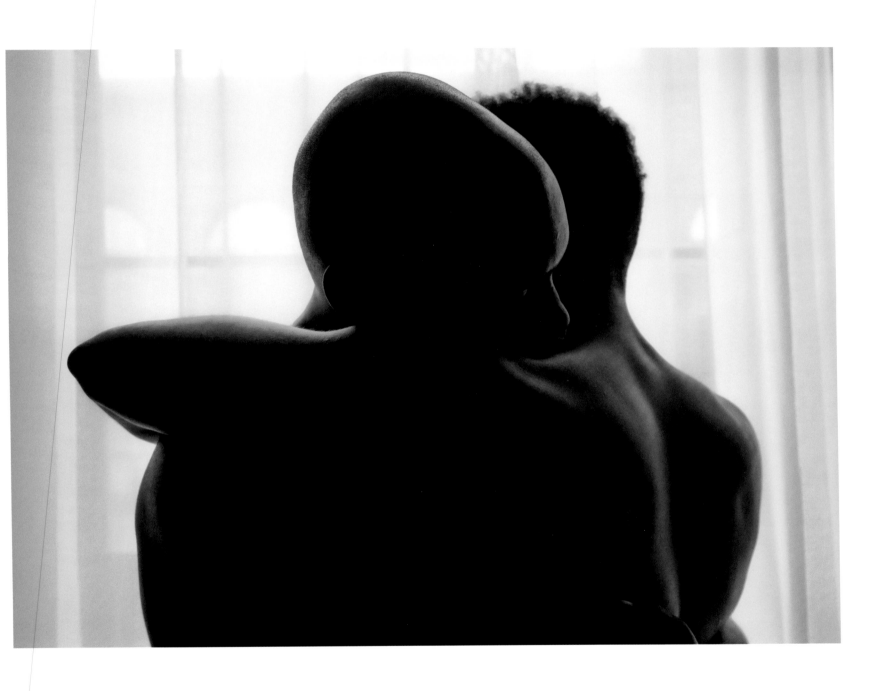

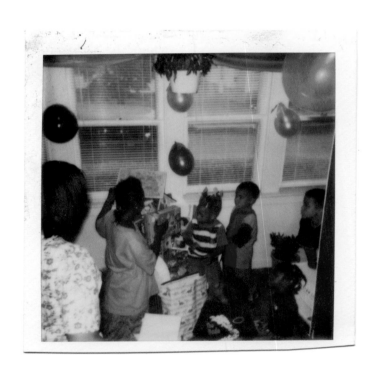

Family friend Kim Jones helps with presents as Mom watches, Joshua's 5th birthday party, Rochester, New York, 1995

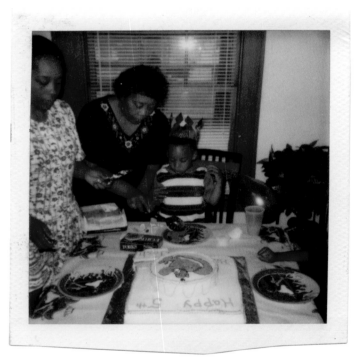

Mom, Grandma Josephine, and Joshua with cake at 5th birthday party, Rochester, New York, 1995

Mom outside St. Monica's Church, Rochester, New York, 1997

Come Ye Disconsolate Wherever Ye Languish, 2019

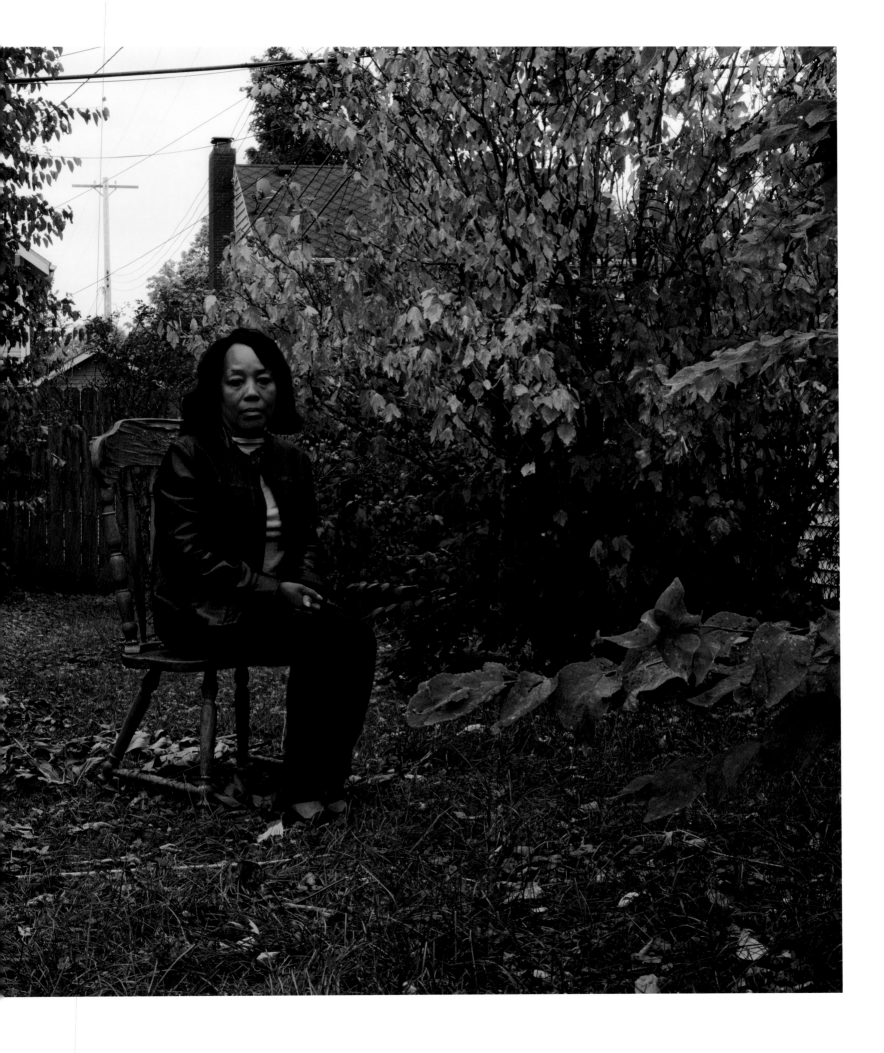

Water No Get Enemy, 2020

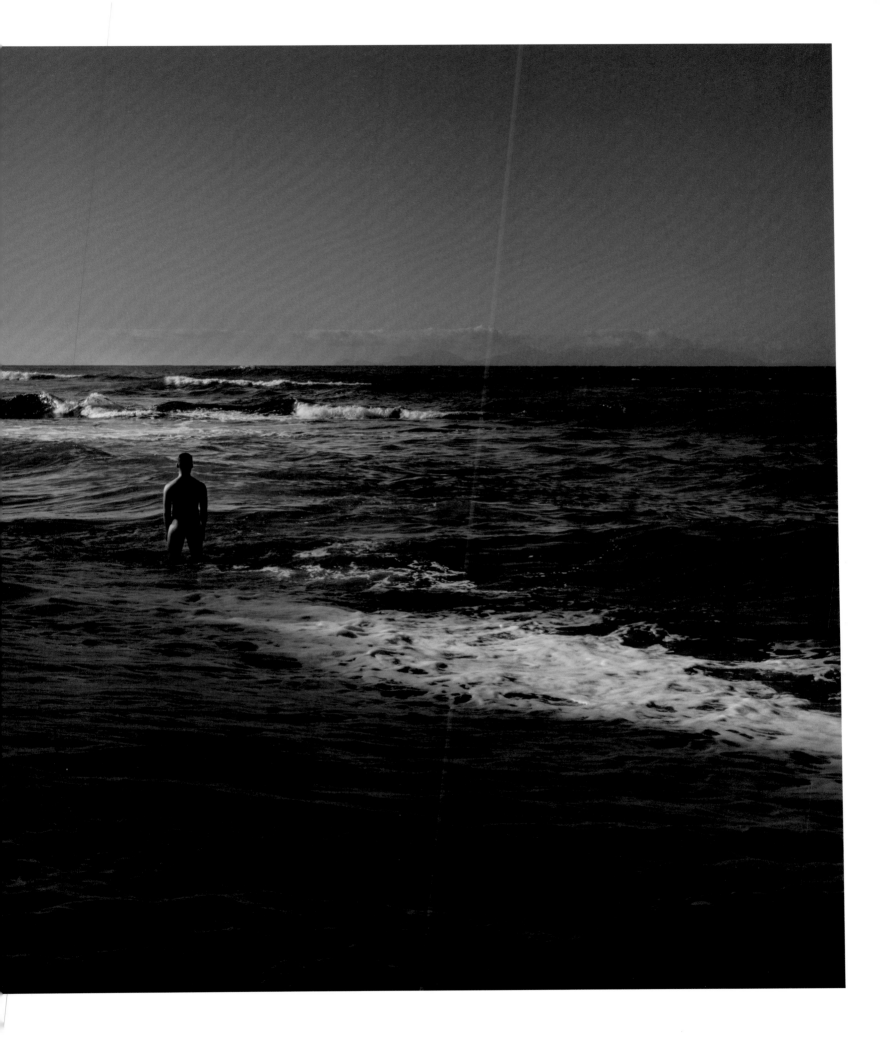

Notes

In the Long Shadow: Black Photography, Anti-Black Violence, and the Great Beauty of Black Life

1. Saidiya Hartman, *Wayward Lives, Beautiful Experiments: Intimate Histories of Social Upheaval* (New York: Norton, 2019), 17–24.
2. For a deeper understanding of what Fred Moten means by *Black social life* or *Black sociality*, see *Black and Blur* (Durham: Duke University Press, 2017) and *Stolen Life* (Durham: Duke University Press, 2018), respectively.
3. Amy Louise Wood, *Lynching and Spectacle: Witnessing Racial Violence in America, 1890–1940* (Chapel Hill: University of North Carolina Press, 2009), 3.
4. See, for example, Ken Gonzales-Day, *Lynching in the West: 1850–1935* (Durham: Duke University Press, 2006), and Jacqueline Goldsby, *A Spectacular Secret: Lynching in American Life and Literature* (Chicago: University of Chicago Press, 2006).
5. Koritha Mitchell, *Living with Lynching: African American Lynching Plays, Performance, and Citizenship, 1890–1930* (Urbana: University of Illinois Press, 2011), 6.
6. In her groundbreaking book *Scenes of Subjection*, Saidiya Hartman writes that "blacks were envisioned fundamentally as vehicles for white enjoyment, in all of its sundry and unspeakable expressions; this was as much a consequence of the chattel status of the captive as it was of the excess enjoyment imputed to the other, for those forced to dance on the decks of slave ships crossing the Middle Passage, step it up lively on the auction block, and amuse the master and his friends were seen as purveyors of pleasure." Saidiya Hartman, *Scenes of Subjection: Terror, Slavery, and Self-Making in Nineteenth-Century America* (New York: Oxford University Press, 1997), 23.
7. See, for a detailed discussion, Linda Kim, "A Law of Unintended Consequences: United States Postal Censorship of Lynching Photographs," *Visual Resources: An International Journal on Images and Their Uses* 28, no. 2 (2012): 171–93.
8. Shawn Michelle Smith, *Photography on the Color Line: W. E. B. Du Bois, Race, and Visual Culture* (Durham: Duke University Press, 2004), 117.
9. James Allen, ed., *Without Sanctuary: Lynching Photography in America*, exh. cat. (Santa Fe: Twin Palms Publishers, 1999).
10. In *The End of Policing*, sociologist Alex S. Vitale offers a robust historical account of policing in the United States. He argues that colonialism, industrialization, and slavery in the United States were the primary drivers of the formation of new police departments. Policing emerged with intent to control, especially in these key moments of exploitation. Vitale contends that the very first modern police force, the Charleston City Watch and Guard, formed in the 1790s, was created to manage a mobile slave population. The underlying contention of Vitale's book is that American policing, historically and contemporarily, has always been about enforcing white supremacy. Alex S. Vitale, *The End of Policing* (New York: Verso Press, 2017). For more, see also: Khalil Gibran Muhammad, *The Condemnation of Blackness: Race, Crime, and the Making of Modern Urban America* (Cambridge, MA: Harvard University Press, 2011); Linette Park, "The Eternal Captive in Contemporary 'Lynching' Arrests: On the Uncanny and the Complex of Law's Perversion," *Theory & Event* 22, no. 3 (2019): 674–98.
11. Hartman, *Wayward Lives, Beautiful Experiments*.
12. Here, I mean to invoke Billie Holliday's "Strange Fruit" in the same way that the title of McFadden's photograph does.

13. Christina Sharpe, *In the Wake: On Blackness and Being* (Durham: Duke University Press, 2016).

14. Shawn Michelle Smith, *Photographic Returns: Racial Justice and the Time of Photography* (Durham: Duke University Press, 2020), 7.

15. Leigh Raiford, "Photography and the Practices of Critical Black Memory," *History and Theory* 48, no. 4 (2009): 112–29.

16. Ibid., 114.

17. Alexander Strecker, "After Selma," *LensCulture*, https://www.lensculture.com/articles/joshua-rashaad-mcfadden-after-selma. Note McFadden's use of "are."

18. Raiford, "Photography and the Practices of Critical Black Memory," 115.

19. My use of *rollcall for the absence* draws from the haunting song "Rollcall for Those Absent" by the Black jazz trumpeter Ambrose Akinmusire, from his album *The Imagined Savior Is Far Easier to Paint*. The piece is both a mourning song and a protest song. The acrobatic trumpet riffs and the long, drawn-out, low vibrational sounds produced by Akinmusire's listeners move us to reflect on the names of Black people killed by the State. The names are read over the trumpet's serenade, and some are even repeated with profound effect.

20. To be in the wake of slavery, writes Sharpe, is to live in the long history of anti-Black terror, from slavery to the present. It is to recognize how we are constituted "through and by continued vulnerability," such as the ongoing State-sanctioned legal and extralegal murders and more. She continues, "living in the wake means living in and with terror in that in much of what passes for public discourse *about* terror we, Black people, become the *carriers* of terror, terror's embodiment, and not the primary objects of terror's multiple enactments; the ground of terror's possibility globally." Indeed, "to be in the wake is to live in those no's, to live in no citizenship, to live in the long time of Dred and Harriet Scott; and it is more than that." Sharpe, *In the Wake*, 15–17.

21. Tina M. Campt, *Listening to Images* (Durham: Duke University Press, 2017), 107.

22. Valerie June, "Astral Plane," track 7 on *The Order of Time*, Concord Music Group, 2017.

23. Keguro Macharia, *Frottage: Frictions of Intimacy Across the Black Diaspora* (New York: New York University Press, 2019).

24. Ibid., 7.

25. Ibid.

26. Tina Campt, "Prelude to a New Black Gaze," a talk delivered at Studium Generale Rietveld Academie, May 2014, https://www.youtube.com/watch?v=IEez-P-lOMg. See also Campt's *A Black Gaze: Artists Changing How We See* (Cambridge, MA: MIT Press, 2021).

27. Dionne Brand, *The Blue Clerk: Ars Poetica in 59 Versos* (Durham: Duke University Press, 2018), 72.

A Conversation: Lyle Ashton Harris and Joshua Rashaad McFadden

1. *The Black Church: This Is Our Story, This Is Our Song*, a four-hour, two-part series that originally aired on PBS in February 2021.

2. "Public Spectacle Lynchings," Equal Justice Initiative, February 14, 2018, https://eji.org/news/history-racial-injustice-public-spectacle-lynchings/ (accessed June 28, 2021).

3. "Mamie Elizabeth Till-Mobley was an American educator and activist. She was the mother of Emmett Till, who was murdered in Mississippi on August 28, 1955 at the age of 14, after allegedly offending a white cashier woman, Carolyn Bryant, at the grocery store." (Wikipedia, 2021, "Mamie Till," September 26, 2021)

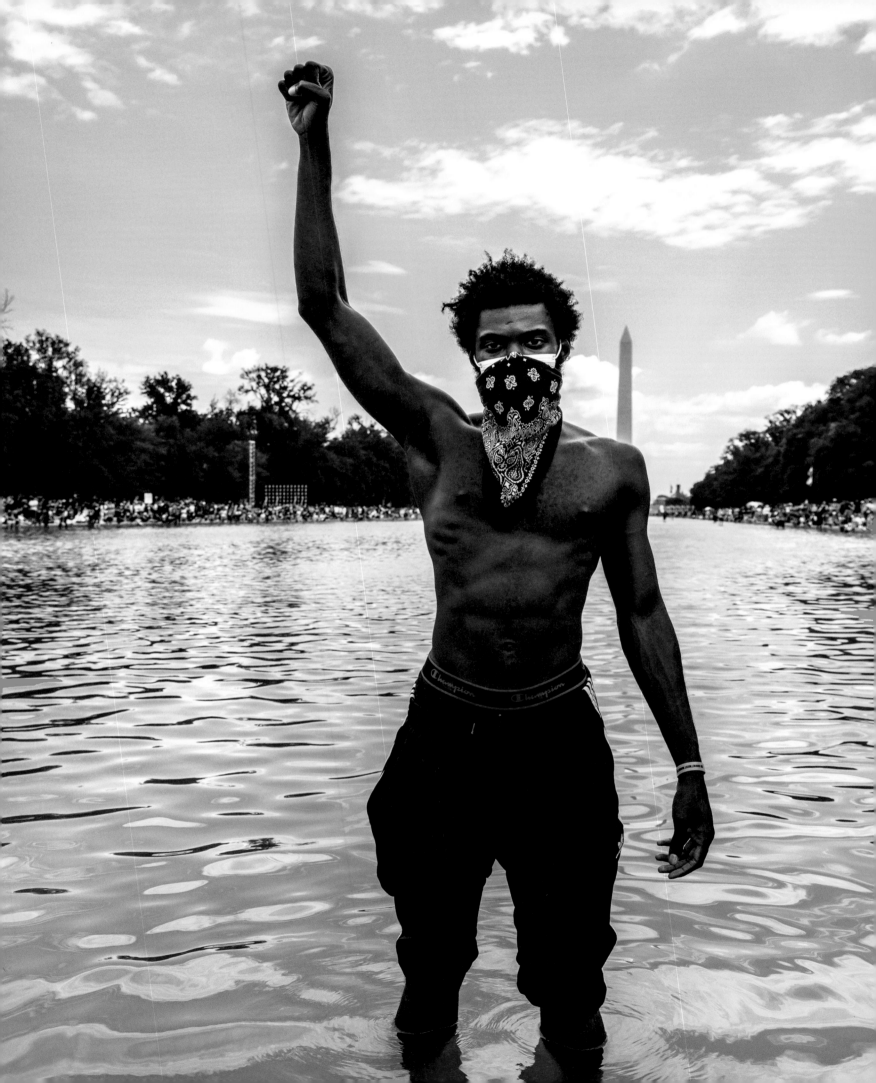

Exhibition Checklist

Except as noted all works are:
Joshua Rashaad McFadden (American, b. 1990)
© Joshua Rashaad McFadden
Lent by the artist

UNREST IN AMERICA
Inkjet prints
Pages 78–135
* Not included in exhibition

White Supremacy Is a Public Health Crisis (Minneapolis, Minnesota), 2020
From *Unrest in America: George Floyd*
21 × 28 in.

Breonna Taylor Park (Louisville, Kentucky), 2020
From *Unrest in America: Breonna Taylor*
15 × 20 in.

Protest at Jefferson Square Park (Louisville, Kentucky), 2020
From *Unrest in America: Breonna Taylor*
15 × 20 in.

Katrina Curry and Preonia Flakes (Louisville, Kentucky), 2020
From *Unrest in America: Breonna Taylor*
15 × 20 in.

Shadai Parr, Elysia Bowman, Erinicka Hunter, Shatanis Vaughn (Louisville, Kentucky), 2020
From *Unrest in America: Breonna Taylor*
15 × 20 in.

Breonna Taylor's Apartment (Louisville, Kentucky), 2020
From *Unrest in America: Breonna Taylor*
15 × 20 in.

Kenneth Walker (Louisville, Kentucky), 2020
From *Unrest in America: Breonna Taylor*
15 × 20 in.

A Sit-in at Kentucky Attorney General Daniel Cameron's Home #1 (Louisville, Kentucky), 2020
From *Unrest in America: Breonna Taylor*
15 × 20 in.

A Sit-in at Kentucky Attorney General Daniel Cameron's Home #2 (Louisville, Kentucky), 2020
From *Unrest in America: Breonna Taylor*
15 × 20 in.

Surveillance, Misconceptions, and Accusations, 2020
From *Unrest in America: Breonna Taylor*
15 × 20 in.

Arrest The Cops Who Killed Breonna Taylor (Louisville, Kentucky), 2020
From *Unrest in America: Breonna Taylor*
15 × 20 in.

Louisville in Protest, 2020
From *Unrest in America: Breonna Taylor*
15 × 20 in.

Tamika Palmer (Louisville, Kentucky), 2020
From *Unrest in America: Breonna Taylor*
15 × 20 in.

Righteous Anger (Minneapolis, Minnesota), 2020
From *Unrest in America: George Floyd*
21 × 28 in.

R We Loud Enough? (Minneapolis, Minnesota), 2020
From *Unrest in America: George Floyd*
21 × 28 in.

Target #2 (Minneapolis, Minnesota), 2020
From *Unrest in America: George Floyd*
21 × 28 in.

Detail, *Black Power (Washington, D.C.)*, 2020.

Say Their Names (Minneapolis, Minnesota), 2020
From *Unrest in America: George Floyd*
21 × 28 in.

The Fires (Minneapolis, Minnesota), 2020
From *Unrest in America: George Floyd*
21 × 28 in.

George Floyd Memorial Site #1, The Week George Floyd Was Murdered (Minneapolis, Minnesota), 2020
From *Unrest in America: George Floyd*
21 × 28 in.

I Can't Breathe (Minneapolis, Minnesota), 2020
From *Unrest in America: George Floyd*
21 × 28 in.

** George Floyd Memorial Site #2, Election 2020, Cup Foods Re-Opens (Minneapolis, Minnesota)*, 2020
From *Unrest in America: George Floyd*
21 × 28 in.

** The First Day of the Derek Chauvin Trial (Minneapolis, Minnesota)*, 2021
From *Unrest in America: George Floyd*
21 × 28 in.

George Floyd Memorial Site #5, Derek Chauvin Found Guilty (Minneapolis, Minnesota), 2021
From *Unrest in America: George Floyd*
21 × 28 in.

George Floyd Memorial Site #4, Justice for Daunte Wright (Minneapolis, Minnesota), 2021
From *Unrest in America: George Floyd*
21 × 28 in.

Rayshard Brooks Memorial Site (Atlanta, Georgia), 2020
From *Unrest in America: Rayshard Brooks*
21 × 28 in.

Irony of Black Policeman (Atlanta, Georgia), 2020
From *Unrest in America: Rayshard Brooks*
28 × 21 in.

Die in (Say Her Name) (Atlanta, Georgia), 2020
From *Unrest in America: Rayshard Brooks*
21 × 28 in.

The Family of Rayshard Brooks (Atlanta, Georgia), 2020
From *Unrest in America: Rayshard Brooks*
21 × 28 in.

Stop Killing Us (Atlanta, Georgia), 2020
From *Unrest in America: Rayshard Brooks*
21 × 28 in.

Confrontation (How Could You?) (Atlanta, Georgia), 2020
From *Unrest in America: Rayshard Brooks*
21 × 28 in.

Tear Gas (Rochester, New York), 2020
From *Unrest in America: Daniel Prude*
21 × 28 in.

Rochester Police Not Charged (Rochester, New York), 2021
From *Unrest in America: Daniel Prude*
21 × 28 in.

Rochester New York in Protest (Rochester, New York), 2020
From *Unrest in America: Daniel Prude*
21 × 28 in.

Daniel Prude Memorial Site (Rochester, New York), 2020
From *Unrest in America: Daniel Prude*
21 × 28 in.

Black Power (Washington, D.C.), 2020
From *Unrest in America: March on Washington*
21 × 28 in.

Alena Holds Her Son, Tamaj (Washington, D.C.), 2020
From *Unrest in America: March on Washington*
21 × 28 in.

A LYNCHING'S LONG SHADOW
Joshua Rashaad McFadden for the *New York Times*
Inkjet prints, 2018
Pages 136–154

E. W. Higginbottom
34 × 2 ⅝ in.

The Road to Oxford Mississippi
11 ⁵⁄₁₆ × 17 in.

Mob Lynches Negro
34 × 22 in.

Descendants of Elwood Higginbotham
11 ⁵⁄₁₆ × 17 in.

The Burial Site
11 ⁵⁄₁₆ × 17 in.

And Blood at the Root
11 ⁵⁄₁₆ × 17 in.

Blood on the Leaves
11 ⁵⁄₁₆ × 17 in.

E. W. Higginbottom and Elwood Higginbotham
17 × 11 ⁵⁄₁₆ in.

To Bear Witness
11 ⁵⁄₁₆ × 17 in.

Southern Trees Bear a Strange Fruit
9 ⁹⁄₁₆ × 17 in.

EVIDENCE
Pages 154–167

Avery Jackson, 2017
Inkjet print and vinyl reproduction of original ink on paper, 74 × 136 ½ in.

LaQuann Dawson, Jr., 2017
Gelatin silver print and ink on paper, 12 × 24 ½ in.

Jermel Moody, 2017
Gelatin silver print and ink on paper, 12 × 24 ½ in.

I Wish I Knew How It Would Feel To Be Free, 2020
Evidence publication presented in newspaper box for distribution
Installation photo by Sari Oister, February 2020

Evidence (United States: Visual Studies Workshop, 2020)
Ink on newsprint, 11 ½ × 15 in.

COME TO SELFHOOD
Inkjet prints
Pages 168–181

*Raheem Pounds, left, and his great-great grandfather,
David Barr*, 2016
30 × 40 ½ in.

Jamel Jones, left, and his father, James Jones, 2015
30 × 40 ½ in.

Lamarr Moore, left, and his father, Larry Moore, 2016
30 × 40 ½ in.

Come to Selfhood (Italy: Ceiba Editions, 2016)
9 ⅝ × 7 ⅜ × ¾ in.

*Jeremiah Thompson, left, and his father,
Joseph Thompson, Sr.*, 2016
30 × 40 ½ in.

Kamall Browne, left, and his father, Venzil Rawle Browne,
2016
30 × 40 ½ in.

SELFHOOD
2016
90 × 44 in.
Pages 182–191

K. B.
Inkjet print with charcoal and coffee
Lent by Lyle Ashton Harris

M. D.
Inkjet print with charcoal and coffee

A. W.
Inkjet print with charcoal
George Eastman Museum, purchase with funds from the
Horace W. Goldsmith Foundation

M. W.
Inkjet print with charcoal and coffee

AFTER SELMA
Gelatin silver prints, 2015
Pages 192–215

The Road to Selma
14 × 21 in.

Gathering #2
14 × 21 in.

50 Years
14 × 21 in.

Little Girl Blue
21 × 14 in.

Forward
14 × 21 in.

Bearing Witness
21 × 14 in.

Demand Justice
14 × 21 in.

Gathering #1
14 × 21 in.

Faith (Heaven Help Us All)
14 × 21 in.

My Sons and I
21 × 14 in.

Southern Tree
14 × 21 in.

LOVE WITHOUT JUSTICE
Inkjet prints except where noted
Pages 216–293

Wisdom Is the Flame Who Will Carry Us into the Sun, 2018
30 × 40 in.

I Stand Before You Naked, 2018
38 13⁄16 × 38 in.

Everything Must Change, 2019
35 ¾ × 61 in.

Let Me Not to Him Do as He Has unto Me, 2018
36 × 27 in.

Still Water Run Deep Yes It Do, 2018
27 × 36 in.

For Without Me Your Beautiful Brown Would Be Forever Gone (Peaches), 2020
28 × 21 in.

For All We Know, 2019
21 × 28 in.

We Used Each Other to Escape Ourselves, 2018
28 × 21 in.

Mantra, 2021
Etched mirror, frame, composition gold leaf, and paint.
77 x 42 x 4 in.

Hot Stuff and a Bit of Blow, 2018
21 × 28 in.

Upon Our Beds to Rest, 2018
31 × 23 ¼ in.

The Truth Needs No Proof, 2019
Each: 16 × 12 in.

Earth Has No Sorrow That Heaven Cannot Heal, 2019
19 ½ × 26 in.

Get Your House in Order, 2019
26 ¼ × 35 in.

Bring Your Wounded Heart and Tell Your Anguish, 2018
Each 72 × 54 in.

For the Stone Will Cry Out from the Wall, 2019
21 × 28 in.

Marcus, 2019
40 ½ × 54 in.

Set Me Free, 2019
31 ¼ × 25 in.

Tenderly Speaks the Comforter, 2020
54 × 72 in.

Come Ye Disconsolate Wherever Ye Languish, 2019
59 ¾ × 79 11⁄16 in.

Water No Get Enemy, 2020
59 ¾ × 79 11⁄16 in.

Included in the exhibition are digital projections of 102 of the artist's family photographs from his personal collection.

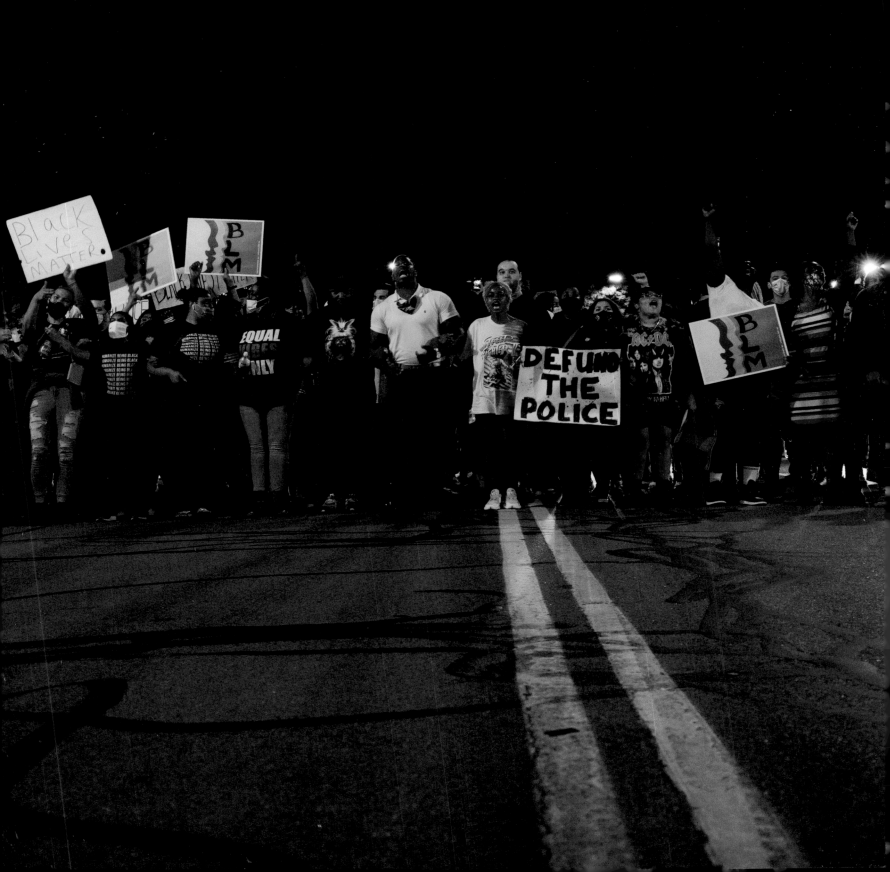